Practical Digital Photomicrography

Dr. Brian Matsumoto received his Ph.D. in Anatomy and Cell Biology from the University of California at Los Angeles in 1981. His research required the development and refinement of techniques for transmission electron microscopy and light microscopy. These tools were used to study the role of actin and microtubules in photoreceptor membrane transport and assembly. From 1992 to 2009, Dr. Matsumoto served as Director of the Integrated Microscopy Facility, a unit administered by the Neuroscience Research Institute and the Department of Molecular, Cellular, and Developmental Biology. This facility provides instruction and support for projects that require advanced imaging. In addition, he served as the instructor for MCDB 220, a graduate level course for digital microscopy at the University of California. He has strengthened the ties between the University and industry by working with such companies as Olympus of America, Media Cybernetics, Q-Imaging, Jackson ImmunoResearch, Prior Scientific, and Image Content Technology. Together, they have developed a digital imaging course that is open to attendees throughout the United States.

Practical Digital Photomicrography

Photography Through the Microscope for the Life Sciences

Dr. Brian Matsumoto

Dr. Brian Matsumoto, brian_matsumoto@mac.com

Editor: Jimi DeRouen
Copyeditor: Cynthia Anderson
Layout and Type: Almute Kraus, www.exclam.de
Cover Design: Terri Wright Design, www.terriwright.com
Printer: Friesens
Printed in Canada

ISBN 978-1-933952-07-9

1st Edition © 2010 by Dr. Brian Matsumoto

Published by:
Rocky Nook Inc.
26 West Mission Street Ste 3
Santa Barbara, CA 93101
www.rockynook.com

Library of Congress Cataloging-in-Publication Data

Matsumoto, Brian.
 Practical digital photomicrography : photography through the microscope for the life sciences / Brian Matsumoto. -- 1st ed.
 p. cm.
 ISBN 978-1-933952-07-9 (alk. paper)
 1. photomicrography. 2. Photography--Digital techniques. I. Title.
 QH251.M3185 2010
 570.28'2--dc22
 2009044039

Distributed by:
 O'Reilly Media
1005 Gravenstein Highway North
Sebastopol, CA 95472

Adobe product screen shot(s) reprinted with permission from Adobe Systems Incorporated.

All product names and services identified throughout this book are trademarks or registered trademarks of their respective companies. They are used throughout this book in editorial fashion only and for the benefit of such companies. No such uses, or the use of any trade name, is intended to convey endorsement or other affiliation with the book. No part of the material protected by this copyright notice may be reproduced or utilized in any form, electronic or mechanical, including photocopying, recording, or by any information storage and retrieval system, without written permission of the copyright owner. While reasonable care has been exercised in the preparation of this book, the publisher and authors assume no responsibility for errors or omissions, or for damages resulting from the use of the information contained herein.

This book is printed on acid-free paper.

Acknowledgments

This book was a labor of love, not only for me, but also for my friends and family who provided the inspiration and help that enabled me to complete this project.

This book is dedicated to my family, especially to my late father, Masamoto Matsumoto, and my mother, Janet Matsumoto, who inspired me and supported my dreams to become a scientist. Also, this book is dedicated to my wife Carol and my two stepdaughters, Elizabeth and Sarah, who exhibited the greatest patience and support while I spent many hours at the computer and microscope.

I thank and acknowledge the support and friendship of Jimi DeRouen and Gerhard Rossbach of Rocky Nook. Both these gentlemen believed in me and in my work and provided endless and meticulous comments on how to improve the quality of this manuscript. Working with them was a pleasure and their friendship was an incalculable reward for having undertaken this task.

In addition, I owe thanks to my friends who were and still are associated with Olympus of America: Ralph Johnson, Art Rosenblatt, Dennis Donley, and Lee Wagstaff, all of whom provided support, encouragement, and discussions on my work with microscopes. I am especially indebted to Art, who made innumerable trips to my laboratory and spent hours discussing microscopes of all types and from all manufacturers. These four individuals exemplified the power of collaboration between the industrial and academic sector and provided exemplary service to the investigators at the University of California at Santa Barbara. They gave unstintingly to our microscopy courses and their contribution to the education of aspiring microscopists cannot be overemphasized.

Table of Contents

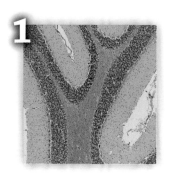

2 Introduction to the Microscope
3 Basic Microscope Parts
8 Köhler Illumination
13 Troubleshooting

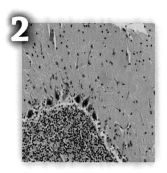

14 The Lens
17 Objective Lens
19 Viewing the Specimen
23 Oil Immersion Objectives
25 Depth of Focus
26 Objective Lens: Types and Controls
26 Water Immersion Lenses Versus Oil Immersion Lenses
27 Role of Condenser and Field Diaphragms
31 Focusing: Coarse and Fine
33 Stage
35 Substage
35 Head of the Microscope

36 Selecting Microscope Accessories
37 Overview
37 Stereomicroscopes
41 Objectives' Limit of Resolution
42 1000x NA Rule
42 Magnification Changer and Eyepiece
44 Adding to Standard Objective Lenses
46 Working with Live Samples in Water
47 Condenser
47 Stage

Table of Contents vii

48 Digital Concepts
49 The Pixel
50 Light Intensity and Bit Level
52 Color Images and Additive Color
53 Introduction to Cameras
55 Consumer-Grade (Point-and-Shoot) Cameras
56 Digital SLRs
56 Dedicated Cameras

58 Digital SLRs
59 Introduction
61 Indirect Mount
61 Direct Mount
63 Simple Tube Adapters
64 Disadvantages of Simple Tube Adapters
65 Advanced Adapters
67 Avoiding Vibration on Digital SLRs
68 Achieving Accurate Focus and Framing
69 Olympus E3
70 Nikon D700
72 Nikon D300
74 Panasonic G1
76 Panasonic GH1

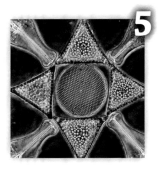

78 Advantages of a Dedicated Digital Camera
79 Definition
79 Superior Imaging by Dedicated Cameras
82 Greater Control through Binning
 and Gain
84 Sensor Array and Magnification
85 Pixel (Photosite) Size and Resolution
87 Mounting Systems

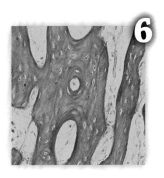

viii Table of Contents

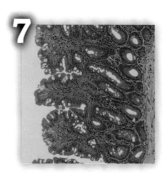

88 Using the Cameras
89 Illuminating the Specimen
89 Color Balancing the Specimen
93 Color and Monochrome
99 White Balance and Fluorescence Slides
99 Optimum Digital Exposure
99 Setting the Exposure
100 Automatic Exposure
101 Manual Exposure

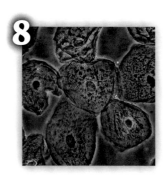

104 Improving the Image
105 Introduction
105 Coverglass Thickness and Contrast
110 Stained Samples
112 Unstained Samples
112 Special Illumination Techniques
116 Fluorescence Microscopy
118 Difficulties of Photographing Fluorescent Specimens
119 Color Imaging in Fluorescence
119 Contrast by Phase Differences
126 The Phase Contrast Image
128 Photographing Phase and DIC Specimens

130 Improving the Image with Software
131 Introduction
131 File Formats
132 Improving the Image
135 Enhancing Contrast in the Micrograph
140 Color and Fluorescence Microscopy
146 Extending the Depth of Field
149 Extending the Dynamic Range of the Camera

54 Buying a Microscope
56 Used Microscopes
57 What to Look for in a Microscope
59 Stage
60 Substage and Illuminator
60 Older Microscopes Suitable for Digital Photomicrography

166 Glossary

174 References

1 Introduction to the Microscope

Basic Microscope Parts

To the neophyte, using a microscope might seem simple. All one has to do is turn on the illuminator, place a specimen on the stage, center it, focus it, and view. Unfortunately, it's not always that simple. Many microscope adjustments require finesse and experience. Nonetheless, a new user can easily learn the proper illumination techniques and correct operation of the microscope to get good results. This book will present both basic and advanced techniques for using a microscope, along with information about different types of specimens, their preparation, and the best way to view them. As with most things, simple techniques yield the most basic images, while more advanced techniques reveal hidden wonders in the microscopic world.

This chapter introduces the microscope by describing the controls used most frequently. Chapter 2 covers the parts of the microscope in greater practical and theoretical detail. Taken together, these chapters provide the basics to get immediate results. When later chapters cover more sophisticated steps and techniques, readers will be able to build on their basic knowledge and understanding to perform the new techniques successfully.

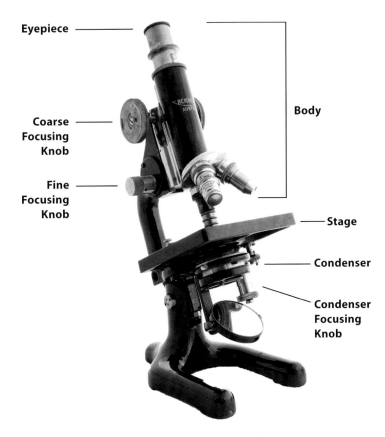

Figure 1-1: A monocular microscope made by Reichert in the 1930s. This is a typical instrument from the early 1900s. Focusing is accomplished by raising or lowering the microscope body that holds the objectives and eyepiece. When a camera is mounted over the eyepiece, its weight can stress the focus controls. Typically, to prevent a downward drift in focus, a friction clutch is tightened on the coarse focus. Turning this knob becomes more difficult, and for this reason, a microscope of this type is unsuitable for digital photomicrography.

The cerebellum is used to control equilibrium in man. This photograph taken with a 4x objective and 1x eyepiece shows the general structure of this tissue. It is stained with a dye combination that colors nuclei a deep purple and the cytoplasm of the cell pink. By using Köhler illumination, it is possible to light the specimen so that the resultant micrograph has high contrast and the field is evenly illuminated.

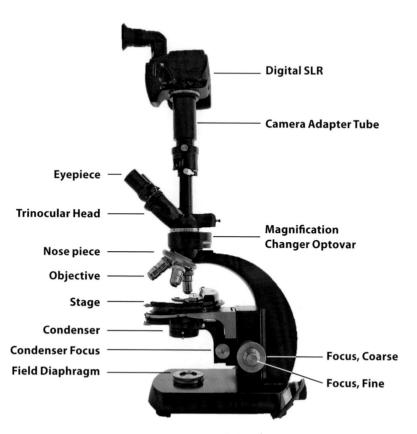

Figure 1-2: A Zeiss WL equipped with a digital SLR camera. This microscope was manufactured in the 1960s and shows the design changes that made the microscope more suitable for photography. The microscope body has a trinocular head with the vertical tube dedicated to holding the camera: a microscopist can view a sample through the eyepieces and conveniently record observations with the camera. Note how the microscope body is fixed in position: raising and lowering the stage accomplishes focus.

There are three functional divisions of the basic microscope controls: the first is holding the specimen, the second is focusing to attain a sharp image, and the third is adjusting the illumination to minimize glare (figures 1-1, 1-2, and 1-3). The stage supports the specimen, which in turn is mounted on a glass slide. While appearing simple, the stage is a precisely engineered flat plate located in the mid-region of the microscope. Its smooth surface is perpendicular to the viewing optics, and it is finely polished to allow minute movements of the slide without any friction or sticking.

The slide is typically a glass rectangle, 1 mm thick and 25 mm wide by 75 mm long. It is made of an optical-grade glass with its surfaces parallel and polished. A sample, which for many users is a thin slice of tissue that has been stained with dyes, is placed on its upper surface. A thin glass cover (coverglass) of a defined thickness is placed over the sample, sandwiching it between the slide and the coverglass. The resulting mounted slide is placed on the stage with the coverglass facing up. Two clips, one spring-loaded, grip the slide securely. Two precise mechanical gears move the clips vertically and horizontally on the stage to position the specimen for viewing.

The microscopist focuses the specimen by moving it closer or farther from the viewing optics. In older microscopes, the slide is fixed and the viewing optics are raised or lowered (figure 1-1). On modern research microscopes, the entire stage assembly is moved while the optical train is fixed (figures 1-2 and 1-3). Focusing by moving the stage assembly is preferred when using a digital camera. Otherwise, the focusing mechanism has to carry the weight of the camera as well as the microscope head. This additional weight can make it

difficult to turn the coarse focus control. For the purposes of this book, I assume that the reader is using a modern microscope with a focusing stage.

There are two focusing controls: coarse and fine. Typically, the coarse focus knob is larger in diameter and is found underneath the stage, to the rear of the microscope. It moves the stage rapidly to position the specimen in relation to the lens. With the coarse focus knob, the user can focus the lower powers quickly and accurately as well as increase the clearance of the lens when large objects are added or removed from the stage. Higher magnification work requires using the fine focus knob. On modern microscopes, it is the smaller-diameter knob that is usually found concentric to the coarse knob. The fine focus knob raises and lowers the stage delicately and becomes the final control when focusing the image through the oculars and camera. Frequently, its rim has tick marks that indicate the movement of the stage in microns. Typically, one full rotation of this control will move the stage 100 microns, or 0.1 mm.

Above the stage, closest to the specimen, is the objective lens. Its name reflects its position in the optical path, as it is closest to the object being examined. The magnification of each lens is engraved on its barrel as a number followed by an x. Usually, there are several objectives mounted on the microscope, and since they have different powers, they are the means for varying magnification. They are mounted on a circular rotating disc called the nosepiece. To change power, the user rotates the objective of the appropriate power so that it lies in line with the eyepiece.

Above the nosepiece is the body of the microscope, and at its top are the eyepieces. In a microscope designed for photomicrography,

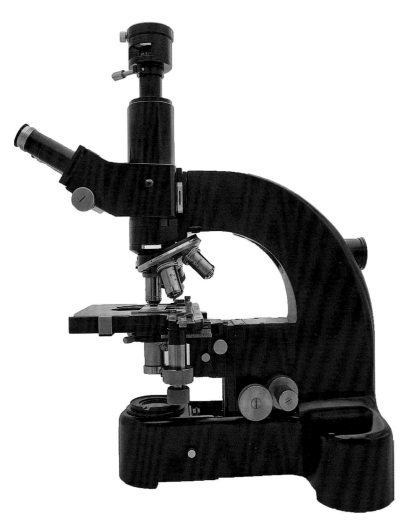

Figure 1-3: A Leitz Ortholux microscope, one of the first modern microscope designs. This microscope was made in the 1950s and is suitable for digital photomicrography. It has a trinocular head that can hold the full weight of a camera. In older microscopes of this era, the knobs were separated. The fine focus knob moves the stage vertically by only 2 mm, whereas the coarse focus mechanism can move the stage 20 mm or more.

the eyepieces are mounted in a trinocular head that consists of two eyepieces and a photographic tube. The eyepieces are paired and angled at 45° and can be adjusted closer or further apart, thus accommodating individual variation in the distance between the left and right eye. To compensate for differences in the strength of the eyes, one of the eyepieces has a knurled control that ensures that the degree of near or farsightedness is equivalent for the two eyes. The photographic tube is vertical and serves to hold the digital camera. A slider on the side of the viewing tube directs the light to either the eyepieces or the camera.

The eyepieces, also called oculars, have an engraved magnification number followed by an x representing the eyepiece's power. Together with the objective's power, the user can determine the visual magnification of the microscope. The magnification equals the multiplied value of the eyepiece and the objective. For example, if the objective is 100x and the eyepiece is 10x, the total magnification power is 1000x.

Beneath the stage are the controls and optics for illuminating the specimen. Almost all modern research microscopes have a built-in illuminator that lights the specimen according to procedures described by Köhler (see the end of this chapter). Understanding this procedure is necessary for high-resolution imaging. Considering that the illuminator is built in, there is little reason for not using it correctly.

In the base of the microscope is the field diaphragm that can be opened or closed with a large, knurled ring. This controls the expanse of light illuminating the specimen; a larger opening lights a larger portion, and a smaller opening lights a smaller portion. Higher-contrast images are obtained by restricting the light to the regions that are being viewed. The size of this field varies because of the range of magnifications. Lower magnifications encompass a larger area of the specimen than higher magnifications. An adjustable field diaphragm ensures that you can match the range of magnifications to the field of view.

Above the field diaphragm is the condenser a group of lenses for focusing the light onto the specimen. Light is focused by raising or lowering this assembly, a task accomplished by a knob that sits beneath the stage and forward of the focus knobs. Additionally, there is a condenser diaphragm for regulating the numerical aperture and centering screws for making the light concentric to the optical axis. Correct adjustment of the field diaphragm, condenser focus, condenser diaphragm, and centering screws are all critical for proper illumination. The following list includes the minimum controls that the user must understand, starting at the base of the microscope and proceeding up to the eyepieces:

- **Field diaphragm** - The iris diaphragm whose diameter controls the area of the specimen that is illuminated.
- **Condenser focus knobs** - The knobs that raise and lower the condenser to concentrate light onto the specimen.
- **Condenser centering screws** - Two opposed screws that center the illumination to the objective lens.
- **Condenser diaphragm** - The iris diaphragm located in the condenser that controls the size of the cone of light projected to the specimen.
- **Coarse focus knob** - The knob that raises and lowers the stage, usually the largest knob underneath the microscope stage. It positions the stage rapidly and can be used to focus objects at low power.

Fine focus knob - The knob that raises and lowers the stage for fine focus. Typically one rotation will move the stage only 0.1 mm. This knob is smaller in diameter than the coarse focus knob.
Stage - The flat plate on which the slide is mounted. It moves vertically and can be raised or lowered.
Mechanical stage - The geared controls that move the specimen across the surface of the stage.
Objective lens - The imaging lens of the microscope, and the one positioned closest to the object being observed. A number engraved on the side indicates its magnification.
Nosepiece - The circular disc that holds multiple objectives and functions as a method to rapidly change objectives.
Trinocular head - The three-tube body above the nosepiece that holds the two eyepieces and the photographic tube for the camera.
Eyepiece - The lens closest to the observer's eye. It is engraved with its magnification, and multiplying this value by the number of the objective gives the total visual magnification.

These parts are the essential components of any modern microscope. Knowing where and how to use them enables the microscopist to improve the chances of recording excellent images. As mentioned earlier, Köhler illumination is required for accurate imaging. The following section breaks down the process into manageable steps and provides a baseline for correctly illuminating the specimen. Failure to follow these procedures can produce inferior results and potentially damage the objective lens.

Figure 1-4: Before setting up Köhler illumination, get the specimen in focus. To do this, place a well-stained slide on the stage, coverglass facing up. Make sure a 10x objective is in place and raise the stage with the coarse focus knob until the slide is just short of the objective. When you look through the eyepieces, you should see the out-of-focus specimen; if it is heavily colored with stain, the colors should be evident. Then, while looking through the eyepieces, turn the coarse focus knob so the stage goes down, away from the objective. The specimen should become apparent.

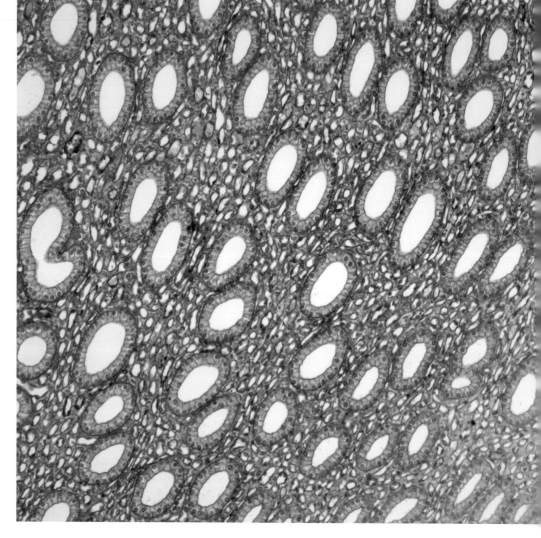

Figure 1-5: Lowering the stage away from the objective ensures that you won't inadvertently crash the slide against the lens. Now adjust the fine focus knob until the image comes into sharp focus.

Köhler Illumination

1. Turn on the microscope illuminator and make sure light is passing through the field diaphragm.
2. Place a slide (a slide of stained tissue is good) on the microscope stage. Secure the slide with the microscope's clips. Make sure the coverglass is facing up.
3. Rotate the objective marked 10x into position. It will be perpendicular to the stage. Make sure it will clear the clips that hold the slide before rotating it into place.
4. Using the coarse focus knob, move the stage to just short of the 10x objective. Be careful not to hit the objective into the slide (see figure 1-4). You should now be able to see an out-of-focus specimen.

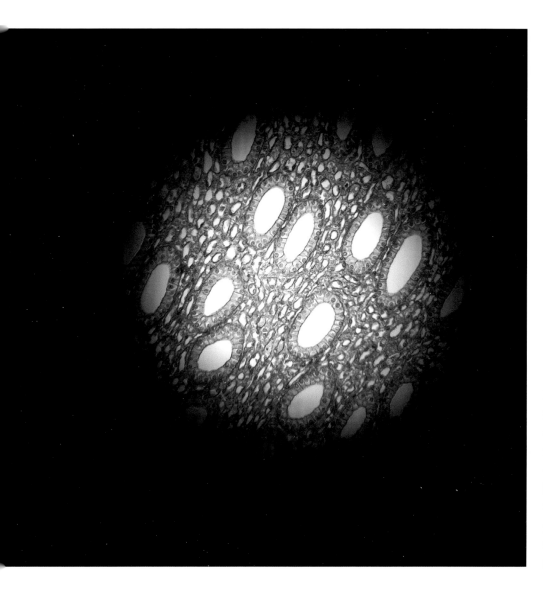

Figure 1-6: When you close the field diaphragm to its minimum size, you will see a circle of light with blurred edges. Since the condenser is not yet in focus, the edges of the field diaphragm appear fuzzy.

5. While looking through the eyepieces, turn the coarse focus knob so that the stage lowers (moves away from the objective) to bring the specimen into rough focus. Lowering the stage ensures that you won't raise the slide and hit the objective.
6. Once the image comes into view, adjust the fine focus knob until the image appears sharp (see figure 1-5).
7. Close the field diaphragm to its minimum diameter. You should see a brightly illuminated spot. Its limit is the edges of the field diaphragm, and generally the edges will appear blurred (see figure 1-6).
8. Adjust the condenser focus control until the edges of the field diaphragm become sharp. When this is accomplished, the

Figure 1-7: Bring the edges of the field diaphragm into sharp focus by raising and lowering the condenser. Typically, the circle of light will be at its smallest diameter when in focus.

image of the field diaphragm is projected onto the specimen plane (see figure 1-7).

9. Open the field diaphragm until it just clears the field of view. This ensures that the region encompassed by the microscope is fully illuminated (see figure 1-8).

10. If the field diaphragm is not centered in the microscope eyepiece, use the condenser centering controls to center it.

11. Remove one of the eyepieces and look down the tube of the microscope. Open and close the condenser diaphragm, watching how the circle of light increases and decreases in diameter. Reopen the condenser diaphragm and observe the maximum size of the illuminated circle. Then, noting this position, close the condenser diaphragm so that the diameter of

Köhler Illumination 11

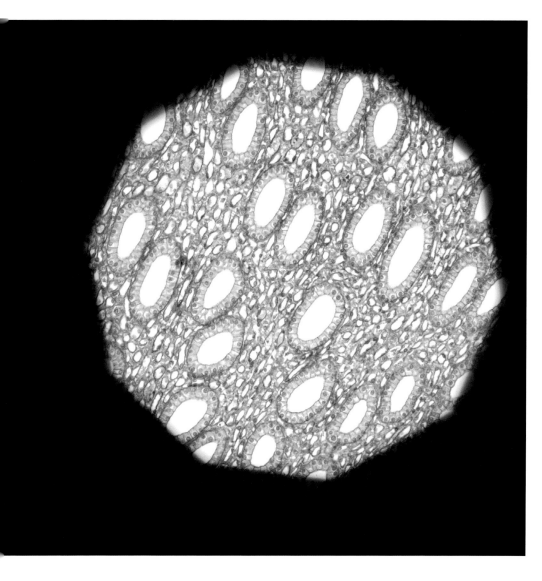

Figure 1-8: When you look through the eyepiece, the field diaphragm will have a circular appearance with a black limit. Open the field diaphragm until its edges just pass the border seen through the eyepiece. This ensures that the area to be illuminated matches the area being observed. If the condenser has centering screws, adjust them so that the field diaphragm is centered on the circular field of the microscope.

the lighted circle is three-fourths that of the widest field (figure 1-9). For stained samples, these settings provide the optimum image for revealing fine details while maintaining contrast. If you close the condenser diaphragm to its minimum diameter, the contrast of the image increases at the expense of losing fine detail. If you open it too wide, the image loses contrast and subtle structures disappear in the glare.

12. To increase magnification, rotate the objective with the next highest number into the optical path. Again, make sure the objective clears the slide and stage clips to avoid scrapping and damaging the objective. Instead of viewing through the oculars, watch the objective while moving

Rear of aperture. Partially filled with light from condenser iris 75 percent opened. Gray is condenser iris occluding light.

Figure 1-9: When the eyepiece is removed, you will see a circle of light, which is the rear of the objective lens. By opening and closing the condenser diaphragm, you will see the circle of light increase and decrease in diameter. Open the condenser diaphragm until you identify the maximum diameter of the light. Then close the condenser diaphragm until the circle of light is reduced by one-fourth.

it into position. This will prevent any damage to the objective that would make it unusable.

13. Repeat operations 6 through 11.

There are two types of objectives: dry objectives that work in air and immersion objectives that work in oil. The operation described earlier is for dry objectives. Immersion objectives require a minute drop of immersion oil to be placed on the slide's coverglass. When the oil objective is rotated into place, its tip is immersed in the oil, which joins the top of the coverglass to the tip of the objective lens (an initial supply of immersion oil is usually provided by the microscope manufacturer).

Because objectives and eyepieces from different manufacturers often share a common mount, it is possible to attach lenses from different manufacturers to a microscope stand. However, unless you are familiar with the history of objectives and eyepieces, this practice is discouraged. Sometimes different manufacturers' products appear to work together but have enough differences so that the resulting images can be inferior or a lens can be damaged.

In a properly configured system, the objectives will be at a defined height above the slide so that all of them will be in near focus as you rotate them into position. The objectives are said to be parfocal. This is a great convenience since it allows the user to quickly establish proper focus after changing powers. All that is required is a fractional turn of the fine focus knob.

However, by indiscriminately mixing objectives, one may lose parfocality. At best, this inconvenience will cause an objective to be out of focus when it is rotated into the optical path. At worst, the objective will be too close to the coverglass, and as you rotate the

nosepiece, it will be scratched by the metal clips of the mechanical stage. For the best results and to avoid potential damage, stick with a set of microscope components that are designed to work together.

Troubleshooting

The information in this chapter should be sufficient to enable someone new to the microscope world to illuminate a specimen properly for viewing and photography. However, things don't always work as planned. The following list will help you troubleshoot any problems that may arise:

- Make sure the illuminator is working. Most lamps have a rheostat for varying light output. Briefly turn it to the maximum value. If light does not emanate from the field diaphragm, check to see whether the transformer is plugged into a socket and whether the socket is live. You can plug a table lamp into the outlet to make sure it is delivering juice. If the outlet is active, check to see if the bulb is good. This may require opening the microscope and inspecting the tungsten bulb. A minute break in the filament will keep a bulb from lighting and you may need to use a magnifying glass to see the split. In this case, the solution is to replace the bulb. If the bulb looks intact, unplug the microscope and determine whether the fuse is blown. If so, replace the fuse.

- If light is emanating from the field diaphragm, determine whether light is being blocked at the level of the condenser. If you raise the condenser, open its diaphragm, and then open the field diaphragm, you can inspect the slide to see if light is hitting it. Note that if the rheostat is set at the highest value, you should not use the eyepiece—the light will be too intense to view through the oculars. If there is no light, check the condenser to see if there is anything blocking the light from entering it. Frequently, a condenser is equipped with a swing-out holder for a filter. It is possible for the rim of a filter to lie directly under the condenser, blocking light from the illuminator. If you see light rising from the condenser and reaching the slide but you still can't see the light through the eyepieces, then light is being blocked between the objective lens and the eyepiece. Make sure the objective is properly centered. When the nosepiece is rotated, there should be an audible click when a new objective is placed in the optical path. If the objective is not properly positioned, it may block the light. If the objective is in position, the problem may be in the microscope head. Many trinocular heads have a sliding prism that can direct the light 100 percent to the eyepiece or 100 percent to the camera. Make sure the slide is positioned to direct light to the eyepiece.

- If you have a problem that can't be solved by the preceding steps, it's time to call for assistance. Some microscopes may have intermediate tubes or filters that block the light path. Advanced microscopes have computer-controlled shutters. If you are uncertain how to operate them, resist the urge to start changing the settings randomly. For a novice, it can be nearly impossible to reset a microscope after random changes. In addition, any permanent damage to the microscope's components would require significant expense to repair.

2 The Lens

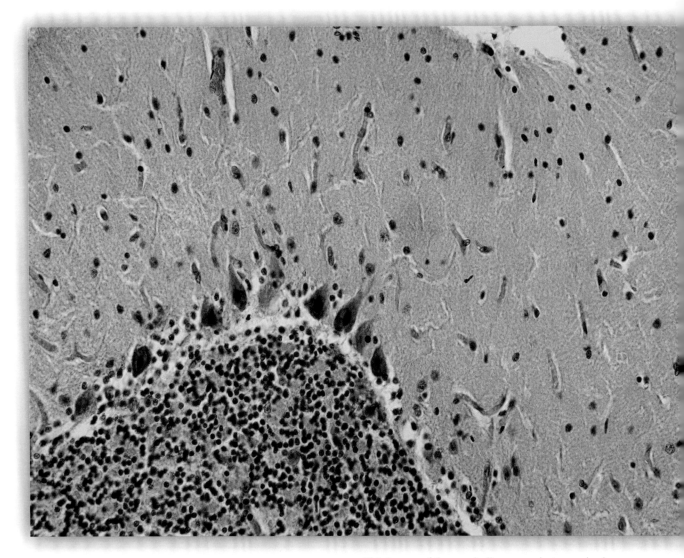

This image of the cerebellum was photographed with a 20x objective and a 1x eyepiece. This lens combination provides enough magnification to reveal individual cells. Köhler illumination is used for high- as well as low-magnification photographs. In both instances, it evenly illuminates the field and generates a high-contrast image.

Chapter 1 described the basic microscope controls, how to set up Köhler illumination, and how to use an oil immersion objective. These basic skills will be all that many people need to successfully photograph specimens. However, it must be remembered that images viewed through a microscope are the result of complex interactions of light. What we see is a representation of the real structure that changes as the lighting is altered. An understanding of light's interaction with the specimen and the microscope will help you decide which lens to use and how much magnification is needed to discern fine structures. This chapter provides a simplified explanation of optics to help you become familiar with additional terms and principles. There will be a minimum number of equations with the focus on providing you with an intuitive and pragmatic approach to the workings of the microscope.

The simplest microscopes are magnifiers or loupes used for studying objects at low power by reflected light. Focusing is accomplished by placing the object close to the lens. These handheld lenses typically magnify 10 times (10x). Correctly using a 10x magnifier requires holding it close to the eye and then bringing the subject about one inch from the lens. These magnifiers are convenient tools; they are small and portable with no moving parts and can be used anywhere. Their main disadvantage is that you must place your head so close to the subject. Holding the specimen and magnifier so close to the eye is tiring, and if the specimen is fixed, you may have to contort your body to view the sample.

A biconvex lens is an example of a simple microscope. It has convex surfaces on each side and an optical axis, a line that passes through the center of curvature of the lens. The light rays traveling parallel to this optical

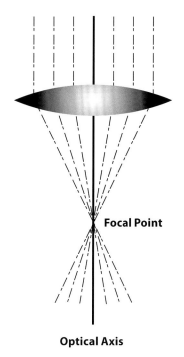

Figure 2-1: Ray diagram of a simple biconvex lens. A set of parallel rays (dashed lines) goes through a simple biconvex lens and is focused at the focal point. This lies on the lens's optical axis (solid dark line), a line that passes through the center of the curvature of the lens. The light path describes magnification and how light intensity decreases with higher magnification, but it does not explain how an image is formed at higher magnification.

axis pass through the lens and then converge at a point on the opposite side. This is defined as the focal point, and its distance from the lens defines the focal length. In the case of a symmetrical biconvex lens (a lens having the same convexity on each side), there will be two focal points equidistant from the lens. As a matter of convention, the focal point that is on the side opposite from the light source is defined as the back focal point. The focal point that is on the same side as the light source is defined as the front focal point.

If you take a simple biconvex lens and place it close to an object, within the focal point, you generate an image that can be seen from the opposite side of the lens. The image is observable when the lens is placed close to the eye. When viewed through the lens, the subject appears enlarged and suspended on the

Figure 2-2: White light (solid lines), which is a mixture of colors, cannot be focused to a single point with a simple lens. Acting as a prism, the glass separates light into its component colors so that red light (light with a long wavelength) is brought to a different focus than blue light (light of a shorter wavelength). The failure to bring all colors of light to a common focus is chromatic aberration.

opposite side. This is a virtual image; it is not real since it cannot be projected onto a screen.

A lens can also form a real image, one that can be projected onto a screen or captured by a camera. This occurs by placing a subject on one side of the lens so that it lies outside the focal length. A real image will be projected on the opposite side of the lens. This image is inverted and can be treated as if it were a real object. When a second lens is used, the real image can be viewed at higher magnification. In essence, the second lens acts as a magnifier that generates greater amplification of the real image. This is the basis of the compound microscope. The lens closest to the object is called the objective, and the lens closest to the eye is called the eyepiece. Each lens provides magnification, and the effect is multiplied so that a 10x objective and a 10x eyepiece create an image at 100x.

Increased magnification reveals the subtle effects that optics have on light. These phenomena have such slight effects on images at lower power (i.e., 10x or less) that they are not a concern. But at higher power (i.e., 100x), their effects reduce image sharpness. For example, a lens acts like a prism and separates white light into different wavelengths (i.e., colors) measured in nanometers (nm). Blue light (shorter wavelength, 490 nm) comes int focus closer to the lens than red light (longer wavelength, 600 nm). As a result, an opaque spot displays different colors as you vary the microscope's focus (figure 2-2). On one side the image appears blue, while on the opposite side it appears red. This is called longitudinal chromatic aberration. There is also lateral chromatic aberration because an image made from red light is a different size than one mad from blue light. When a point is viewed with white light, it will have the appearance of a small line varying from red at its periphery to blue at its center. These color fringes interfere with identifying the specimen's borders.

Color fringes can be corrected by using multiple glass elements to form a compound lens. By focusing two wavelengths of light, usually red and blue, a compound lens shows reduced color fringing. This type of lens is defined as being achromatic, or without color. In spite of its name, an achromatic lens does not fully correct color errors. When a lens brings the two extreme wavelengths, blue and red, to a common focus, there are still colors with wavelengths longer than 490 nm and shorter than 600 nm that are not brought to the same focus. This situation is described as residual chromatic aberration.

Figure 2-3: A lens may not bring parallel light to a common focus. Light rays passing through the periphery of the lens are brought to a different focus than light rays passing through its center. This is a reflection of a spherically ground surface, i.e., an example of spherical aberration.

To provide improved color rendition, there are objectives that focus three or more different wavelengths to the same focal point (blue, 490 nm; green, 550 nm; and red, 600 nm). Such a lens is defined as being apochromatic. Achromatic lenses are the least expensive, while apochromatic lenses are the most expensive. Lenses that have an intermediate correction are described as semi-apochromats, or fluorites. These definitions refer to lenses made in the 1950s; the terms are flexible and have changed with improvements in lens design. The degree of correction in modern lenses has improved. Today's achromatic lens can focus three colors to a common point, while an apochromatic lens can focus four or more colors to a common point.

Another term a microscopist should know is "spherical aberration" (figure 2-3). Spherical aberration is the failure of the lens to bring all the parallel rays of light to a focal point. Rays that strike the peripheral edge of the lens are brought to a different focus than rays that strike the center. Images viewed through a lens with spherical aberration appear "soft", lacking definition and contrast. Edges are not well defined, and image contrast is reduced. Using multiple lens elements can solve this problem.

Objective Lens

The objective lens projects a real image of the specimen up toward the eyepiece, and its design and quality determine image sharpness. An understanding of its optics and specifications enables you to determine the most appropriate magnification and illumination for visualizing the specimen.

The first concept we will investigate is calculating the limits of seeing fine detail with a microscope. Microscopists have an equation to determine the minimum distance that can be resolved by an objective lens. This equation has three factors that influence the ability to resolve fine detail: the angle of light captured by the objective, the medium that lies between the objective and the specimen, and the wavelength of light that illuminates the specimen.

A microscope's ability to resolve and distinguish fine detail depends on its ability to gather a wide cone of light. Specifically, this is referred to its angular aperture. A lens can have a varying angular aperture depending on its diameter and its closeness to the object. The greater the angle of light the objective can receive, the greater its potential for discerning fine detail.

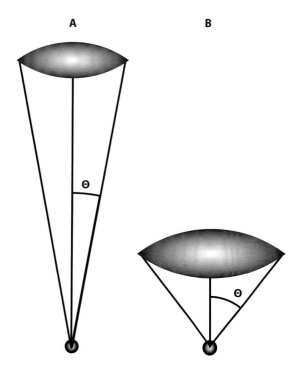

Figure 2-4: This diagram shows how two objectives can have different angles of acceptance. Objective A receives a narrower cone of light than Objective B. Two factors influence the cone of light captured by the objective: the diameter of the front lens and the distance of the front lens from the specimen. For a given distance from the specimen, a larger-diameter element will accept a larger cone of light. For a given diameter, the lens placed closest to the specimen will accept a larger angle. The cone is described by θ (theta); numerically, this is the half angle of the cone. The numerical aperture (NA) of these objectives is defined as RI sinθ (RI is the refractive index of the medium between the specimen and the objective lens). In the case of air, the refractive index is 1, so NA is defined as sinθ. Assuming that θ can have a maximum value of 90, then an objective working in air can have a theoretical maximum NA of 1. When the objective is working in a medium such as water or oil, the NA can be greater than 1.

The second factor determining the ability of a lens to discern fine detail is the medium between the specimen and the objective lens. When light moves through a transparent material, its speed is diminished; this reduction is described by the medium's refractive index (RI). The RI of air is 1; when traveling through air, light's speed is undiminished. The RI of water is 1.33; when traveling through water, light's speed is diminished by approximately 30 percent. The RI of oil is 1.515; when traveling through oil, light's speed is reduced by approximately 50 percent.

Taken together, the immersion medium and the angle of light are described by the term "numerical aperture" (NA). It is expressed by this equation:

NA = RI sinθ

Each objective has an NA value inscribed on its casing, typically a number between 1.4 and 0.01. Occasionally the letters A or NA will appear next to the number. NA is the mathematical designation of the cone of light accepted by the objective. This is shown in figure 2-4, which illustrates two objectives that accept two different cones of light. In this figure, θ is the half angle of the cone and is smaller for Objective A and larger for Objective B. Objective A accepts a narrower cone of light, while Objective B accepts a wider cone with a greater angle. As a numerical value, θ is expressed as sinθ with a value between 0 and 1.

As mentioned earlier, an objective lens's NA can be greater than 1. To get these larger values, the equation for NA multiples sinθ with RI. It is important to include this factor

because the resolving power of the lens improves markedly when it is immersed in higher refraction mediums such as water and oil. When you're using a lens that works in air, the RI is 1, so the angular aperture and numerical aperture are equivalent values. When the lens is immersed in water or oil, the numerical aperture has a different value from the angular aperture.

The final factor that determines the resolving power of the lens is the wavelength of the light used to image the sample. Daylight appears white to the human eye; however, it is possible to break it up into its component wavelengths by passing it through a prism. This was demonstrated by Newton, who showed that white light is composed of colors ranging from violet to red.

The equation for calculating the resolving the power of the lens is as follows:

$$R = \frac{0.61\, \lambda}{NA}$$

R equals resolution (the minimum distance between two objects seen as separated), λ is the wavelength of light in nanometers (nm), and NA is the numerical aperture of the objective. In the case of resolution, the shorter the wavelength, the better the resolution. This formula demonstrates that resolution improves if you reduce the wavelength of light or if you use a lens with a higher NA. For the purposes of illustration, assume that λ is 550 nm, a wavelength of light that appears green to the eye. When you're using an objective with an NA of 0.95, the resolving power is 353 nm; with an objective with an NA of 1.25, the resolving power is 268 nm. Thus, selecting a lens with a greater numerical aperture allows you to see finer details. However, you can also improve lens performance by choosing a lower wavelength of light. Using a wavelength that appears blue violet in color (425 nm) can achieve significantly better performance. With the preceding equation, you can calculate that an objective with an NA of 0.95 will resolve structures separated by 272 nm. This resolution compares favorably to that of an objective with an NA of 1.4 when used with green light. In summary, enhancing the theoretical performance of an objective can be accomplished by elevating the NA or by decreasing the wavelength of light.

Viewing the Specimen

Although it seems counterintuitive, the image seen through the microscope is not a direct representation of the subject being observed. Light interacts with the system, and its wave-like property is responsible for image formation. Light rays can bend, interact with other light rays, and react to obstacles in their path. Light also interacts with the specimen on the microscope's stage as it passes from below, traveling through and around the specimen. The objective, eyepiece, and mounting medium, to name a few components, all play an integral part in how the image appears through the eyepiece.

The following experiment by Ernst Abbe demonstrates how light rays bend and interact with each other to form what is seen through the eyepiece. Our understanding of the numerical aperture's effects on resolution is based on studies by Abbe. For a test specimen, he used a grating with a regular pattern of opaque bars separated by clear spaces. He showed that the objective lens generates a diffraction pattern that can be observed by removing the microscope's eyepiece and

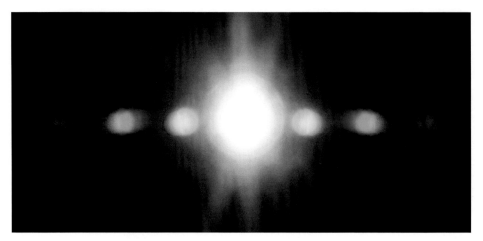

Figure 2-5: A micrometer scale is transformed into a series of spots that are visible when you remove the eyepiece and peer down the tube at the back of the objective lens. This pattern shows the interaction of direct light passing through the microscope and diffracted light that is scattered by the specimen. The bright center light is the direct light called the 0 order diffraction spot. The colored dots flanking it are the first- and second-order diffraction spots that carry the information on the specimen's fine details. If the objective aperture collects a cone of light that accepts the first-order spot (the one closest to the bright center spot) and the 0 order spot, it is possible to transform the image so as to reconstruct the scale. This scale is seen when the eyepiece is replaced. The scale is not seen when the aperture of the objective fails to include the first-order diffraction spots.

looking down its optical tube. There one can see the circular border of the back of the objective lens, a bright spot (uncolored) in its center, and a series of colored spots radiating from the center spot (figure 2-5).

The bright center spot is referred to as the 0 order spot, which is composed of light that passes through the grating and does not interact with it. In contrast, the colored spots surrounding the bright center are the first-order spots. As you go outward, the subsequent sets of spots are numbered second-order, third-order, etc. The colored spots represent light interacting with the grating. As the light rays pass the edges of the grating, their path is bent and they radiate in a fanlike pattern (diffraction). These rays carry information on the spacing of the grating. If you have more bars closer together, the colored spots spread out laterally. This phenomenon is based on the wave nature of light and the interaction of light rays from neighboring edges of the grating.

As the subject becomes more complicated, the diffraction pattern changes. In the case of

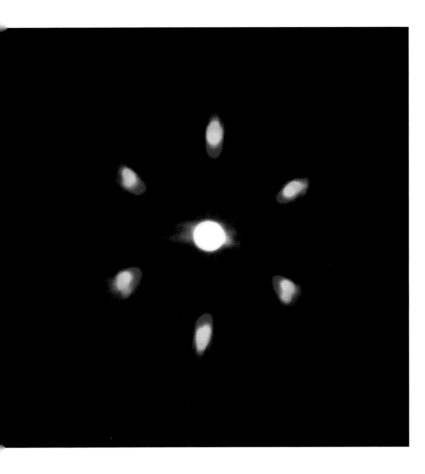

Figure 2-6: The diffraction spots generated by the specimen change in appearance when the pattern of the repeating structures differs. If you have a specimen with a regular punctuate array, you obtain a diffraction image like this one. The pattern seen here is generated from the shell of a single cell alga (*Pleurosigma angulatum*).

a regular lattice of tiny pores, the diffraction pattern appears as a central spot with six colored (first-order) diffraction spots spread out laterally (figure 2-6). In this example, you can see the fine pores that generated this pattern with the eyepieces (figure 2-7). If you alter the objective lens so that it cannot capture the first-order spots, you will see only the bright central direct spot in the back of the objective lens (figure 2-8). Abbe's theory predicts that the fine details will not be detected (resolved) under this condition. Examining the specimen with the eyepieces shows that the fine dots are invisible (figure 2-9).

This phenomenon demonstrates the interactions of the specimen with the illuminating light. What makes it significant is that the diffraction spots interact with each other and influence the appearance of the image seen through the eyepiece. This is demonstrated by blocking the first and higher order diffraction spots to prevent them from being projected up into the eyepiece (figure 2-8). If you allow only the bright central 0 spot to travel up to the eyepiece, the fine detail is no longer visible (figure 2-9). In other words, the amount of detail seen through the eyepiece is directly related to the light interaction between the diffraction spots. These experiments illustrate

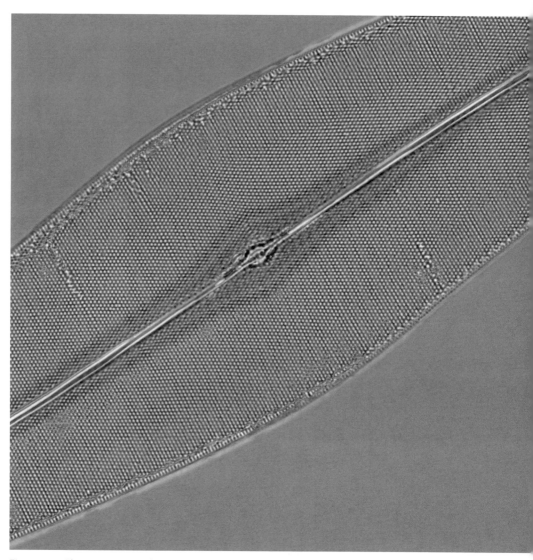

Figure 2-7: *Pleurosigma angulatum* belongs to a group of plant cells called diatoms. This group is characterized by making a shell (frustule) with minute pores. Their spacing can be highly regular and serve as a test object. In this case, the pores are spaced approximately at 0.5 micron increments. They can be readily resolved with a high-quality objective lens provided that it has a large enough numerical aperture to capture the first-order diffraction spot. This lens has that capability as evidenced by the diffraction pattern (figure 2-6) and the detection of the pores in this photograph.

Figure 2-8: The same lens is used to capture the diffraction pattern of *Pleurosigma angulatum*, but with one alteration. A small internal iris diaphragm is closed so that the first-order diffraction spots are blocked from entering the objective. All that is captured is the direct light from the illuminator; the diffracted light that forms the first-order spots is excluded.

that what is seen through the eyepiece represents the interaction of light collected from the objective and that failure to collect diffraction spots (0, first, second, third, etc.) causes a loss in resolution.

Understanding how diffraction spots are collected helps explain why an objective with a higher numerical aperture can see finer detail than one with a lower numerical aperture. A lens that can accept a wider cone of light captures more of these interactive spots, while a lens that fails to capture them misses the fine detail that they convey.

Oil Immersion Objectives

A light ray emanating from a specimen mounted under a coverglass takes a different path if the objective is working in air versus working in oil (figure 2-10). As the ray emerges from the coverglass into the air, the air's lower refractive index causes it to bend outward. As the angle increases, the ray is reflected out of range of the objective lens (solid half circle) instead of going up into it, and in some cases the ray is reflected back downward through the coverglass and slide. In contrast, a light ray emerging from the coverglass into oil does not deviate at all. Oil's

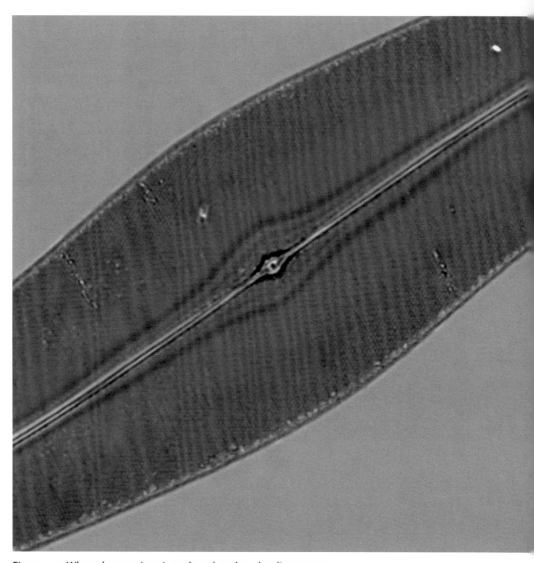

Figure 2-9: When the eyepiece is replaced so that the diatom can be viewed, the altered lens no longer shows the fine details in the frustule. The pores have disappeared. Opening the iris so that the lens can capture the first-order diffraction spots plus the 0 order diffraction spot restores the view of the pores (figure 2-7).

refractive index is the same as glass (1.515), allowing the light ray to continuing traveling in a straight line through the coverglass and into the objective lens. When you work in a medium with a higher refractive index, more light rays travel forward through the objective.

Depth of Focus

An objective lens can be focused in only one plane at a time. As the lens moves up and down, its focus also moves up and down. Depth of focus refers to the degree that these regions, or planes, appear to be acceptably sharp.

A large depth of focus has a greater zone of sharpness than a narrow depth of focus. In photomicrography texts, there are a variety of equations quantifying depth of focus; however, depending on the assumptions made for the equations, the resulting values can vary by a factor of two or three. Rather than discuss or debate the merits of which equations are most accurate, it is more fruitful to realize that the depth of focus in microscopy does vary—and that its range of sharpness varies with NA.

A photographic print is a two-dimensional image of a three-dimensional subject. In order to obtain great depth of focus, a photographer may choose a lens with a smaller numerical aperture and sacrifice lateral resolution. However, for some subjects, a photographer may decide to use a higher numerical aperture, making the subject of interest more dominant by throwing objects slightly above or below it out of focus. Many writers refer to such a lens as generating "optical sections".

Pragmatically, you should be aware of this characteristic of microscope images and realize that obtaining a good photomicrograph

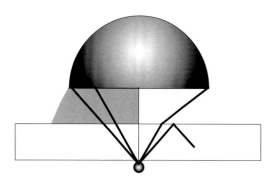

Figure 2-10: This diagram shows how an oil immersion lens captures a wider cone of light rays than one working in the air. The right half of the lens shows the path of a light ray as it moves from the specimen through the coverglass and into the air. The ray bends away from the center as it leaves the coverglass (rectangle). Eventually, as the angle increases, the light ray is reflected down into the coverglass so the front lens of the objective does not collect it. The left half of the lens shows the path of a light ray for an oil immersion objective. Instead of bending away from the center, the light ray travels through the oil (grayed area) in a straight line so that the peripheral ray is captured by the objective lens.

is an exercise in finding the optical plane that best represents the structure of a three-dimensional object. With digital imaging, it is possible to take several pictures of the subject at different planes and then merge them for an extended depth of field. Software that will accomplish this task will be discussed in chapter 9.

Objective Lens: Types and Controls

As I have stated earlier, objective lenses are characterized as being either dry or immersion: the former has front elements that work in air, while the latter has front elements that work in liquid. Most commonly, the immersion liquid is oil with a defined RI of 1.515. There are other immersion objective lenses designed to work in water rather than oil. A water immersion lens may be a simple dipping lens; the specimen is in a petri dish and the lens is lowered directly into the medium. Other types of water immersion lenses are designed so that the lens is attached to the specimen's coverglass with a drop of water. Immersion objective lenses can have a numerical aperture greater than 1, giving them the highest capabilities in discerning fine detail.

Dry objective lenses are sometimes described as high dry or low dry, depending on their magnification. High dry lenses have a magnification greater than 20x, while low dry lenses having a magnification less than 20x. In all cases, dry lenses have a numerical aperture of less than 1; the highest NA is 0.95. For light of a wavelength of 550 nm, these lenses should be able to resolve objects separated by 0.35 microns.

Nonimmersion and water immersion objectives with high numerical apertures (NA greater than 0.8) have a rotating collar on the barrel of the lens to correct for variations in coverglass thickness. Such lenses assume that a thin optical element, i.e., a coverglass, lies immediately over the specimen with a refractive index of 1.515 and a thickness of 0.17 mm. If the coverglass is of a different thickness, the objective lens correction for spherical aberration is reduced. The resulting image has low contrast, as though a film were spread over the surface of the lens. Fine details that normally would be visible are obscured.

To correct this image degradation, the objective's collar rotates and compensates for incorrect coverglass thickness. It takes some skill to apply this correction by rotating the collar. As you turn it, the image is thrown out of focus. To determine whether the adjustment has improved the image, you must refocus the specimen. Judging the quality of the improvement requires mentally comparing the before and after images. It should be noted that an oil immersion lens does not require any adjustment for variation in coverglass thickness if the sample is mounted in Permount or another medium that has a refractive index of glass.

Water Immersion Lenses Versus Oil Immersion Lenses

Water immersion objective lenses have become popular due to the interest in live cell imaging, especially for studies that require confocal or two-photon microscopy. For older microscopes made in the 1960s and 1970s, the availability of this type of lens is limited. For modern infinity tube microscopes made by Olympus, Leica, Nikon, and Zeiss, there is a much broader range of lenses. A modern research laboratory interested in doing live cell studies can justify buying the latest model microscope with water immersion lenses. An individual laboratory worker who studies stained permanent slides has little need for these lenses.

Water immersion lenses have two major limitations. First, the maximum numerical aperture is 1.2, so a water immersion lens cannot match the resolution capabilities of an

il immersion lens of 1.4. Second, you need to become skilled in using the coverglass correction collar to achieve the full capability of the lens. The correction collar is used continuously, and an operator who does not correct for coverglass thickness gets inferior results. It should be noted that an oil immersion lens with an RI of 1.515 does not require a correction to obtain its highest resolution when the slides are mounted in a hardening medium. This is not the case with the water immersion lens.

That said, water immersion lenses do have their advantages. Personally, since I work most with aqueous samples, I enjoy working with water immersion objectives since, unlike with oil objectives, it is easy to remove the immersion medium and return to a lower magnification.

Role of Condenser and Field Diaphragms

Proper illumination of the microscope requires that the condenser concentrate the illuminant's light on the specimen. The first task is to establish the optical plane of the specimen by viewing it through the eyepiece and adjusting the stage so the specimen appears sharp. First, you are focused on the specimen plane. Next, by raising and lowering the condenser, you can see the light source and focus its image onto the specimen plane. When the image of the illuminant is superimposed on the specimen, its light is maximally concentrated on the subject.

In the 1800s, the flame of an oil lamp served as the indoor light source. The lamp was placed in front of the microscope, and a substage mirror was tilted to direct the light toward the bottom of the condenser. Since a broad flame generates a wide image, the subject was evenly illuminated when the flame was projected onto the specimen plane. This situation changed when electrical light sources became available. A light bulb has a coiled metallic filament for generating light. Compared to the size of a flame, these filaments were much smaller; when the condenser focused their image onto the specimen plane, they failed to fill the field with uniform light. Instead, the brightly glowing filaments were seen as superimposed on the specimen. This distraction interfered with studying the specimen's fine details.

To enlarge the physical size of an electrical light source, a ribbon filament bulb was developed. This light source provided a rectangle 2 mm by 18 mm that was focused onto the specimen, illuminating a uniform field of view. Edward Nelson was a proponent of this type of lighting, and it was previously known as Nelson Critical Illumination. Today, it is known as source-focused illumination.

Using this form of lighting is simple and inexpensive. All you need is a frosted light bulb and a microscope with a mirror for directing the light to the condenser. Place the frosted light bulb in front of a microscope and aim the mirror so that light is directed up toward the condenser. Then take a slide and focus on it using a low-power objective lens. When you have a sharp image of the subject, raise and lower the condenser focusing controls until the image of the light source is focused on the specimen. Usually slight imperfections on the bulb's surface can be used for focusing it onto the specimen plane.

The major disadvantages of source-focused illumination is that it generates flare and that the image may have reduced contrast. A bulb

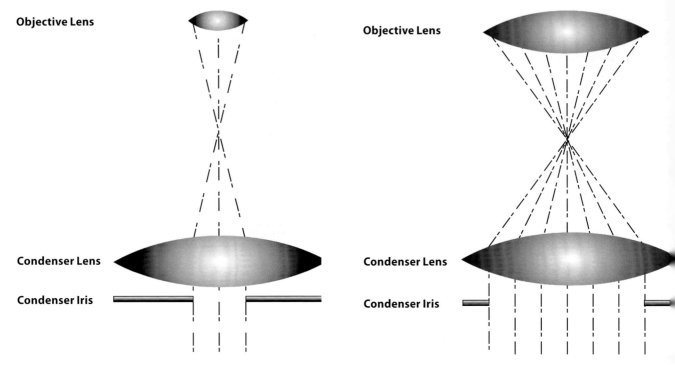

Figure 2-11: The condenser (bottom lens) focuses light onto the specimen (at the area where the dashed lines cross) so that it is collected by the objective lens. Although theoretically it is possible to have one condenser focusing a cone of light for each objective lens so that it matches its numerical aperture, such a solution is impractical. One condenser lens can serve several objective lenses, provided the size of its aperture can be changed. This is accomplished with the condenser iris. When it is closed down, the numerical aperture of the condenser is reduced so that it can provide a cone of light for objectives with a small numerical aperture.

Figure 2-12: In this diagram, opening the condenser iris results in a larger cone of light focused on the specimen. This larger cone emanates from the specimen and is collected by an objective lens with a larger numerical aperture. One condenser can serve objectives with numerical apertures ranging from 0.2 to 1.4.

with a frosted surface illuminates a much larger area. To obviate this distraction, the majority of microscopists use Köhler illumination, the technique described earlier in this chapter. Köhler illumination provides an even field of illumination, and it is employed in some form by all microscope manufacturers on virtually all of their microscopes.

Like source-focused illumination, Köhler first requires that you focus on the specimen. Then, using the specimen plane as a reference point while viewing through the eyepiece, raise and lower the condenser until you see the image of the field diaphragm. Condenser focus is achieved when you focus the edges of the field diaphragm. To minimize glare,

Role of Condenser and Field Diaphragms

Rear of aperture. Filled with light from condenser iris fully opened

Rear of aperture. Partially filled with light from condenser iris 90% opened. Gray is condenser iris occluding light.

Figure 2-13: You can determine the extent to which the condenser diaphragm controls the cone of light presented to the objective lens by a simple expedient. Remove the eyepiece, look down the microscope tube, and see how much light is passing through the objective lens. This diagram shows the objective lens completely filled with light; the black represents the darkened area surrounding the circular rear aperture of the objective. This usually indicates that the condenser iris is opened so wide that the angle of light exceeds what the front aperture accepts.

Figure 2-14: If you look down the microscope while closing the condenser iris, you will see the bright circle becoming smaller. Careful observation reveals that the condenser iris is intruding in the field and its edges can be seen. Closing the condenser iris so that 90 percent of the objective is filled with light is good for the highest-resolution work. This diagram shows how the back of the objective looks when the eyepiece is removed.

open the field diaphragm so that its edges just disappear from the circular field seen in the eyepiece, thereby ensuring that only the field in view is illuminated. If the diaphragm is opened too much, the field being illuminated extends beyond the field being observed and image contrast is reduced.

In both source-focused and Köhler illumination, the goal of focusing the condenser is to generate a cone of light that fills the numerical aperture of the objective lens. The field diaphragm defines the area being lighted.

The condenser's cone of light is adjustable so that it can illuminate a variety of objectives, each having its own numerical aperture (figures 2-11 and 2-12). Closing or opening the condenser iris accomplishes this task. Closing the condenser iris forms a narrow cone of light, suitable for a lens with a narrow angular aperture. Opening the iris forms a wider cone of light, suitable for a lens with a greater angular aperture. Opening the iris so that it creates a cone of light greater than what the objective receives can also create flare and

Rear of aperture. Partially filled with light from condenser iris 75% opened. Gray is condenser iris occluding light.

Rear of aperture. Partially filled with light from condenser iris 50% opened. Gray is condenser iris occluding light.

Figure 2-15: Some specimens, especially those that are weakly stained, may appear "washed out", and background glare may reduce contrast. Closing the condenser iris even further increases contrast; here, the objective is 75 percent filled with light. There is a loss of resolution, but in many cases it will be found acceptable. Using an oil immersion lens and a condenser that is not oiled to the slide produced this image of the objective's rear aperture. To fill an immersion lens with an NA greater than 1 requires that the condenser's front element also be immersed. This diagram shows how the back of the objective looks when the eyepiece is removed.

Figure 2-16: To see an image under extremely low-contrast conditions, it may be necessary to close the condenser iris so that the objective is only 50 percent filled with light. The resulting image will have better contrast and clear cells will be envisaged, but the resolution will be reduced. This diagram shows how the back of the objective looks when the eyepiece is removed.

reduce contrast in the image. If you remove the eyepiece and peer down the tube to look at the back of the objective lens, you can judge how well the condenser is filling the objective's aperture.

When light from the condenser fills the objective, its entirety is filled with light (figure 2-13). When you close the condenser iris, the bright circle of light becomes smaller until it is narrower than the objective. On a well-stained specimen, the best objective lens can have 90 percent of the aperture filled with light with no noticeable loss of contrast (figure 2-14). A transparent specimen is a challenge because it lacks areas that absorb light, thereby causing the image to have little contrast. To solve this problem, use a narrower cone of light so that the condenser iris is only 75 percent (figure 2-15) or even 50 percent (figure 2-16) filled with light. Closing down the aperture more

Figure 2-17: This is a close-up photograph of the coarse and fine focus knobs on an Olympus BH2 microscope. The two controls are concentric, and you can see the increment marks on the fine focus knob. A reference line is found on the coarse adjustment. Each increment represents 2 microns, so you can move the fine focus in 2-micron increments for taking a sequential series of photographs. One complete rotation of the fine focus knob results in an excursion of 200 microns, or a 0.2 mm movement of the stage.

than 50 percent creates diffraction effects that obscure details along the border of the subject.

Condensers come in a variety of configurations. Those used in a "dry" configuration, with their top elements working in air, limit the numerical aperture to slightly less than 1. Just like objective lenses, condensers designed to work with oil immersion are marked with a numerical aperture greater than 1 (NA 1.2 to 1.4). To get a larger numerical aperture for the highest-resolution work, you need a condenser designed to work in oil. Such a condenser requires oil contact between the top element and the bottom of the slide. Working with a condenser and an objective lens oiled top and bottom to the slide provides the highest-resolution image; however, such work is messy. Many workers decide that the inconvenience of cleaning the lens is not worth the effort and use the condenser dry.

For most transmitted light work, oiling the condenser is unnecessary. With stained slides, the loss in performance is slight to the point where many do not notice it at all. However, those who work at the microscope's limit of resolution must oil the condenser for the finest definition. For example, in video microscope studies of subcellular organelles and microtubules, resolution is improved when the condenser is oiled to the slide. The specimens are so small and finely detailed that using an oil immersion technique for the condenser becomes a necessity.

Focusing: Coarse and Fine

All microscopes come equipped with a coarse or rough focusing mechanism for obtaining near focus. Once the specimen's outlines are visible, the fine focus is used to attain the sharpest image. Modern microscopes have

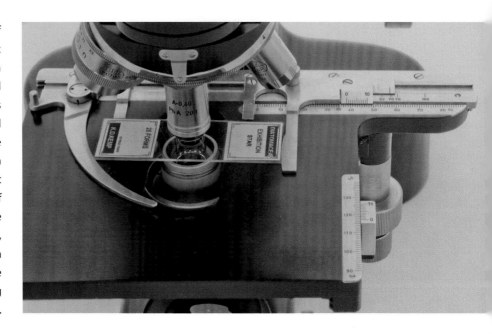

Figure 2-18: This is the top of the stage of a Leitz Ortholux microscope. A slide placed on its surface is gripped by a metal holder. The holder's right side is rigid, while the left side is curved and spring-loaded so it can be opened to accept the slide. When closed, it clasps the slide against the right angle holder. A pair of concentric knobs, located to the right and underneath the stage, move the specimen. This is a mechanical stage that allows the slide to be moved precisely along its surface.

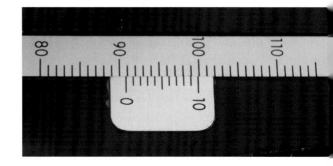

Figure 2-19: This is a close-up of the mechanical stage's scale on a Nikon SKe microscope. Typically, the readout is in mm; with the vernier, the position of a subject can be found to 0.1mm. In this photograph, the index mark is set to 90.9 mm.

coarse and fine focus mechanisms positioned concentrically. This convenient arrangement ensures that the fine focus can be operated without having to look away from the eyepiece to identify the knob. In addition, the fine focus operates through the entire range of movement of the stage. In older microscopes, the gearing systems are separated, with the fine focus traveling only 2 mm. This design is to be avoided if you intend to mount a motor for controlling fine focus. If the fine focus is brought to an abrupt stop, it can damage the motor.

For research that demands the highest magnification and resolution, the fine focus should traverse 100–200 microns per rotation. Some student microscopes have a fine focus that raises or lowers the stage 400 microns per rotation. This can be inconveniently fast for high-magnification work, and I prefer the slower rate. A slower rate is especially critical if you wish to use software for extending the depth of field. This requires

taking a series of photographs at various heights by moving focus in fine, regular increments. A micron scale, which measures the vertical distance traversed when the fine focus is turned, is invaluable for this work. Such a scale simplifies setting focusing "steps"; for example, you can take a sequence of 20 pictures, each differing 1 micron in the vertical dimension (figure 2-17).

The focusing controls of a modern upright microscope are designed to move the stage rather than the body. This design simplifies adding a motor for controlling fine focus. Additionally, the weight carried by the focusing controls is limited to the stage. If these controls had to raise or lower the body tube, the weight would vary depending on the accessories added to the microscope. Adding a camera can increase the weight by several pounds. By restricting movement to the stage, the gears carry a fixed weight and the eyepieces do not move vertically. In earlier designs, when these controls carried the weight of the body, mounting a camera or other optical accessories placed additional weight on the gears and greater force was required to raise the unit.

Stage

The stage holds and moves the specimen in three-dimensional space. Specimens are mounted on this flat plate whose surface is perpendicular to the optical axis of the microscope. A precision gearing system, or mechanical stage, delicately moves the slide, whose position is defined on an x,y coordinate (figure 2-18). Focusing is accomplished by moving the stage with the specimen along the vertical or z-axis movement. Together, these coordinates define the specimen's position

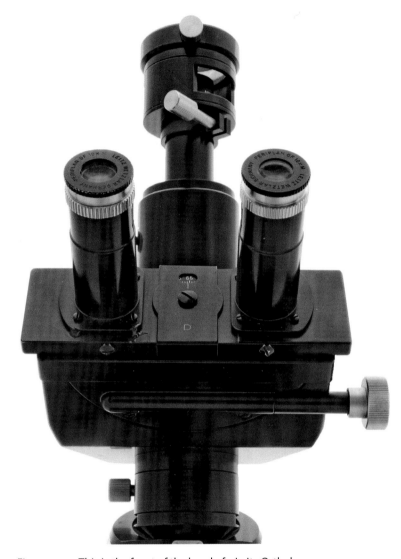

Figure 2-20: This is the front of the head of a Leitz Ortholux microscope. The binocular eyepiece tubes are canted at a 45° angle so you can view the specimen while seated at the microscope. A photographic port behind the viewing eyepieces can hold a digital camera.

Figure 2-21: This is the substage of an Olympus BH2 microscope, showing the controls that move the condenser in three dimensions. On the left side of the image is a black knob that focuses the condenser by moving it vertically, closer or farther away from the specimen. Two light-colored knurled knobs are used to center the condenser to the optical axis of the microscope. This moves the condenser in the x,y-plane; the focus moves the condenser in the z plane. The knurled knob with a white vertical index mark controls the iris diaphragm of the condenser. On the barrel of the condenser are numbers, e.g., 1.2, 1.0; these refer to the numerical aperture set by the condenser iris. Beneath the condenser is the field diaphragm. A knurled ring opens and closes this aperture.

in three-dimensional space. As with the fine focus, the mechanical stage is graduated with verniers for reading the slide's position to an accuracy of 0.1 mm (figure 2-19). By recording the values, you can return to these points of interest simply by dialing in the coordinates.

Most biological microscopes are equipped with rectangular stages; however, polarization microscopes may be equipped with rotating stages. Such stages are useful for obtaining the proper composition of a specimen in photography or for orienting a specimen that requires polarized light.

Substage

In an upright microscope stand, the region beneath the stage is called the substage. It consists of a carrier for the condenser (figure 2-21). This mechanism allows the condenser to be removed and exchanged. Additionally, it has two controls for manipulating the position of the condenser in three dimensions. There is a focusing control for moving it vertically and centering screws for moving it laterally. The former is used for focusing light onto the specimen and the latter for centering the light onto the optical axis of the microscope. Within the condenser, an iris diaphragm regulates the cone of light emanating from its top lens elements. Beneath the condenser, another diaphragm controls the area of the slide that is illuminated. This is the field diaphragm, which is used as a reference for focusing and centering the condenser.

Beneath the condenser is the illuminator. In modern microscopes, the illuminator is built into the microscope's base. This ensures that the components of the light source are properly positioned; the distance of the bulb and its alignment to the focusing lenses do not have to be adjusted prior to use of the microscope. The illuminator's field diaphragm is positioned beneath the condenser and is readily accessible. The days of using an external light source and aiming it at the mirror of the microscope are long past.

Head of the Microscope

The head of the microscope holds the eyepieces and the camera. For photography, the best system is one that has three tubes: two binocular tubes for viewing and a vertical monocular tube (photographic port) for photography. These ports are optically equivalent; they can provide an image for a camera. This has been done with light consumer-grade cameras held to the eyepieces. Results from this simple technique can be very good; indeed, publication-quality prints have been generated with this strategy. However, for serious work involving hundreds of pictures and long sessions at the microscope, this system would be inadequate. For intensive applications, it is more efficient to use a trinocular head system that has binocular heads for viewing the specimen and a single vertical tube for photography (figure 2-20).

In modern microscopes, the usual arrangement is to have a sliding prism. In one position, the prism allows 100 percent of the light to be used for visual observation; in a different position, 100 percent of the light is directed to the photographic port. Such an arrangement uses all the light efficiently, and for faint specimens, it ensures better photographs by delivering all the light to the camera.

3 Selecting Microscope Accessories

Overview

A typical microscope used for photography comes with a trinocular head, four objectives, an Abbe condenser, a mechanical stage, and a built-in illuminator. This is a good starting point for photography; however, there are several additional accessories that can expand the microscope's utility. This chapter discusses some of these accessories, such as additional objectives, eyepieces, and magnification changers. We begin by discussing another important accessory, the stereomicroscope, which is suitable for lower-magnification photography and sample preparation.

Stereomicroscopes

Stereomicroscopes have a limited magnification range. The primary objective lens is usually 1x, though when coupled with special accessory optics it may be raised to 2x. With a 10x eyepiece and a 1-10 zoom module the resulting magnification range is 10x to 200x. Because of this limited range, many microscopists use only the compound microscope for photography. Its objectives have a magnification range of 1x to 100x; when combined with a 10x eyepiece, specimens can be observed at 10 to 1000 times magnification.

Unfortunately, while the compound microscope is efficient for high magnification work, its utility is limited with lower-power shots. The stereomicroscope excels at these lower magnifications. Stereomicroscopes provide a greater depth of field, a wider field of view, and a longer working distance than the compound microscope. When viewed through the eyepieces, their images are upright and correctly oriented laterally so that it is possible to perform fine dissection. Stereomicroscopes are frequently called dissecting microscopes because of their utility in this application. They are suitable for working with large, bulky specimens that cannot be mounted on a 1 x 3 inch glass slide.

Unlike compound microscopes, stereomicroscopes view a specimen in three dimensions. The dual eyepieces are, in effect, two microscopes—one for each eye. By canting the view so that they tilt to a common focusing point, they generate a stereo image. There are two basic designs. The first is the Greenough, consisting of two instruments mounted in tandem, like binoculars. The objective lens and eyepieces are paired and aimed at the subject. A low-power, three-dimensional image facilitates performing delicate work on small objects, hence their use as dissecting microscopes. The second is the common main objective (CMO), a versatile design that

Bone formation is a complex phenomenon: the destruction of previously formed scaffolds of mineralized calcium is required before laying down a new matrix, and many cell types participate in this process. In order to show the diversity of cell types and variations within the tissue a lower-power photograph is advantageous. This photograph was taken with a 4x objective and a 1x eyepiece.

Figure 3-1: A Common Main Objective (CMO) stereomicroscope. This Olympus SZH Stereozoom has an objective with a numerical aperture of 0.1 and is useful for low-power photography. It has an internal zoom lens, and its built-in base has a light source that provides evenly diffused transmitted light as well as darkfield illumination. A complicated substage with a focusing condenser lens is unnecessary for work at 100x. This microscope has a trinocular head, an optional accessory.

accepts a wide variety of user-installed accessories.

Lower-cost stereomicroscopes are generally used for visual work, while the more expensive models are better suited for photography. In their simplest form, stereomicroscopes can be bought for around $100 used or $200 new. The basic models are not modular designs, so accessories like camera ports should be bought as part of the initial order. Typically, the head cannot be upgraded later. The magnification can be changed by swapping a paired set of objective lens or eyepieces. More expensive stereomicroscopes may have a zoom magnification changer that provides additional magnification options. It should be noted that the most brilliant and crisp images are obtained at magnifications less than 100x.

More expensive stereomicroscopes cost up to $20,000 and use the CMO design, with a large lens serving as the first optical element. The paired optical axis passes through the periphery of that lens. This is a flexible, modular design that can be customized with accessories such as single or dual photographic ports, an epifluorescent illuminator for fluorescence microscopy, and tilting binocular heads to ensure that the operator has an ergonomic posture while performing fine manipulative work. These microscopes hold their value. It is rare to find a used modern stereomicroscope because they are so useful and robust that they tend to remain in a user's possession for decades.

Usefulness of a Stereomicroscope

The stereomicroscope's utility is seldom appreciated. For many, its low magnification and lack of accessories belie its importance in a well-equipped photographic lab. However, even if the microscope is not used

photographically, it is invaluable for screening specimens and judging whether a sample is worthy of mounting on a slide for a closer view with the compound microscope. For work involving live specimens, such as water harvested from littoral zones or plankton samples, the low power, wide field view of 20x is useful for finding and isolating small organisms.

If you are fortunate enough to have a stand with a photographic port, the stereomicroscope may prove to be more useful than a compound microscope for low power work. I found that an Olympus SZH Stereozoom (figure 3-1) provided sharper images of a stained slide than an Olympus BX51 compound microscope equipped with a 1.2x or 2x objective. Examining test slides showed that the superior performance of the stereomicroscope was due to its objective's higher numerical aperture. The BX51 lens had a numerical aperture of only 0.04, while the SZH lens had a numerical aperture of 0.1. In other words, the stereomicroscope was capable of twice the magnification of the compound microscope. Further investigation showed that for work involving magnifications less than 40x, specimens photograph better with a stereomicroscope than a compound microscope (figure 3-2). It must be noted that for magnifications of 40x or greater, a compound microscope with a 4x objective is preferred. At that magnification, the compound microscope's numerical aperture of 0.14 outperforms the stereomicroscope for recording delicate detail. It should also be noted that low-cost stereomicroscopes have objectives whose numerical aperture is only 0.04, so to gain in performance requires the acquisition of a more expensive stereomicroscope.

 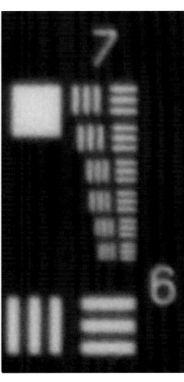

Figure 3-2: This comparison shows the difference in sharpness between a standard compound microscope and a high-end stereomicroscope. The photograph on the left was taken by an Olympus BX51 with a main objective NA of 0.05, while the picture on the right was taken by an Olympus SZH Stereozoom with a main objective NA of 0.1. The bars are clearly separated on the image taken with the stereomicroscope as compared to the image taken with the more expensive compound microscope. For low-power photographic work, the 1x objective of this stereomicroscope is superior. To match its results, the compound microscope would need a 4x objective.

Figure 3-3: A useful accessory for stereomicroscopes is an illuminator with flexible light pipes. This photograph shows the end of these fiber-optic illuminators. The flexible metal covering allows the fiber optics to be positioned for illuminating a specimen by reflected light.

Stereomicroscope Stage and Illuminator

Typically, a stereomicroscope has a simple, flat metal stage plate with an aperture for a circular opaque disc. One side of the disc is painted white, while the opposite side is painted black and used for opaque subjects illuminated by reflected light. Unfortunately, this design is too limiting for photographic applications. It is desirable to replace this type of stage with a raised base that has a built-in illuminator to project light up through the specimen. The opaque disc is replaced with clear glass so that slides can be viewed. By angling the light so that it strikes the specimen obliquely, you can increase contrast for easier identification of living unstained organisms. Organisms placed in a culture dish can be photographed directly. If you can aim the light so it strikes the specimen but misses the objective lens, you can generate a dark-field effect that highlights transparent organisms against a black background. At more moderate angles where the light hits both the specimen and the objective, you can generate a three-dimensional effect that heightens contrast.

Another useful accessory is a fiber-optic illuminator equipped with paired light tubes (figure 3-3). The light pipes can be positioned to angle the light, providing a way to control shadows in three-dimensional images. A dual light source is far superior to a single light source. The latter is often provided as an inexpensive accessory for the microscope; however, while it is useful for visual work, its utility for photography is limited. Single light sources lack intensity and can cast a dark shadow if set at a fixed angle, obscuring fine details. A dual light source enables you to minimize or prevent shadows on the specimen.

Objectives' Limit of Resolution

As you gain experience with your microscope, most likely you will look for additional optical components to expand its capabilities. Microscope manufacturers provide several objectives that may seem identical, i.e., that have the same magnification. For example, Olympus and Nikon may have four or five objectives at 10x. How do you decide which lens to buy?

It is helpful to begin with understanding the limitations of optics and cameras, especially numerical aperture and how it relates to both resolution and magnification. Although we have discussed NA earlier, it pays to review it in relationship to practical applications.

The optical performance of the objective lens is defined by numerical aperture (NA), a value inscribed on its barrel with the following equation:

$$R = \frac{0.61\, \lambda}{NA}$$

R = Minimum Resolved Distance

The wavelength of light is measured in nanometers (nm). As before, we will use 550 nm as the wavelength of light, making the equation

$$R = \frac{0.61 \times 550\, nm}{NA} = \frac{336\, nm}{NA}$$

R = 336 nm/1.4

Thus, when you're using an objective lens with an NA of 1.4, the minimum resolved resolution is 240 nm.

By using this simplified equation, we can then discuss the role of magnification. Notice that the equation does not relate magnification to resolution. The formula does not actually give the microscope's results but rather

the best-case scenario of what the lens can do. If such things as the technique, the eyepieces, or the camera are not up to par, the results will be less than the formula predicts and will keep you from realizing that level of performance. There are a couple of rules to keep in mind.

1000x NA Rule

For visual work, there is a 1000x NA rule that states that the limit of useful magnification is 1000 times the numerical aperture. If the microscope's total magnification (objective power x eyepiece power) exceeds 1000 times the objective's NA, then increasing magnification will not reveal greater detail; it will simply enlarge the image. This situation is described as empty magnification. Explicitly, this rule recognizes that magnification can be increased infinitely but that its value in revealing finer structures is finite. Thus, if you have a 100x objective and a 10x eyepiece, you are working at 1000x. If the objective's NA is 1.4, you are working within the microscope's limit of useful magnification, which is 1400x. This means you can increase either the objective's or the eyepiece's magnification to take the total power to 1400x. In most cases, the objective stays fixed and the increase is assigned to the eyepiece. However, if you employ a 20x eyepiece, the final magnification will be 2000x and no additional detail will be seen over using a 14x eyepiece.

This working rule is imprecise because of variations in eyesight. People with poor vision may find that a 10x power eyepiece is insufficient and that a 20x becomes their preferred tool for high-resolution work. Also, if the specimen lacks contrast, working beyond the 1000x rule is sometimes helpful. Even with these caveats, the rule can help determine whether a given eyepiece and objective provide a useful addition to your stockpile of accessories. For example, if you have a 60x objective with an NA of 1.4, then you might wish to use a 20x eyepiece to reach 1200x for high resolution. However, the 20x eyepiece will not be as useful if the objective has a magnification of 100x and you are working at 2000x.

The principal of the 1000x NA rule is the same with a camera. You can increase the magnification to a level at which no finer detail is captured by the camera. If your camera has a photodiode size of seven microns, you can apply the Nyquist criteria to come up with a camera magnification rule: in this case, the maximum useful magnification is 70 times the NA.

Magnification Changer and Eyepiece

As mentioned earlier, magnification is a multiplicative function—it is determined by multiplying the power of the objective by that of the eyepiece plus any intermediate magnification device. In newer microscopes, many camera adapters have a 1x factor so that the magnification to the camera is simply that of the objective lens. However, if you have a projection eyepiece, you can insert it in the camera tube to achieve either greater or lesser magnification. There are adapters that increase power by 2x or decrease it by half (0.5x). Which of these you use depends on the NA of the objective and its power. You want the magnification to stay within the range of usefulness and not in the range of empty magnification.

Unfortunately, using projection eyepieces for changing magnification is inconvenient. You must remove the camera to get at the eyepiece, swap out the eyepiece, and then reattach the camera. If the projection eyepiece is not removable, then you need two adapters with built-in projection eyepieces at different magnifications. Since these adapters can cost $500 apiece, this is an expensive solution. A more convenient alternative is a magnification changer that fits beneath the camera adapter. It can have several lenses, and you simply dial in a new power without removing the camera. In some of the more advanced microscopes, the magnification changer has four lenses; you can select 1x, 1.25x, 1.6x, or 2x and vary the magnification of the projected image in 25 percent increments. Olympus has an adapter that changes the magnification to both the eyepiece and the camera. Users of the old West German microscopes by Zeiss are familiar with the Optovar that performs the same function.

Precisely regulating the magnification of the camera is critical. Once the image is captured, there is limited latitude for enlarging it. The captured image has all the detail it will ever have; increasing the magnification on the computer will only result in enlarging the captured detail. This is akin to viewing a print—the fine detail seen from a normal viewing distance is not increased by reducing the viewing distance. If you want a high-magnification image, it is best to use the highest optical power that fits within the camera's frame. Simply changing objectives is too coarse an adjustment for altering the magnification; the power is increased at 2x intervals. A magnification changer provides finer control by varying the power at 25 percent increments and minimizes the need to enlarge the image on the computer.

The photographer has two concerns when deciding what magnification to use: one is too much magnification, and the other is too little magnification. The camera and lens have limited ability to record fine detail, and you must be aware of which component is the limiting element. If the magnification is too high, the lens is the limiting element in recording fine details. However, if the magnification is too low, then the limiting element is the camera. To get the maximum resolution out of the lens, know the limits imposed by the camera.

To simplify this task, I have modified the 1000x NA rule. As you may recall, multiplying the lens NA by 1000 gives the limit of the useful magnification when viewing through the eyepiece. A lens with an NA of 1.4 indicates that the maximum useful magnification is 1400x. If you have an eyepiece and objective that exceed this value, e.g., a 20x eyepiece and a 100x objective, you have 2000x magnification. Exceeding the maximum is regarded as empty (not useful) magnification in that no finer detail is observed by the eye and the resolution is no better than a 10x eyepiece with a 100x objective.

Admittedly, this rule is subjective. Some people with poor vision may benefit from having more than 1000x the NA. Also, specimens of low contrast and exceedingly fine detail may benefit from exceeding this rule. Thus, this rule is not engraved in stone and it may be exceeded depending on the viewing conditions.

One can devise a similar rule for digital cameras. Working on the assumption that the camera has a photodiode size of seven microns, you can have a 70x NA rule that

works the same as the 1000x NA rule. Multiply the objective's numerical aperture by 70 to get the magnification the camera needs to record the theoretical resolution of the lens. If you use less magnification, the camera does not record all the fine details revealed by the lens, and the photographer complains that the picture is not as sharp as what he sees through the eyepiece. For the captured image to appear that sharp, you must make sure that the magnification to the capture is 70x, or greater than the numerical aperture of the objective. If you exceed this rule and use a higher magnification, the captured image will not reveal any more details than what is seen through the eyepiece.

Per this rule, to determine the useful magnification of an objective with an NA of 1.4, multiply that value by 70x to determine that the limit is 98x. In other words, a 100x objective will reach its useful magnification limit when used with a camera adapter that provides 1x power. With this adapter, you are assured that the image will show all the details the NA 1.4 lens is capable of providing. If you use a higher power adapter that raises the magnification to 200x, the camera will not record any finer detail in the image—the objective is the limiting element. This rule was based on using a sensor that has an individual photosite of 7 microns. This is valid for many digital SLRs and dedicated photomicrography cameras.

If you use a 60x objective with an NA of 1.4, it will be under the 70x limit; this magnification is too low for the camera to record the full potential of the lens. The camera will limit the sharpness of the recorded image, and the captured image will not record the capabilities of the lens. You can always raise the power with a magnification changer of 1.6x to get a magnification of 96x. On the other hand, a 2x setting would bring the total magnification to 120x, exceeding the useful magnification of the lens.

Adding to Standard Objective Lenses

When using a digital camera with a microscope, the goal is to determine a magnification that enlarges the specimen so it fills the frame of the camera. It is not a good idea to blow up the digital image later and hope for increased detail. Generally, any attempt to enlarge the image during post-processing will produce a blurred, unsatisfactory result.

Most microscopes come with a generic set of objective lenses: three dry lenses at 4x, 10x, 40x, and one oil immersion lens at 100x. These lenses are satisfactory for visual work, and when used with a 10x eyepiece, they give a total magnification of 40x, 100x, 400x, and 1000x respectively. However, for photographic work, these large jumps in magnification are too abrupt, especially with cameras that do not have a high pixel count. The images from low-resolution cameras cannot be magnified sufficiently because the image occupies such a small area of the sensor. In fact, the pixels will become visible if the image is enlarged too much. This is especially true for the magnification range between the 10x and 40x lens.

Most microscopists find that a 20x objective is a practical addition to their lens collection since it fills the gap between the 10x and the 40x. This lens is a better fit for framing a specimen that is too large for the 10x and too small for the 40x. Typically, the least expensive 20x objectives have an NA of 0.4, while the more expensive models have an NA of 0.6 or greater. For photography, the 0.4 NA lenses

are almost equivalent to the more expensive .6 NA lenses if combined with a 1x adapter. If you apply the 70x NA rule, an inexpensive 20x objective has a useful magnification limit of 28x—so an image captured with a 20x lens and a 1x adapter is actually limited by the sensor, not the lens.

To exploit the full capabilities of the 20x lens, you can use a 1.6x magnification changer to raise the useful magnification limit to 32x power. As this is over the required 28x, the sensor will fully record the objective's capabilities. A common 20x objective lens has an NA of 0.6. This is a popular lens for visual work—you can use a 20x eyepiece and have a critically sharp image. But if you're using a digital sensor with a 1x adapter, it will not generate a sharper picture because its useful limit is even higher, 42x. To exploit the superior capabilities of the more expensive 20x lens with an NA of 0.6, you can use the 2x setting on the changer to increase the projected power to 40x. This is a useful exercise in selecting the right lens for microphotography. An expensive lens will not improve the ability to record fine detail unless it is matched with a suitable magnification.

A typical 40x lens has an NA of 0.65 and a useful magnification limit of only 45.5 (0.65 x 70). There is little room for optically enlarging the image for the camera, and a typical 1x adapter allows the lens to realize its full resolution. There is little point in exchanging this lens unless you have a magnification changer. There are many 40x lenses with higher numerical apertures, such as dry objectives with an upper limit of 0.95. With that lens, the limit of useful magnification is 66.5, and you can increase its power 1.6x with the magnification changer.

A similar situation exists for an oil immersion lens with a numerical aperture of 1.3. With this objective, the limit of useful magnification is 0.91, and there is no room to raise its power above 100x. If you have a magnification changer, it is justifiable to replace this lens with one that has a lower primary magnification of 60x. Then, you can use up to a 1.6x increase in magnification to reach 96x. My personal favorite is a 40x water immersion lens by Olympus with an NA of 1.15. This lens reaches its limit of magnification with the 2x setting of the magnification changer. Although the oil objective lens provides potentially greater resolution, its advantage cannot be realized with my present cameras.

If you have a good 40x objective with high numerical aperture, the next lens of value is the 60x. Oil immersion 60x lens can have an NA of 1.4 and are widely regarded as the pinnacle of the optician's art. They have the highest resolution of any objective; however, they are also one of the most expensive lenses. The fine images generated by a 60x objective lens are not recordable by a digital camera with a seven micron pitch size with a 1x phototube. To exploit their superior performance, you need to increase the magnification by 1.6x. Otherwise, fine details are better recorded with a 100x objective and a 1x adapter.

If you have a magnification changer that provides sufficient power, the issue is whether it pays to retain the 100x objective. This lens has a very short working distance, and it may not reach focus if the preparation is too thick. In this regard, the 60x with a 1.6x boost in magnification is superior.

Although it can be advantageous, I have never felt a pressing need to upgrade my 4x and 10x objectives to higher numerical apertures. Though these lenses have a low

magnification for their rated NA, it can be amplified easily with the 2x setting of the magnification changer. For example, a 10x lens has an NA of 0.25 that works well with the magnification changer (2x with the eyepiece or 1.6x with the camera). The same reasoning for using the 2x setting follows for a 4x objective with an NA of 0.1.

The general conclusion of this discussion is to be aware of how much power you wish to use with the camera. With a 1x adapter, adding higher numerical apertures is justified if you have access to a magnification changer or another means of increasing the magnification to show the objective's full performance. In the preceding examples, the objectives were purchased as accessories so that the magnification could be increased to fill the frame of the sensor while recording a sharp image.

Working with Live Samples in Water

Many microscopists study living organisms isolated from water samples. A drop of water placed under a coverglass enables the microscopist to study these creatures with all the objectives of the microscope. These preparations are of great interest to the hobbyist, and their study can provide hours of enjoyment. While you can photograph them with the standard lens available on a compound microscope, accessory optics will enhance the instrument's utility.

As mentioned earlier, microscopes are generally provided with 4x, 10x, and 40x dry objectives plus a 100x oil immersion objective. The first three objectives are the most useful for studying pond organisms. You can quickly switch objectives to increase the magnification while studying a live swimming organism. However, the oil immersion lens is much less useful. The process of adding a drop of oil and immersing the tip of the objective is time consuming, allowing the organism to swim outside the field of view. Additionally, the specimen's position shifts when focusing with the oil lens. The viscosity of the oil lifts and lowers the coverglass as you change focus, which may even displace the organism from the field of view. To obviate this problem, you may wish to use the dry 40x lens with an NA of 0.95 with a magnification changer. This lens has a large NA that provides the highest resolution for a dry objective, and its correction collar compensates for variations in coverglass thickness.

If you need higher resolution, you might consider a water immersion objective with an NA of 1.2. For most investigators, this lens is equivalent to an oil immersion objective with an NA of 1.25. If you select an objective with a magnification of 60x, it will have a greater working distance than a 100x lens and be more useful for pond water examination. It should be noted that the lower viscosity of water reduces the vertical displacement of the coverglass when raising or lowering focus. Also, unlike oil, water is easily removed and you can quickly change to a lower-power dry objective.

For studying protists, I use the set of objectives listed below:
- 4x NA 0.15
- 10x NA 0.4
- 20x NA 0.7
- 40x NA 0.95
- 60x water immersion with NA 1.25

They provide a wide range of magnification and are unusual in that they have higher than normal numerical apertures. This gives

exibility in adjusting the magnification of the camera. Frequently, a magnification changer is used to rapidly compose the image so that it fills the frame of the camera.

It should be noted that a 60x water immersion objective is a rare lens to find on a microscope with a fixed tube length. Very few of these objectives were produced in the 1950s and 1960s, but they are more commonly available for microscopes manufactured within the last decade.

Condenser

For bright-field work with stained slides, a microscope usually comes equipped with a simple Abbe condenser. This condenser is not corrected chromatically. When you image the field diaphragm onto the specimen plane, you will see color fringes intruding into the field. The resulting shift in color values will destroy the white balance of the image and introduce an overall color hue.

To obviate this problem, you can open the field diaphragm to a wider than normal value so that it is bigger than the field of view. Unfortunately, this will introduce glare, and the image will suffer from reduced contrast. A better solution is to replace this condenser with an achromatic one to minimize the formation of color fringes. An achromatic condenser ensures the highest contrast image and allows you to maintain color balance.

Stage

Most microscopes come equipped with rectangular stages that can't be rotated. This is unfortunate since it means you cannot orient the specimen to the edges of the frame for photographic composition. A rotating stage may not be available for the most basic teaching and laboratory microscope stands, but it can be acquired for any research stand. It is a desirable element for a photographic microscope.

I have used an Olympus BX51 extensively, and its standard rectangular stage can be revolved about its optical axis. For photography, this simple design is all you need. In the case of the Olympus, the design is rudimentary but very serviceable. For example, there is no provision for centering the axis of rotation, and the specimen can drift out of the field of view as the stage is rotated. More expensive stages alleviate these inconveniences. Some rotating stages are equipped with ball bearings that can be adjusted precisely to center the revolution on the field of view.

A rotating stage is more critical for digital SLRs than for dedicated electronic cameras. Typically, the latter can be rotated on a microscope, and the camera frame can be oriented easily to the specimen for a pleasing composition. With a digital SLR, however, the optical viewfinder and fixed position of the eyepiece mean that the camera cannot be turned easily.

Digital Concepts

The Pixel

Generally speaking, we don't analyze the components of an image when we see it. Just about any view of the world contains an amazing wealth of fine details, subtle variations in intensity, and many hues of colors. When we attempt to capture an image with a camera, we assume that it is recorded in infinitely fine detail and that it is an accurate record of what we see. This is not the case. A digital camera image simplifies what we see into quantifiable units. These units translate details into minute squares, and each square records intensity as an electrical signal. All of this is accomplished by breaking the image into fundamental units, the picture element, or pixel.

The sensor for a digital camera has thousands of photosensitive elements arranged in a rectangular array. Individually, each element is a sensor that captures light. Their position is defined on a Cartesian coordinate. The overall size of the sensor array can range from 17 mm² (3.6 × 4.8 mm) to 864 mm² (24 × 36 mm), which is approximately the size of a postage stamp. For a given lens, this represents how much of the image will be captured; the smallest values cover a smaller area than the larger sensors.

Figure 4-1: The basis of all solid-state sensors is the photosite (pixel), which captures light and converts it into an electrical signal. A sensor array has millions of individual photosites, and their position is identified on a Cartesian coordinate. For a given-size sensor array, the number of photosites determines how finely detailed an image can be. In this diagram, the photosites are large. This sensor has less resolving capability than one with a greater number of photosites.

Small arteries transport oxygenated blood to the tissues, and within their lumen, red blood cells can be found. This low-power micrograph, taken with a 10x objective and a 1x eyepiece, shows a cross section of such a small artery. This vessel has thick walls that can withstand the pressure needed to force blood through the tissues. Using this eyepiece and objective allows the framing of the whole vessel within the photograph.

Figure 4-2: In this sensor array, the number of photosites (pixels) is doubled, allowing the camera to record and distinguish finer details. However, smaller photosites suffer from increased noise and less dynamic range than larger photosites.

To view an electronically captured image, it must be magnified. To comfortably view an image on a 1 x 1.5 inch sensor (24 x 36 mm) requires it to be enlarged to a final image size of at least 4 x 5 inches. However, there are limits as to how far you can magnify the image. Eventually, with increasing power, the individual pixels will be visible as discrete squares (figure 4-1). How much a digital image can be enlarged is a function of the number of pixels—the more pixels packed in the sensor, the more the image can be magnified (figure 4-2). For example, to publish an image in a printed paper or manuscript, the image must have at least 300 pixels per inch. Therefore, a square image with 900 pixels per side will make a 3 x 3 inch print. If an image has 1,800 pixels per side, it can be enlarged to 6 x 6 inches.

The pixel counts of camera sensors vary over a large range. There are scientific cameras with 512 x 512 pixel arrays, and there are hobbyist cameras with 3000 x 4000 pixel arrays. The pixel count in the array is determined by multiplying the two numbers together, giving a total pixel count of 262,144 for the former and 12,000,000 for the latter. With such large numbers, it is easier to express the counts in millions of pixels, translating in these examples to 0.26 megapixels and 12 megapixels respectively. These numbers define the level of detail that can be captured in each image.

Light Intensity and Bit Level

Another important consideration is the accuracy and precision of recording light intensity. In the preceding example, the 512 x 512 pixel array is better at quantifying low levels of light than a camera with the same size sensor packed with 1024 x 1024 pixels. The larger individual photosites can collect more light because of their larger surface area, and their size provides a greater degree of quantification. In contrast, a denser pixel count will enable the camera to more accurately record where light falls on the sensor array.

In order to record an image, each pixel must display an intensity value ranging from absolute black to complete white. A pixel generates an electrical signal proportional to the light it captures. Intensity values are quantified by a digital measure. Since the values are digital and derive from the binary system, they are expressed as powers to the base 2—where, at the simplest level, the sensor reports whether an object is lighted or not. This is a basic black/white display, and its precision is expressed as a single bit (2^1). The black text on this white page is an example of a 1-bit range of intensity values. While eminently useful for reading, this brightness span is unsuitable

or a pictorial display. Black and white images require a gray scale to show varying levels of light intensity, so digital cameras capture and digitize light intensity to 8 bits (2^8) or 256 intensity levels. Computer monitors use 8 bits to display black and white images. This is sufficient since our eyes can distinguish only 7 bits of intensity (2^7) or 128 gray levels. In graphic programs such as Photoshop, brightness is expressed in values ranging from 0-255 with 0 defined as absolute black and 255 as absolute white.

A point of potential confusion is that although 8-bit depth refers to the range of intensity that can be recorded, an 8-bit image file may not capture the entire range. For example, it is possible that an 8-bit image will show only 128 gray levels out of the 256 maximum, resulting in an image with very low contrast. To envisage this concept, imagine a clear bead in a glass of water. The bead has little contrast—it does not generate a jet-black shadow, nor does it have a brilliant highlight. A recorded image of the bead may have an intensity range of only 128, with the darkest part of the bead at 64 and its brightest part at 192. On the other hand, if we put a white marble in water and illuminate it with light from one side, we will get a high-contrast image. There will be a highlight where the light strikes the marble (255) as well as a shadow that lacks light (0). This image will span the entire intensity range from 0 for black to 255 for white. In both cases, the image is captured to 8 bits depth.

The accuracy with which light is recorded also depends on the size of the individual photosites, and in this case bigger is better. Solid-state detectors absorb light and result in an accumulation of charge. Larger sensors accumulate more charge, thereby recording a higher intensity of light. As a result, larger photosites can accurately measure higher light intensities that in turn increase the measurable dynamic range. To illustrate this point, the detector can be viewed as a bucket and the light as the water droplets (photons) that are falling into the bucket. A larger bucket can capture more water before it overflows, and the increased volume represents the increase in range of water captured. Additionally, if water is measured in milliliters, the accuracy of measuring a filled bucket is 1 ml out of 4000 ml. In contrast, filling a smaller bucket of 1 liter allows a measurement accuracy of only 1 ml out of 1000. The graduation of the bucket is analogous to the amount of bit depth of a photosite. A larger photosite can accurately measure a greater range of light intensities than a smaller photosite and thus allow more variations to be recorded.

Digital sensors will not record information beyond their maximum charge capacity. Using the water analogy, the bucket simply overflows. The strategy for optimum imaging is to expose for the brightest regions to the point where they accumulate a charge that approaches saturation. In photographic terms, you expose for the highlights and let the shadows take care of themselves. Thus, the physical size of the photosensors is critical for measuring light since it determines how much charge can be accumulated. Larger sensors can absorb a greater number of photons and store an increased charge. This increases the dynamic range—that is to say, the range of light measured from bright to dim regions. Sensor bit levels determine the precision with which these measurements can be made.

This discussion of photosite size is significant because there is a balance between accurately measuring the light and determining

the delicacy of detail that can be recorded. Many digital photographers lose sight of this by being concerned only with the megapixel count. This is understandable since it is easy to think in terms of spatial information that is encoded in the image—e.g., a 12-megapixel camera can record finer detail than a 6-megapixel camera. However, the quality of the light measurement does not depend on the pixel count but rather on the size of the individual pixel. This is a subtle aspect of image quality, and it determines the accuracy with which the light is measured. Accurate light measurement is critical if you are doing quantitative analysis or extensive image processing.

In the sciences, the majority of users are concerned with recording and documenting images, and the ultimate accuracy in quantifying light is not a priority. Since the overall size of the camera's sensor is fixed, increasing the pixel count is accomplished by reducing individual photosite size. Therefore, to attain greater spatial detail, you sacrifice the accuracy and precision with which light is recorded. The only means to increase pixel count and retain performance is to expand the overall size of the array. This is the justification for developing larger-sensor cameras. The advantage can be seen by comparing two cameras that have 12-megapixel sensors but different APS formats (15 x 24 mm versus 24 x 36 mm, full frame). For example, the Nikon D300 and D700 both have 12-megapixel sensors, but the former has photosites of 5.45 microns while the latter has photosites of 8.45 microns. The D700 records a greater range of intensities with an increased dynamic range.

In comparing these two cameras, the low-light performance of the Nikon D700 is superior to that of the D300, although the spatial resolution of 12 megapixels is the same.

Larger photosites are needed for photographing dim subjects since they can capture more variations in light. It should be noted that the difference in performance is most obvious in low-light conditions. When illumination is intense, such as with bright-field microscopy or scenic photography at midday, the loss of performance in smaller photosites is not obvious. For the majority of consumers, the loss is acceptable, and many are happy using cameras with small photosensors.

For those employing the most rigorous quantitative and qualitative techniques, it is necessary to use a camera with large photosites. For the greatest precision, choose a camera with 10 bits (2^{10} or 1024 gray levels) or 12 bits (2^{12} or 4096 gray levels). The improvement in accuracy can be illustrated by using a hypothetical image that occupies half the dynamic range of the sensor. For an 8-bit camera, the range of intensity that can be measured is in increments of 128; for a 10-bit camera, it is in increments of 621; and for a 12-bit camera, it is in increments of 2048.

Color Images and Additive Color

When recording black and white images, the luminosity of light is treated as a single intensity value. Recording color requires measuring three sets of intensities, each representing one of the primary colors of light (red, green, or blue). For example, you can take three sequential images using different filters—the first with blue, the second with green, and the third with red. Combining the three separate images into one generates a full-color image. This strategy is used by professional photomicrography cameras when photographing a static specimen.

Some manufacturers' black and white cameras can be fitted with a turntable containing the three color filters. By rotating the filters, it is possible to capture the three images (figure 4-3). If the camera can capture an 8-bit monochrome image, the color output produces a 24-bit color image (8 × 3). However, such a strategy is unsuitable with moving subjects. To capture a moving subject requires that the three colors be collected simultaneously. A strategy used by top-end video cameras is to divide the image into its three color components by using three separate color filters with a digital sensor behind each filter.

The majority of digital cameras use a single sensor overlaid with a Bayer mask that covers each pixel with either a red, green, or blue filter (figure 4-4). Usually, there are two green pixels for every blue and red pixel. This predominance increases the sensor's sensitivity to green light in order to mimic the human eye's greater sensitivity to that light. A single exposure captures all three of the primary colors, but at a sacrifice. Since four pixels are needed to collect the three primary colors, a 1024 x 1024 pixel array is reduced to a 256 x 256 array in terms of color. Grouping pixels to provide color information results in a loss of spatial detail of about 30 percent.

Figure 4-3: This diagram shows circles of red, green, and blue—the three primary colors of light. The previous two figures (4-1, 4-2) show sensor arrays for black and white cameras that are not able to distinguish color. Color recording requires filters and identifying the degree of red, green, and blue present in each pixel. This can be accomplished by taking three pictures with red, green, and blue filters. When combined, the three images have all the information needed to generate a color image.

Introduction to Cameras

Successful photography depends on understanding the limits of the camera and using illumination that plays to the camera's strengths. Thus, an understanding of the sensor's capabilities and limitations is critical. Unlike film cameras, which can be adapted to different roles by selecting different emulsions, digital cameras work most efficiently

Figure 4-4: A Bayer mask consists of color filters overlaid on a digital sensor. This enables the camera to obtain color information for a scene with a single exposure. Unfortunately, there is a slight loss in lateral resolution since four pixels are needed to establish color information for each single pixel.

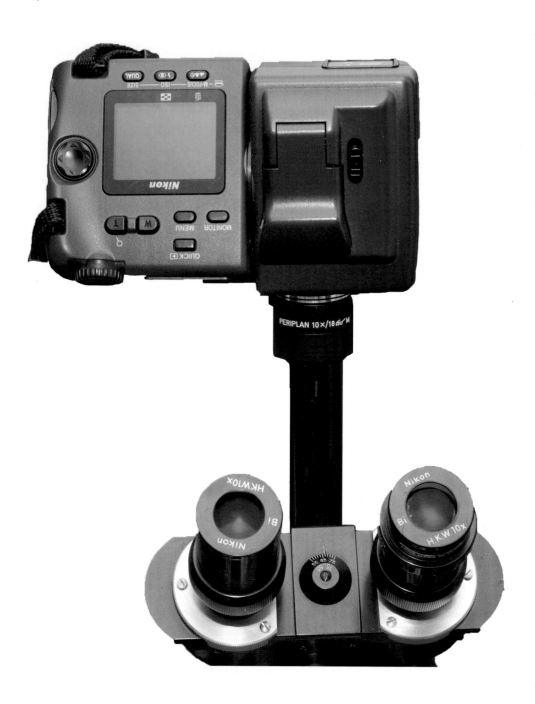

…der specific types of lighting. They may
… designed for recording color under bril-
…nt illumination or recording monochrome
…ages under low illumination. Ideally, you
…ould select a camera for a specific purpose
…d have several cameras available for differ-
…t types of projects. But for many of us, it
…n be costly to purchase multiple cameras to
…cord different scenarios—hence the quest
…r a single "general purpose" camera. For-
…nately, it need not be expensive to capture
…chly detailed and accurately colored images.
… hobbyist or scientist can find many adequate
…meras costing around $500. Scientists who
…udy specimens in low light and do extensive
…nage processing and analysis require cameras
…at range in price from $5,000 to $50,000.

There are several types of solid-state sen-
…ors for digital cameras described by acronyms
…uch as CCD (Charged Couple Device), CMOS
…omplementary Metal Oxide Semiconduc-
…or), and MOS (Metal Oxide Semiconductor).
…heoretically, each type of sensor has advan-
…ages and disadvantages. For example, the
…CD is acknowledged by many research scien-
…ists as the best sensor for recording images
…t low light levels. In the past, the CMOS was
…iewed by many research scientists as being
…ess suited for low-light work, a belief that is
…ecently being debunked. The most popular
…igital SLR camera for low-light work is cur-
…ently the Canon, which has a CMOS sensor.
…ndeed, a number of new cameras featuring
…he CMOS sensor attain excellent low-light
…erformance. Ultimately, cameras should be
…elected based on their real-life performance.

There are three basic types of cameras:
…onsumer grade, digital SLRs, and dedicated
…ameras.

Consumer-Grade (Point-and-Shoot) Cameras

Consumer-grade cameras are low-cost cameras ($100 to $1,000) designed for general photography. They have an integral zoom lens, and their digital sensors receive the image and project it to an LCD screen. Typically the screen is mounted at the rear of the camera for framing the subject and viewing the recorded image. Such cameras can even capture short video clips and be used as rudimentary camcorders.

The low cost of these cameras has prompted many hobbyists and some research scientists to adapt them for microscope work. They are treated as the electronic equivalent of the human eye, and the lens is positioned just over the microscope's eyepiece—just where the human eye would be placed. With this simple strategy, you can view the microscope image on the camera's LCD screen, focus, and capture an image. Since the LCD screen receives its input directly from the sensor, you get a realistic preview of the image.

The results from this simple setup are surprisingly good, and it is a testament to the users' skill and enthusiasm that these simple cameras have been used to generate prints for scientific publications. In spite of this, consumer cameras are not designed for photomicrography and do not give the highest-quality images. This is not to say that the results will appear blurry with muddy colors; image quality can be very good with brightly lighted subjects. However, when light levels are low, sensor noise becomes visible and areas that should have a uniform intensity or color show a "salt and pepper" appearance, i.e., individual pixels appear brighter or darker rather than having a consistent intensity value.

Digital SLRs

The digital SLR is an interchangeable lens camera that uses a mirror to project an image from its lens onto a frosted screen (optical viewfinder). This optical viewfinder is used to focus and frame the subject. The screen receives light from the lens by way of a mirror that is canted at 45°. To capture the image, the mirror swings up and allows light to continue to the sensor at the rear of the camera body. Unlike a consumer camera, the sensor usually does not provide a means for viewing the subject for composition—the mirror blocks the light, reflecting it to the optical viewing system.

The digital SLR advantage is its large sensor array, with individual photosites that are much larger than those used in consumer cameras. Digital SLRs can record superior images, especially at low light levels. Additionally, these cameras are designed as versatile pictorial tools. They not only accept different types of lenses for general photography, they also have the option of removing the lens and using the sensor with optics designed for a specific application. Consumer cameras must always use the same general-purpose lens, which can introduce artifacts when coupled with microscope optics. A digital SLR used on a microscope employs a lens system designed for that purpose, ensuring maximum fidelity.

Digital SLRs are more expensive than point-and-shoot cameras but still reasonably priced and affordable to the hobbyist. Prices range from $500 to $5,000, and for most users, the difference in performance between the least and most expensive SLR is minor. For the majority of users, a camera costing between $500-$3,000 will be satisfactory. The digital SLR's primary disadvantage is that its controls are not designed for microscope use, but rather for general photography. When the camera is mounted on a microscope, it's viewfinder and LCD screen point vertically upward and are unavailable to the microscopist who is seated at a lower level. Accessories can make the camera more ergonomic, and they will be discussed later with examples for individual cameras.

Dedicated Cameras

Dedicated cameras are specifically designed for use on microscopes and are ill equipped for other applications. Typically, they lack an optical viewfinder and cannot be used as handheld cameras. Instead, they are connected to a computer, which is integrated into all their functions. For example, the camera controls and the viewfinder are seen on the computer monitor.

Dedicated cameras are more expensive than digital SLRs, ranging from $1,000 to $50,000, with the majority between $5,000 and $10,000. For many, the cost is unreasonable. In terms of pixel count, dedicated cameras are inferior to digital SLRs; it is unusual for a dedicated camera to have a sensor of 4 megapixels or larger, whereas digital SLRs have sensors from 6 to 24 megapixels. Yet in spite of this disadvantage, I have observed that technicians prefer these cameras because of their ease of use. The controls of a dedicated camera are readily available and easily viewed on a computer monitor. Focusing the microscope is easier because of the large view provided by the monitor. At a research laboratory dedicated cameras are incorporated into ergonomic workstations that facilitate the rapid and convenient acquisition of images. For the

atistical analysis of slides, they provide an easy means of collecting hundreds of images.

For the experienced microscopist, dedicated cameras also provide superior image control. The computer interface has several software tools for measuring light intensity and adjusting color balance. Couple this with a real-time view of the specimen and immediate feedback for evaluating the effects of changing exposure or white balance, and the dedicated camera becomes a superior tool for photomicrography. To illustrate this point, the following example shows how computer/camera integration improves image acquisition.

A problem with low-contrast specimens is that enhancing detail also brings out the defects in the microscope's optical system. Dust particles and uneven lighting, which are unnoticeable in the eyepiece, now become evident in the final image. The computer can remove these defects by recording them without the subject. This is done by capturing a reference frame in an area of the slide that has no subject matter, which becomes a record of all the optical defects arising from the microscope optics. By subtracting the reference frame from the captured image, the defects are erased; it appears that the image was taken with pristine optics and lighting. This is an example of flat-field correction, an invaluable tool for quantitative microscopy. The process can also be performed using a dedicated camera on a live image in real time. Whenever you capture an image using this technique, it is automatically corrected by the erasure of the microscope's optical defects. To accomplish this with a digital SLR requires that the subtraction be performed after the photographic session.

Another advantage of dedicated cameras is that their sensitivity for dim samples can be higher than digital SLRs. All digital SLRs are color cameras equipped with a Bayer mask. Many dedicated cameras for scientific work are not equipped with this mask. Remember, it is a color filter, and its removal allows more light to fall on the sensor. So a camera equipped with the mask is less sensitive than one that lacks it. If you purchase a dedicated camera, you can request a monochrome camera for low-light work or a color camera for work with brighter samples. Also, the optical viewfinder of the digital SLR is inefficient when working with dim samples, sometimes making it difficult to focus on fine details. A dedicated camera's sensitivity enables you to see details invisible through the eyepieces.

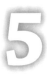

Digital SLRs

In the Victorian era, microscopists enjoyed studying diatoms and selecting individual frustules and placing them in precise geometric patterns. These exhibition slides can be beautiful; however, the low contrast of the silica cells reduces the contrast of the diatom. By using phase contrast and image processing, it is possible to increase their contrast and present a high-contrast image. These arranged diatom shells were photographed with a 20x objective and a 1.25x eyepiece. There are nine diatoms framed within this photograph.

Introduction

The digital SLR (Single Lens Reflex) is a professional tool, adaptable for almost any photographic task (figure 5-1). Its interchangeable lens can be replaced with optics encompassing a range of views, from an extreme wide-angle view of 180° to an extreme narrow-angle view of 1°. When its lens is replaced with a microscope, the optical viewfinder receives light from the microscope so you can frame and focus the image.

The viewfinder is based on an opalescent screen that receives a projected image from the microscope via a mirror. In its default position, the mirror intercepts the image from the microscope and reflects it to the screen. When the camera is fired, the mirror swings up and covers the screen, allowing the image to be projected to a digital sensor. The swiveling mirror has two functions: reflecting light to a viewfinder for composition and swinging out of the light path for image capture. To ensure that the correct amount of light is collected during exposure, a shutter opens so light falls on the sensor and closes when sufficient light is captured.

For microscope usage, the lens is replaced with a connector for joining it to the microscope. This is accomplished in one of two ways. The first way is indirect: the camera is attached to a copy stand and there is no contact with the microscope's phototube. This isolates the camera's vibration so that it is not transferred to the microscope. The second way is direct: the camera is attached to the microscope, which supports its weight. Both mounting methods have their advantages. With the indirect method, you can eliminate blurring induced by camera movement but desk space is sacrificed for the copy stand.

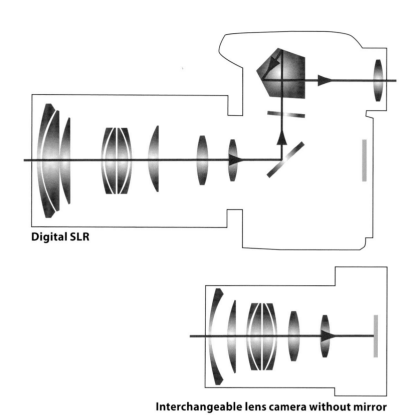

Digital SLR

Interchangeable lens camera without mirror

Figure 5-1: These two diagrams illustrate the light path through modern, interchangeable-lens cameras. At the top is a digital single lens reflex camera. Light, the red line with arrowheads, travels through the lens and is reflected by a mirror, angled at 45°, to an opalescent screen and an optical viewfinder. The mirror is hinged at its top and it swivels at this joint to direct light to the digital sensor, the vertical green bar, for recording the image. Subsequently, the mirror swings down, blocking light from the sensor and directing it to the optical viewfinder. This operation blocks the sensor from light, making it inoperable.

The lower diagram shows the light path of a new model of interchangeable-lens camera, which dispenses with the optical viewfinder; light continues directly to the digital sensor. This design allows the sensor to operate continuously, generating a signal to a liquid crystal display for focusing and composing the image. The absence of the mirror and an optical viewfinder allows the lens to be placed much closer to the sensor and, in addition, allows the sensor to be used as a video capture recorder. Moreover, the absence of a swinging mirror makes camera operation vibration-free.

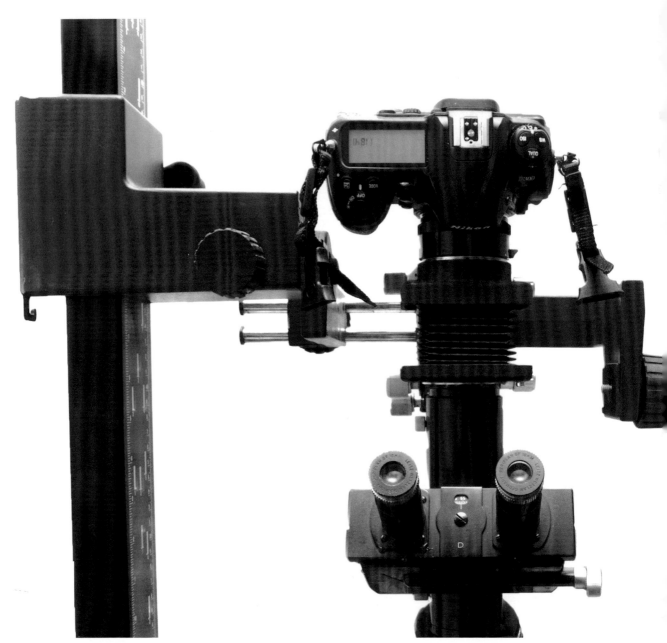

Figure 5-2: An example of indirect mounting on a Leitz Ortholux microscope. On the left, the arm of a copy stand supports the Nikon digital SLR. A bellows extends down from the camera; it can be extended so that its mount covers the microscope's photographic tube. There is no direct contact between camera and microscope. The copy stand is so massive that it dampens any vibration resulting from the camera's mirror and shutter movement. Note the quick release camera clamps. While a shoulder strap is needed to carry a digital SLR safely in the field, the strap is a danger in the laboratory. A quick release coupling provides a convenient way to remove the shoulder strap when using the camera on the microscope.

With the direct method, desk space is preserved but camera vibration is transmitted to the microscope, which can blur photographs.

Indirect Mount

The apparatus in figure 5-2 is not purchased as a unit but put together by the photographer. The heavy copy stand allows the raising and lowering of the camera. Its baseboard must be large enough to contain the microscope base. The bellows unit is a device commonly used in macro photography. When inserted between the lens and camera body, the bellows increases the distance between the lens and the sensor. It is, in effect, an adjustable extension tube that can be lengthened or shortened as the camera is raised or lowered.

To use this device, first place the trinocular microscope on the copy stand's baseboard and position it so that the camera will be overhead and in line with the vertical photographic tube. Then remove the lens from the digital SLR and attach the bellows unit, which in turn attaches to the copy stand. Use a level to make sure the camera back is parallel to the baseboard. Then extend the bellows, lower the camera and bellows, and carefully align them to the photographic tube. In my laboratory, the front of the bellows overlaps the photographic port and is sufficiently close so that room light does not fog the digital sensor. However, depending on the bellows and the diameter of the microscope tube, you may have to make a light shield.

The photographic tube contains a low-power eyepiece (2x–5x) that projects the image up to the camera sensor. A flexible bellows maintains a light-tight shield as you lower and raise the camera body, which varies the position of the camera from the eyepiece—and lowers or raises the projected magnification. If you use a massive stand, any vibration from firing the shutter will be dampened. The disadvantages of this arrangement are that it takes up table space and that it is cumbersome to change microscope stands if you need to use the camera on a different microscope. This device best suits a single user who takes maximum care in composing his images. If the unit is shared among several users with varying degrees of expertise, the less experienced may find it intimidating.

Direct Mount

To preserve table space, the camera may be mounted directly on the microscope so that it serves as a stand. A rigid adapter fixes the distance of the sensor from the microscope and provides a single magnification. Unfortunately, with direct coupling, the camera's swinging mirror and moving shutter transmit vibration, which will blur the resulting image.

The coupling device can be as simple as a hollow tube with fittings to clamp its bottom half to the microscope and a bayonet mount on the opposite side to accept the camera's lens mount. Alternatively, the device can be so complex that it contains a built-in shutter, a focusing telescope, and an exposure meter. The latter devices were designed originally for use with 35mm film, and the camera body was simply a light-tight film carrier. These adapters were popular from the 1950s to the 1980s, but their popularity waned with the advent of digital cameras. Microscope manufacturers discontinued these accessories; however, they

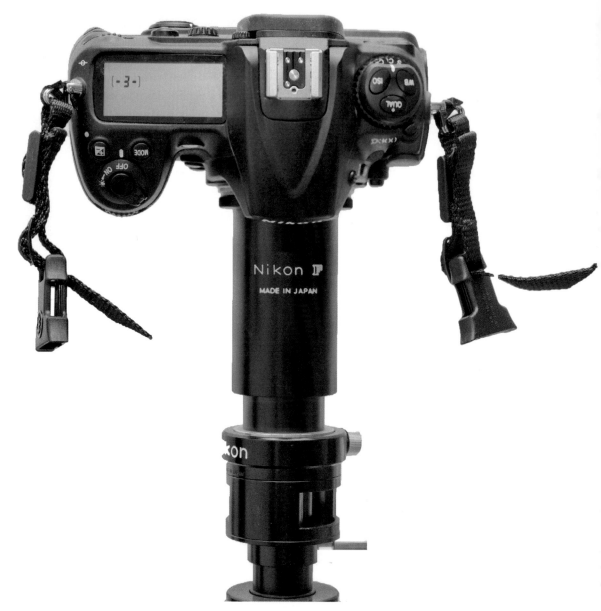

Figure 5-3: Nikon produced a rigid microscope tube adapter that can be found in online auction houses or as a used item in photographic stores. The top of the tube contains a bayonet mount that connects to the microscope, and the bottom has a clamping collar that attaches to a 25 mm OD photographic port. This accessory fits a wide variety of microscopes and, with suitable adapters, several brands of digital SLRs. The photographic port is especially useful because it has an internal lens that reduces the eyepiece power by 0.5x.

can still be found. For most users, a simple tube adapter is adequate, but there are special conditions where the more elaborate attachment may prove helpful.

Simple Tube Adapters

The availability of simple tube adapters for mounting a digital SLR to a microscope depends on when the microscope was made. Ironically, there are more options for mounting digital SLRs on older microscopes manufactured when film was the primary means of recording experiments. Historically, these adapters were part of a systems concept that SLRs should be usable on any optical instrument. All the major camera manufacturers sought to have microscope adapters for their cameras. Today, this marketing strategy is not practiced, and it is difficult to find a company who produces this accessory. In addition, many modern microscope manufacturers do not provide digital SLR adapters for their current microscopes.

In older microscopes made with fixed tube length objectives, many photographic ports have an outside diameter of 25 mm (figure 5-3). These tubes take an eyepiece, and this arrangement became a de facto standard for attaching microscope adapters. At the bottom of the adapter is a collar that can be clamped onto the photographic port. On the opposite side is the proprietary mount for the digital SLR. Generally, these devices do not have any optics. A notable exception is the Nikon tube adapter, whose internal lens reduces the magnification of the eyepiece by 0.5x. It should be remembered that these accessories were developed for a 35mm film camera whose sensor was 24 mm x 36 mm (figure 5-4).

Figure 5-4: Many older microscope accessories were designed for film cameras that recorded an image within a 24 mm x 36 mm frame. These dimensions are larger than the sensors of most modern digital SLRs, as diagramed in this figure. The circle represents what is seen through the microscope's eyepiece; the large frame represents the view covered by a film camera; and the small frame represents the view covered by most digital SLRs. The large frame is 24 mm x 36 mm, sometimes called full frame. The small frame is 25.1 mm x 16.7 mm, which matches a discontinued film size popularized by Kodak's Advanced Photo System (APS).

This format is rare in today's digital SLRs; the more common sensor sizes are smaller (25.1 × 15.7 mm for a Nikon D300). Thus, a modern digital SLR has a much more limited field of view, equivalent to 1.5x more magnification. This makes Nikon tube adapters very advantageous since they reduce the magnification of the eyepiece so the camera sensor has a wider field of view.

A benefit of Nikon bayonet mount accessories is that a variety of digital SLRs can be fitted with adapters for using them. Canon, Sony, Panasonic, and Olympus cameras can

be equipped with third-party adapters to allow them to mount Nikon lenses. If properly designed, these adapters will retain the proper distance between sensor and lens flange. Thus, these camera bodies would be optically equivalent to using a Nikon body, and if the sensor of a Nikon body is in focus with the viewing oculars, these other camera bodies would also be in focus.

Today, a generic adapter is in production for any camera body. One side clamps onto the 25 mm outer diameter (OD) tube, while the opposite side is threaded to accept a T adapter. A bayonet mount from any manufacturer can be secured to these threads. This universal lens mount allows an accessory to be attached to all camera bodies.

Frequently, modern microscopes with infinity tube length objectives use a larger-diameter photographic tube. These larger tubes will not take accessories that clamp onto a 25 mm OD tube. Instead, they have proprietary fittings and are designed to take cameras with a C mount. This mount is found on video cameras and on dedicated cameras for microscopes, but its diameter is too small for a full-frame digital SLR (24 mm x 36 mm).

For most cameras, the adapter provides very little magnification to the objective. In fact, many adapters are simply described as 1x and do not impart any magnification to the image; therefore, the magnification is determined solely by the power of the objective. Many cameras have photosites designed to work with a 100x oil immersion objective so that the sensor records the full resolution of this lens. Generally, a photosite with a 7-micron diagonal pitch works well with a 100x oil immersion objective and a 1x adapter.

It is my impression that the major microscope manufacturers are unconcerned about carrying adapters for digital SLRs. This is understandable because such adapters would require that support personnel be familiar with a plethora of cameras, the majority of which are manufactured by competing companies. Providing technical support and troubleshooting would not be cost effective. Expertise is critical because users often obtain inferior results with digital SLRs as compared with dedicated cameras. Unless care is taken, mirror and shutter movement from a digital SLR will blur images. Fortunately, Optem sells a series of simple adapters for Canon and Nikon digital SLRs that have a magnification of 1.3x or 1.9x.

Disadvantages of Simple Tube Adapters

One disadvantage of simple tube adapters has been already mentioned: the transference of vibration between camera and microscope. As mentioned earlier, taking a photograph with a digital SLR involves a series of mechanical operations. A mirror is raised, a shutter is opened, a shutter is closed, and the mirror returns down to position. Of these four operations, the first two are the most detrimental to image sharpness. The sudden rise of the mirror and its abrupt halt jar the camera, and a series of vibrations persist for a fraction of a second. The movement can be so severe that even a very brief shutter exposure (1/1000 second) will not hide this defect.

A second problem is that the camera's optical viewfinder is ill-suited for microscope work. The view through the camera's eyepiece is disappointing; instead of the clear, bright image seen through the microscope eyepiece, you see a small, dark, diffuse view that makes

focusing difficult at high magnifications and impossible with faint subjects. To compound these difficulties, the eyepiece does not face the seated microscopist. Instead, it faces the ceiling, and the photographer must stand to frame and focus the image through the camera. Methods of solving these defects will be presented in the next few pages.

Advanced Adapters

One of the adapters available for owners of older fixed tube length microscopes is an advanced photomicrography unit with a right-angle viewing telescope and built-in shutter (figure 5-5). An example of this is the Microflex PFM adapter made by Nikon for their film cameras.

The adapter clamps to the 25 mm OD photographic tube and has a focusing unit whose eyepiece faces the microscopist. A prism directs light from the microscope to the user, presenting a bright, clear view of the specimen. The field of view has framing lines for composing the image. Depressing a control swings the prism and directs light to the camera. A built-in shutter controls the amount (duration) of light to the optical sensor. The shutter is designed for low vibration and does not blur the image by imparting a vibration to the photographic sensor.

To use the Microflex PFM adapter, follow these steps:

1. Mount the digital SLR on the unit via its Nikon mount.
2. Mount the unit on the microscope's vertical 25 mm photographic tube.
3. Adjust the microscope with the oculars until you have an image.
4. Direct the light to the photographic tube so that you see the image through the Microflex's focusing tube.
5. Focus and compose the image.
6. Open the camera shutter with the bulb setting so that the sensor is available to receive light. Exposure will not occur until the Microflex's shutter is fired.
7. Swing the Microflex's prism out of the light path.
8. Release the Microflex's shutter.
9. Close the camera shutter, readying it for the next shot.
10. Repeat processes 3 through 10 for multiple shots.

These steps seem cumbersome; however, they address the problems of accurately focusing the image to the sensor and eliminating camera-induced vibration. The Microflex PFM adapter has an advantage in that it can be found with the Nikon F mount, making it usable not only with Nikon but also with Canon, Sony (Minolta), Olympus, and Panasonic cameras. If the accessory camera adapters are properly made, the non-Nikon cameras will be in focus when using the Microflex PFM adapter. A caveat in purchasing this item used is to make sure it is equipped with the Nikon F mount. Many units come equipped with a simpler mount designed for a film carrier rather than an SLR camera.

Other manufacturers, such as Zeiss, Leitz, Wild, and Olympus, have made similar adapters. However, make sure that they come with the proprietary mount that allows them to be used with SLR cameras.

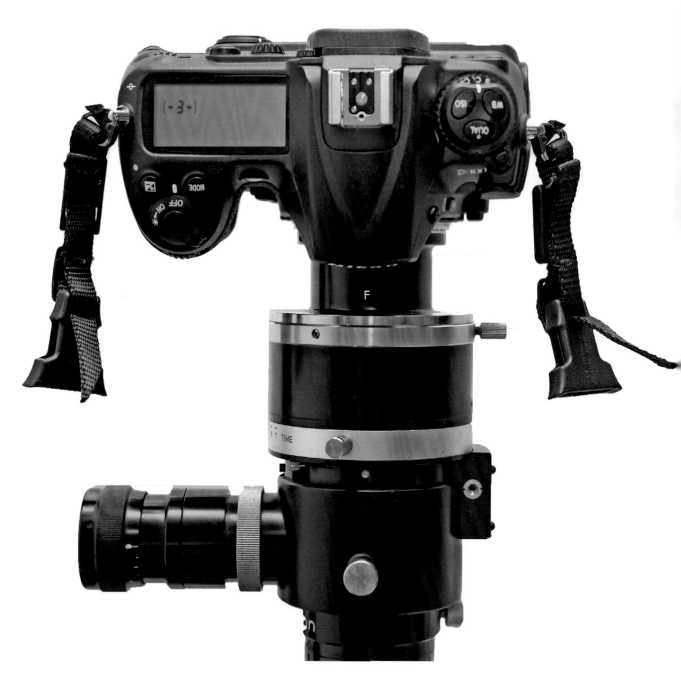

Figure 5-5: One method of coupling a digital SLR to a microscope is an advanced photomicrography unit once sold for film cameras. This Nikon digital SLR is mounted on a Nikon Microflex PFM adapter designed for that company's film camera. It has a right-angle viewing telescope. When the image is in focus through the eyepiece, it is also in focus for the digital SLR. This not only facilitates focusing but also circumvents the camera's built-in finder, which generates a dim, grainy image. The adapter has a built-in shutter that generates less vibration than the camera's built-in shutter.

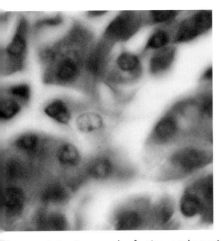

Figure 5-6: A micrograph of a tissue taken with a camera that has an instant return mirror. The image is blurred by vibration from raising the mirror and releasing the shutter. Compare to figure 5-6.

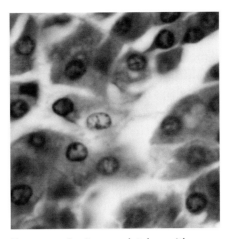

Figure 5-7: A micrograph taken with a camera where the vibration of the instant return mirror was isolated by releasing it independently from firing the shutter. The mirror was released two seconds prior to releasing the shutter. The fine details of the tissue are rendered clearly. Compare to figure 5-6.

Avoiding Vibration on Digital SLRs

There are two major sources of vibration-robbing sharpness when firing the shutter of a digital SLR: the raising of the mirror and the release of the shutter (figure 5-6, figure 5-7). These effects can be mitigated with good camera design and knowledgeable camera handling.

To remove vibration resulting from raising the mirror, use a camera that has independent controls for the mirror release and shutter. This is achieved in one of two ways. The first, a mirror lock-up function, raises the mirror so that the only source of vibration is the movement of the mechanical shutter. This does much to improve the sharpness of the captured image. The Nikon D300 and D700 are examples of cameras that have independent mirror lock-up.

Cameras lacking this control may still be usable. For example, the Olympus E3 and E510 have a self-timer control that separates the movement of the mirror from that of the shutter. Actuating the self-timer raises the mirror; after a delay, the shutter fires to expose the sensor. You can select the time between the mirror flying up and the shutter being released. With my microscopes, a two-second delay between mirror movement and shutter firing is sufficient to remove mirror-induced vibration. Depending on the microscope and camera, the delay may need to be longer or shorter. I have found that a two-second delay is ample for an Olympus BX51, a Zeiss RA or WL, and a Leitz Ortholux.

Once mirror shock is mitigated, the next source of vibration is the shutter as it opens to expose the sensor to light. This vibration may last about 1/15 of a second. If the vibration occupies a large fraction of the exposure time, it will blur the image. Thus, shorter shutter speeds do not help because the entire exposure time is subjected to movement. For example, if the exposure is 1/1000 of a second, that entire period is subjected to camera movement. In contrast, a longer exposure may be beneficial because the camera moves for only a fraction of the total exposure time. If the movement occupies a very short period, its effects are unnoticeable. For example, if you have a one-second exposure, then 14/15 of the exposure occurs during a vibration-free period and the loss of sharpness occurs only during 1/15 of the exposure. Such a brief period of vibration does not detract from image sharpness. Canon cameras are reputed to have a "quiet mode" that reduces vibration; however, I have no direct experience with this feature or its utility in photomicrography.

The vibration that results from closing the shutter and lowering the mirror is inconsequential, as these actions occur after the image has been recorded.

Achieving Accurate Focus and Framing

Generally, the optical viewfinder of a digital SLR is unsuited for microscope work. It is designed to preview a scene, and it is not optimized to provide a crisp, high-contrast image because the photographer generally uses automatic focus. Relying on automatic focus actually reduces the optical viewfinder's usefulness for previewing an image.

During the era of film photography, professional SLRs had optical viewfinders that were designed to evaluate the scene. As a result, they provided a large, high-contrast image for accurate focusing that was further enhanced by interchangeable viewing screens and prisms. It was possible to replace a frosted screen with a clear one and replace the prism with a high-magnification, waist-level finder. This combination enabled a film SLR to provide clarity rivaling what could be seen through the microscope eyepiece. Moreover, the optical viewfinder allowed framing and focusing while the user was seated at the microscope.

Sadly, those days are gone, and no digital SLR has this flexibility. One helpful accessory is a right-angle viewing telescope, which at least presents a view while you're seated at the microscope. The best units, such as Nikon and Olympus, have a high-magnification mode that allows a closer view of the focusing screen. You can toggle to a lower-power view to see the entire screen. Generally, units with a single magnification mode do not provide enough amplification to facilitate focusing. There are third-party companies that provide variable right-angle finders for several brands of digital SLRs.

One of the most significant developments in digital SLRs is live preview. When you raise the mirror, these new cameras take the electrical output from the sensor and provide a live preview on the LCD screen. The sharpness and contrast of this view enable you to focus the microscope. In addition, these cameras provide a high-magnification view of the sensor to facilitate focusing on the finest detail as well as evaluating color balance and exposure.

A weakness in the present design of these cameras is the failure for all models to provide

an articulated LCD screen. Instead, many cameras have a screen that is fixed in position. When mounted on a microscope, this screen sends an image to the ceiling. If the screen is hinged, you can position it to face you so that you can evaluate the image while seated at the microscope.

Olympus E3

This digital SLR functions well as an independent unit mounted directly on a microscope without being tethered to a computer. The following features and accessories make it useful in conjunction with a microscope:

- Live preview with an adjustable screen for viewing at a convenient angle.
- Mirror pre-release to avoid deleterious vibration by swinging the mirror out of the optical path two seconds before releasing the shutter.
- Right-angle viewing telescope with variable magnification (available accessory).
- Shutter release for firing the camera with minimum contact (available accessory).

The Olympus E3 has proven to be a convenient workhorse for photomicrography. It has one of the shortest flange-to-sensor distances of any digital SLR, so virtually any manufacturer's lenses or accessories can be mounted to it. In my laboratory, I have used the Olympus E3 with a Zeiss WL, Nikon S, Leitz Ortholux, Olympus BH2, and Olympus BX51, and the camera has performed admirably on all of these stands.

This is an easy camera to focus. The Olympus E3 is equipped with live preview so the specimen appears on the rear LCD screen. By swiveling and tilting the screen's articulated mount, you can view the specimen while seated at the microscope. The display has an electronic boost to assist in focusing dim specimens. While these images are noisy, they are helpful for focusing and viewing slides when there is insufficient illumination to see them through the eyepieces. The microscope can be operated from a laptop computer, but in that case the monitor will not provide a live preview. Instead, a television monitor must be used for the live preview function.

Here are some guidelines for using the Olympus E3:

- Color balance the camera against a slide without a specimen. Once it's balanced, neutral density filters control light intensity from the illuminator. Do not use the rheostat for varying the voltage to the bulb. While it may seem convenient, a lower voltage will introduce an orange tint to the recorded image.
- To minimize mirror-induced vibration, set the mirror to be released two seconds before the shutter is activated.
- Set the exposure meter for center-weighted measurement.
- Set the automatic exposure mode to aperture preferred.
- Adjust the light intensity so the camera exposes the specimen for 1/15 second or longer. If you attempt to use a shorter exposure, the shutter may move the sensor. For example, a 1/15 second shutter speed always results in a blurred photograph when using the Olympus E3 mounted on a Leitz Ortholux.

Figure 5-8: This photograph was taken with a modern infinity tube length microscope, a 1x adapter, and a full-frame camera, the Nikon D700. Notice the vignetting.

Nikon D700

The Nikon D700 has a sensor that's the same size as a 35mm film negative, 24 mm x 36 mm. It is often described as a full-frame camera, and it provides a wide field of view for a given eyepiece and objective. Unfortunately, this benefit is reduced by the camera's tendency to vignette when used with the standard 1x adapters provided for infinity tube length microscopes (figure 5-8). The periphery of the photograph is hidden in shadows at low magnification. There are several strategies to reduce this defect. The first is to increase the magnification to 1.6x. Since this eyepiece is not sold as an independent accessory for many microscopes, you need a mount that has this additional magnification. If you have a 1x

Figure 5-9: This is a screen shot of a computer controlling a Nikon digital SLR with Nikon's Camera Control Pro software. The black area provides a full-frame preview of the specimen to aid in the overall image composition. The live preview image has sufficient clarity to enable the operator to focus on the subject. The microscope is a Zeiss WL with a 5x eyepiece. There is no vignetting (compare to figure 5-8).

adapter and do not wish to buy another one, you can opt for a 2x tele-converter. This accessory is mounted between the camera body and a telephoto lens. Outdoor photographers use them to increase the magnification of a lens by 2x. Microscopists use 2x teleconverters to provide a higher-power view. Teleconverters can be purchased new for $500 and used for $200, whereas magnification changers can cost $2,000.

However, if you have the budget, the magnification changer is more convenient because

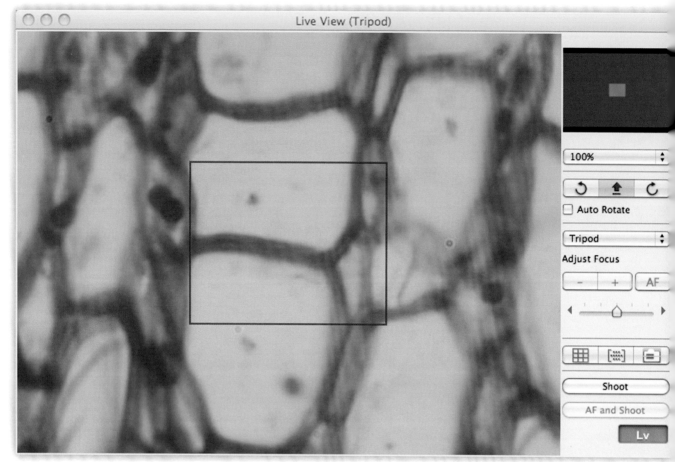

Figure 5-10: This is a screen shot of a computer controlling a Nikon digital SLR. The live preview image provides a high-magnification view of the center of the screen and enables the operator to focus on the finest details of the subject.

it provides between two and four additional powers. For example, Olympus has a low-cost magnification changer that provides 1x or 1.6x settings and a more expensive magnification changer that provides 1x, 1.25x, 1.6x, and 2x settings.

Nikon D300

To reduce vignetting, you can use a less expensive camera with a smaller pixel array. The Nikon D300 has a 12-megapixel sensor that is only 15.7 mm × 24 mm versus the D700's 12-megapixel sensor that is 24 mm × 36 mm. The smaller sensor records a smaller field than the full-frame camera. Many photographers refer to this effect as a 1.5x multiplier. A

camera with a smaller sensor avoids vignetting by recording a narrow field of view where this effect is not seen. Plus, if you use a D300 body in place of a D700 body, you will save $1,000.

As stand-alone units, both Nikons suffer from a fixed-position LCD preview screen that cannot be viewed by a seated microscopist. For easy viewing, I recommend using a computer monitor with Nikon's Camera Control Pro software (figure 5-9). Driving the camera from the computer facilitates focusing, since the preview image on the computer monitor is much larger than the image on the camera's live preview screen. Additionally, you can further enlarge the preview image to focus on the finest details of the specimen (figure 5-10).

The software is critical since it provides a means for releasing the mirror and firing the shutter independently. Ironically, the Nikon manual does not describe how to accomplish this. You need both the Nikon cable release for firing the camera and the Nikon software for activating and turning off the live preview function. The cable release would seem redundant because the camera is typically fired from the computer; however, you need it to release the mirror independently of the shutter. The method is described later.

Tethering this camera to a laptop computer makes it almost as convenient as using the Olympus E3. However, the Nikon D700 does not record or save images rapidly. Instead, images are saved to the computer's hard drive and camera operation is suspended until the file is saved. This takes a second or two for RAW files.

Nikon produced a range of microscope adapters that can be used with the D700 and older microscope stands. For infinity tube length microscopes, there are 1x adapters that provide a direct connection between the camera and microscope. One adapter commonly available online or as a used item in camera stores is a simple tube adapter equipped with a half power lens. These simple adapters are reasonably priced and are a convenient means of mounting this camera to older microscopes.

A more advanced adapter is the Nikon Microflex PFM. I have used it with the Nikon D700 and find that it makes a convenient setup that circumvents some of the difficulties of using the light preview. It has a right-angle viewing telescope that is parfocal to the focal plane of the camera so that you can focus and frame with it.

Here are some guidelines for using the Nikon D700 or D300:

1. Mount the camera directly on the microscope.
2. Attach the camera cable release.
3. Set the white balance against a blank slide using an illuminator running at a constant voltage.
4. Connect the camera to a laptop computer running Nikon Camera Control Pro software.
5. Lock up the mirror.
6. Set the meter for center-weighted reading.
7. Set the camera to live view with Nikon software.
8. Set the camera for automatic exposure mode.
9. Activate live view with the Nikon software.
10. Turn off live view with the Nikon software.
11. Trigger the cable release once to raise the mirror (mirror lock-up).
12. Trigger the cable release a second time to fire the shutter.

Figure 5-11: This is the first frame of a video sequence showing a small prey animal, the bright ellipsoid near the center of the frame, caught in a vortex generated by the predator. Figures 5-12, and 5-13 are a continuation of the video clip, each frame showing the escape of a small prey organism from a large protozoan, a red colored *Blepharisma*. The interval between frames is approximately 1/10 of a second.

13. Use an exposure of one second and adjust light intensity by adding neutral density filters.

These guidelines will help you capture vibration-free images. Hopefully, Nikon will implement a proper live view function so that the mirror simply remains up when firing the shutter.

Panasonic G1

This new interchangeable lens camera is not an SLR. It dispenses with the movable mirror by using an electronic viewing system that provides real-time output to the camera's LCD. The screen is articulated and can be tilted for convenient viewing. Unlike the Nikon and Olympus models, the Panasonic G1 transmits very little vibration to the microscope

Figure 5-12: The second frame shows the prey drawn against the predator and pressed against its body.

during exposure. The absence of a movable mirror eliminates "mirror slap", and there is no need for using a mirror lock-up or a pre-release. When fired, the mechanical shutter induces so little jarring that it does not detract from image sharpness when used on a Leitz Ortholux, Zeiss WL, Nikon S, or Olympus BX51. Of all of the stand-alone systems, this is perhaps the most convenient.

The major problems with this camera are its unique lens mount and its short flange-to-sensor distance. To maintain the proper distance when using a different manufacturer's lens, the adapter has to provide an extension.

Panasonic sells an adapter that allows the camera to use standard 4/3 lenses. When so equipped, an adapter for Nikon F accessories can be added.

Here are some guidelines for using the Panasonic G1:

1. Mount the camera on the microscope. The bayonet mount is a new and requires an adapter to convert to the standard 4/3 mounts. With this adapter, the camera can use standard 4/3 or Nikon F accessories.

Figure 5-13: The final frame shows that the prey escaping from the current and swimming away from the carnivore.

2. Set the white balance against a blank slide using an illuminator at a constant voltage.
3. Attach the cable release to the camera.
4. Set the camera to aperture priority mode so that it will set its own shutter speed.
5. Adjust the exposure with the exposure compensation button.
6. Choose any shutter speed; all are usable.

Panasonic GH1

In March 2009, Panasonic released the Lumix GH1, an improved model of its older G1 camera. Its main advantage over the previous model is its ability to take high-definition videos. These movie clips can be recorded in one of two formats. Its highest resolution mode records images at 1920 by 1080 pixels at 24 frames per second or 1280 by 720 pixels at 60 fps. Panasonic recommends that these two

modes be output directly to a high-definition television. Although the files can be transferred to a computer as AVCHD files, they are difficult to edit. If one wishes to have easy-to-edit files, Panasonic recommends saving the files in a QuickTime Motion JPEG format. These files can be recorded at a resolution of 1280 by 720 pixels. They can be opened with several software programs (QuickTime, Windows Media Player) and edited with QuickTime version 7 to isolate the most pertinent frames and adjust the images' brightness, contrast, and color saturation.

To mount this camera on the microscope, you can use the adapters and accessories described for the Panasonic G1.

This is an expensive camera. At the time of publication, it is selling for $1,499. In part, this high price is due to the included lens, a 10 to 1 zoom that is designed for video recording. Unlike other video recording digital SLRs, the Panasonic lens will autofocus while recording videos. For microscope work, this lens is unnecessary. If the microscopist is only interested in still photographs, the older G1 is much less expensive. With its included lens, a 3 to 1 zoom, the older camera will cost approximately $600. However, if you wish to record high-quality video, this camera is highly recommended.

Advantages of a Dedicated Digital Camera

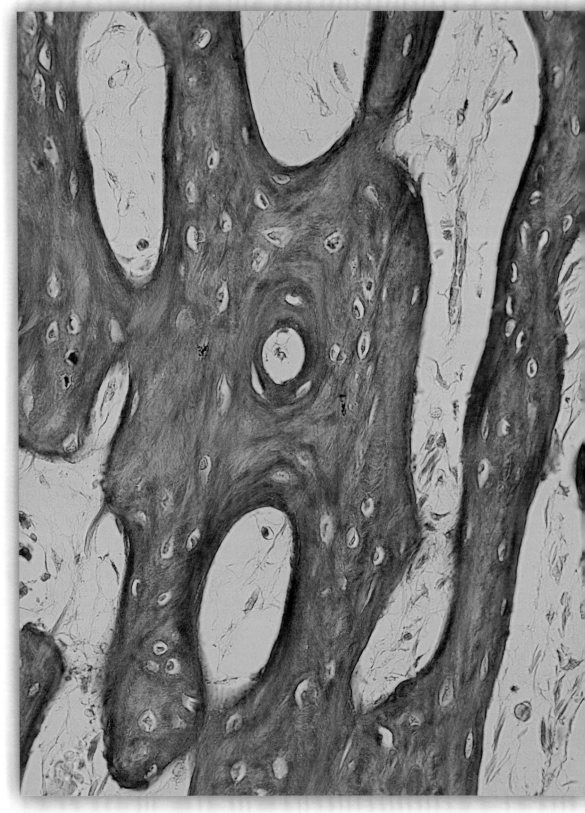

Definition

For the purposes of this book, a dedicated digital camera is defined as one that requires a computer for controlling the exposure and storing the image. These cameras are not for handheld use, nor can they be operated independently of a microscope. Digital SLRs have some of the attributes of dedicated digital cameras when connected to a computer, but dedicated digital cameras have more flexibility and versatility for microscope work.

The earliest dedicated digital cameras required a specialized image capture card mounted in a desktop computer. This setup was awkward; the computer body, keyboard, mouse, and monitor took up a large desktop area in addition to the area already occupied with the microscope. Additionally, the capture card was a proprietary design of the camera vendor, which added to the expense of taking pictures through the microscope. Presently, the need for a frame grab card is obviated by cameras that use a serial interface to communicate with the computer. This may be either a USB 2.0 port or a FireWire (IEE 1394 high-speed serial bus). These serial interfaces are either standard components or components that can be added easily by the user.

Today, the majority of dedicated cameras use USB 2.0 for communicating with computers. These ports are common and can be found on Windows and Apple desktops as well as laptops. Thus, almost all personal computers can be fitted with a dedicated camera. For users who must capture hundreds of images at a single session, the dedicated camera's operational speed justifies its permanent placement on the microscope.

A caveat with the USB port is that early computers contained a version with a slow transfer rate that made it unsuitable for microscope work. Make sure that the port meets the specifications for USB 2.0, providing a transfer rate of 480 mbits/sec. USB 1.0 only supports half this transport rate, making it too slow for operating a megapixel digital camera.

FireWire is another serial transfer method commonly used on Apple computers. Although FireWire is not as prevalent as the USB port, it operates at a transfer rate of 400 mbits/sec and the newer version (FireWire 800) promises an even faster rate of 800 mbits/sec. If a FireWire port is desired, it can be easily added by buying an accessory card for either Apple or PC computers.

Superior Imaging by Dedicated Cameras

The sensors on dedicated digital cameras are of higher quality than those found on digital SLRs. There are several types of dedicated cameras optimized for different applications. For example, cameras for black and white (monochrome) work lack a Bayer mask, which increases the sensor's spatial resolving power and sensitivity over color cameras. Additionally, cameras for monochrome work

This is bone with cells (osteocytes) residing in lacunae. To reveal cells, it is necessary to use at least a 20X objective. This photograph shows the bone as a reddish-colored matrix.

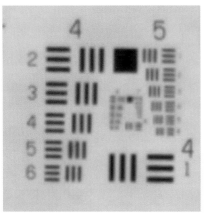 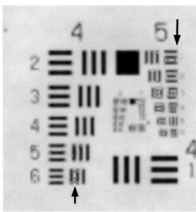

Figure 6-1: These two photographs of a resolution test pattern illustrate the improvement that a dedicated camera has over a digital SLR. The image on the left was taken with a monochrome camera and the image on the right, with the blue tinge, was taken with the same type of sensor but overlaid with a Bayer mask. Essentially, it is an image recorded by a color camera and is typical of a digital SLR. The image on the left, shows the resolutions bars clearly separated at bars near the number 5 and 6. In comparison, the color camera shows imaging defects in these areas (see arrows). This slight degradation of performance is to be expected if one uses a digital SLR.

can be equipped with electronic coolers (Peltier devices) to reduce thermal noise. Such cameras are the preferred choice for low-light work that requires detecting fluorescent dyes.

Dedicated color cameras equipped with Bayer masks usually have more software controls for previewing and improving image quality than digital SLRs. For example, contrast can be adjusted in real time and its effects judged immediately on the preview screen. Adjusting the white balance of the illuminator is simplified by limiting the size of the area used. Digital SLRs use the entire sensor for evaluating white balance. Thus, a specimen that occupies a large portion of the field contributes its color for the measurement, thereby rendering it inaccurate. In contrast, a dedicated camera measures the color in a small target area. By moving this area to a region devoid of the specimen, the operator measures only the color of light coming from the illuminator. White balance is set for this limited region in real time, and the improvement in color balance can be evaluated immediately on the preview screen.

Another function available to the dedicated camera is flat-field correction. This feature improves image quality by removing defects caused by the optics or lighting of the microscope. Frequently, an imaging system does not project a uniform field of light to the sensor. This causes the corners of the field of view to appear darker than the center, producing the optical artifact known as vignetting. Additionally, the microscope's lens may have dust that can be projected onto the sensor as opaque spots or out-of-focus shadows (figure 6-2). These artifacts sometimes escape notice in a photograph containing fine details that span the entire field of view. A complex image conceals these defects. However, if the field consists of individual cells separated by clear regions, these defects become evident—especially if the image is low contrast and you use software to increase the contrast. For critical work, particularly if you must measure the

Figure 6-2: Cells (squamous epithelial) photographed in brightfield with a black and white camera. The image's contrast was increased and while the cells are evident, the dirt on the sensor is also seen.

optical density of objects across the field of view, this is unacceptable.

To correct this, first take an image through the microscope without the specimen, mapping out such features as shading off at the corners or dust in the field of view (figure 6-3). This image serves as a mask. The image of the specimen is a composite of the subject plus these optical defects. Then set the dedicated camera to subtract the mask from the preview, which occurs in real time.

This imaging strategy is not available as a real-time function with digital SLRs. Instead, the mask must be subtracted from the recorded image as a post-processing step. First, you photograph the specimen and save

Figure 6-3: By taking a picture in an area without cells, it is possible to record the dirt on the sensor. This can serve as a mask, demarcating the defects on the chips. This mask will eventually be subtracted from the image in figure 6-2.

the file. Then you remove the specimen from the field of view by shifting the slide so that the camera sees only an empty area. A photograph of this area serves as the mask. Then, with specialized software, you can subtract the data on the mask from the image of the specimen, thus removing any defects associated with the instruments being used (figure 6-4).

Greater Control through Binning and Gain

Binning is a feature of dedicated cameras that is missing from digital SLRs. It combines the output of adjacent pixels so that they function as one. A 2 x 2 bin means that four adjacent pixels pool their output, allowing the four pixels to function as a single pixel. Combining the

Figure 6-4: This is the result of the subtraction between the reference frame, demarcating the defects on the chip, and the cells taken with the dirty chip. The dirt is removed. Flat-field correction is a feature commonly supplied with dedicated cameras. The subtraction process is easily accomplished with the camera's software.

output of the individual pixels has the benefit of providing an increased signal for a selected shutter speed. Or, if you wish to maintain a given signal output, binning allows you to use a shorter shutter speed. When binned, a 2048 x 2048 (4 megapixel) sensor operates with 1024 x 1024 (1 megapixel) active sensors. This increases the camera's sensitivity by 4x and allows a reduction in exposure. Thus, a nominal four-second exposure for a 2048 x 2048 sensor becomes a one-second exposure for the binned sensor, which operates as a 1024 x 1024 unit. This reduction in shutter speed can be an invaluable aid in fluorescence microscopy where the signal is faint.

To illustrate this point, imagine a sample that requires a four-second exposure without binning. This will cause a delay of four seconds

between turning the focus knob and viewing its effects on the preview screen—a delay that is too long to provide feedback for precisely determining focus. By using 2 x 2 binning, the sensor needs only one second to complete the exposure. This shortened interval is sufficiently brief to evaluate the effects of changing focus. Another benefit of binning is that you can record an image while reducing the incident light falling on the specimen. (Reducing incident illumination enhances the viability of live preparations.) The reduced illumination results in a fainter image, but binning the output enables you to work with a fainter image. Each binned pixel has four times as much light, allowing the image to be collected more easily.

Another advantage of using a dedicated digital camera is that you have more control over the camera's sensitivity, also called "gain". Gain is the electronic amplification of a weak signal. With a digital SLR, you set the gain by adjusting a single control: the ISO switch. With a dedicated camera, you can set the gain to two different values: a high value when previewing the live image and a low value when capturing the image. Dedicated cameras provide rapid switching between high and low gain.

The high setting allows you to view the specimen, adjust the microscope's controls, and see the effects in real time. However, it should be remembered that working with high gain causes an increase in noise, i.e., the random fluctuation of signal. This is evidenced by a "salt and pepper" appearance like what you might see in low-light images from night vision scopes. By increasing gain, you reduce the need for long shutter speeds at the expense of a "noisier" image. Although the image quality is low, this is acceptable when it is important to ascertain the effects of focusing and framing the image. If you choose to use high gain for recording the image, it will not sacrifice the spatial resolution of the sensor. A 4-megapixel sensor will record a 4-megapixel image.

Binning the sensor and increasing gain enhance the versatility of the dedicated camera for recording dim samples. Such settings allow you to electronically view samples that are too faint to be seen directly through the eyepieces. This is important when working with low light levels. There are no equivalent controls on digital SLRs, which limits their utility when working with fluorescent or darkfield illumination.

Sensor Array and Magnification

For microscopists interested in producing large photographic prints, the dedicated camera's greatest limitation is its small pixel count. The majority of these cameras have sensors with only 2.3 or 4 megapixels. This is significantly less than modern digital SLRs, which routinely have 12-megapixel sensors. The limited number of photosites makes it critical that the entire sensor area be used for framing the image. If the image is too small, it cannot be enlarged since there are too few pixels to show fine details. Therefore, adjusting optical magnification is crucial.

When working with smaller sensors, a magnification changer becomes invaluable for enlarging the image. The changer mounts between the objective and the camera, inserting lenses into the optical system to provide finer increases in magnification than can be achieved by simply changing the objective. Modern microscopes tend to change

magnification in units of two with a typical objective set at 4x, 10x, 20x, 40x, and 100x. A magnification changer provides the convenience of changing magnification in increments of 1.25 or 1.6, a more gradual increase in power.

To illustrate the importance of this point, keep in mind that you need 300 pixels per inch for a publication-quality print. Using this guideline, a sensor with a 1200 x 1600 pixel array will generate a print of 4 x 5.3 inches. However, the sensor does not have enough pixels for a detailed 8 x 10 inch print. Similarly, if the subject occupies only half of the area of the sensor, it is no longer suitable for a 4 x 5.3 inch print. In this case, it would occupy a region of 600 x 800 pixels, suitable for a 2 x 2.5 inch print—which may be too small for a publication. If you increase the magnification of the previous example by 50 percent, then the workable image increases in size to 3 x 3.75 inches. Such fine increases in magnification are obtainable only if you have a magnification changer. You cannot accomplish this by rotating a more powerful objective in the optical train since that will only increase magnification by a factor of two. A magnification changer allows you to hone in on a more exact magnification power.

Zeiss and Olympus have optical changers that vary powers by 25 percent, which increases magnification by 1.25x, 1.6x, and 2x. This provides you with much greater control. Although it is possible to add eyepieces to the phototube to provide a gradual increase in magnification, their utility is hampered by the inconvenience of having to remove the camera to exchange the eyepieces.

Pixel (Photosite) Size and Resolution

When doing research work, the photomicrographer must remember that the camera is a sampling device that can limit the microscope's ability to reveal fine detail. This is evident when work requires recording the finest details at the limit of lens performance. With too little magnification, fine details are obscured because the individual pixels are larger than the details they are trying to capture. Therefore, all of the detail falls on a single photosite.

There are two requirements for distinguishing objects as separate or resolved. To detect two objects as being separate, each one must fall on a different photosite. Additionally, these photosites must be separated by photosites where the object is absent (figure 6-5). In effect, there must be a "spacer" to indicate the separation. The critical question is how many photosites without the subject are sufficient to indicate that the two points are separate.

The minimum sampling frequency to resolve fine spatial detail is 2.3, a value known as the Nyquist criteria. The rationale for computing this number is beyond the scope of this book. However, intuitively, you can appreciate that to resolve fine details, individual photosites must be smaller than the finest details that they are attempting to detect. The Nyquist criteria suggests that if you wish to resolve an object separated by one unit, the detector must be smaller than 1/2.3. For most purposes, I have found that the sensor should be approximately one-third the size of the finest detail. To record two points separated by one unit, the detector must be an area one-third that size. In other words, 3 pixels will accurately record the space separating two objects.

Figure 6-5: A diagram illustrating how pixel size determines the ability of the camera to determine whether two points are occupying the same or different coordinates on the sensor. The colored circles represent two points of light falling on the camera sensor, the black borders are the limits of the photosite, and the blue color indicates whether the pixel is providing a signal in response to the presence of the two spots. When two points of light fall within the largest pixel (top square), the camera sensor will report that they lie within the same pixel of the sensor. If the pixels are reduced in size so that the spots fall on two adjacent pixels, the camera cannot distinguish that the pixels are separate structure. They are viewed as being contiguous. For the camera to record the points as being separate, there must be intervening pixels that report the absence of a signal.

To illustrate this point, suppose you wish to resolve an object separated by 0.270 microns. To do so, you need a detector that will see an area one-third of this value so that each block of data covers 0.09 microns. To determine if the camera can see this small of an area, you need to know the size of the photosite and the magnification of the image projected onto it. This information is available from the manufacturer. For example, one of the dedicated cameras I have, a Lumenera Infinity Four, has photosites that are 9 microns in size. Knowing this, along with the magnification projected onto the sensor, I can calculate the size of the area seen by the camera's photosite. If I attach this camera to an Olympus BX51 microscope with a 1x adapter and a 100x objective, the magnification to the photosite becomes 100x. Thus, the individual photosite sees an area that is 9 microns/1000, or 0.09 microns. In this case, the camera and the magnification that it sees from the microscope satisfy the Nyquist criteria and can resolve an object separated by 0.270 microns.

This example is more than an arithmetic exercise. It is a means to determine whether the camera will capture all the details that the objective is capable of revealing. The above example succeeds; however, it is possible to have a situation where the camera fails to record the lens' capabilities. For example, if I had a 60x objective and the same camera, the photosite would see an area of 9 microns/60—in other words, an area of 0.15 microns, a larger size than the .09 required by the Nyquist criteria. As a result, the camera and lens would fail to detect objects separated by 0.27 microns and instead would only detect objects separated by 0.45 microns. Even if the 60x objective lens were designed to exceed the performance of the 100x lens, the camera would only record 0.45 microns. The best way for this lens to achieve its putative performance is to increase the magnification to the camera by using a more powerful eyepiece or setting the magnification center to a higher value.

Returning to the microscope, each objective's ability to resolve fine detail can be calculated from the data inscribed on its barrel. In chapter 2, the term "numerical aperture" (NA) was defined and its role in resolution shown in the equation:

$$R = \frac{0.61\,\lambda}{NA}$$

the wavelength used to observe the specimen in nanometers is λ, and 550 nm is commonly used for the value λ. This is green light, the color to which the human eye is most sensitive.

To the right is a table showing resolution versus NA for light with a wavelength of 550 nm.

From this table, you can determine the putative resolving power of the objective mounted on the microscope. It should be noted that these values are calculated under the assumption that the microscope is being used correctly. For example, the failure to use Köhler illumination, as described in Chapter 1, reduces the performance of the microscope.

NA	Resolution microns	NA	Resolution microns
0.1	3.36	0.75	0.45
0.25	1.34	0.95	0.35
0.45	0.75	1.15	0.29
0.65	0.52	1.25	0.27
0.75	0.45	1.4	0.24

Mounting Systems

There are at least six major manufacturers of digital SLRs (Canon, Nikon, Olympus, Pentax, Sony, and Sigma), and each has a unique mounting system for its lenses and optical accessories. Olympus has developed two mounting systems (4/3 and μ4/3). Finding the right means to connect the camera to the microscope can be a challenge. In contrast, dedicated digital cameras all have a simplified mounting system. A threaded female adapter mounts to a male adapter on the microscope, allowing the image to be transmitted through the connection to the camera. The mount is approximately 25 mm in diameter and corresponds with most microscope adapters. It is commonly called a C-mount (cine mount). In comparison, digital SLR adapters whose mount is approximately 40 mm in diameter transmit more light from the microscope to the camera. This is due to the smaller overall size of the dedicated camera's sensor.

The C-mount is commonly used by all manufacturers for research microscopes and for the majority of dedicated scientific-grade cameras. For modern microscopes with infinity tube length objectives, C-mount adapters may not provide any magnification. They are referred to as 1x power. If you wish to increase the magnification, you need to purchase an adapter designed to insert a lens that serves as an eyepiece. This is a clumsy way to alter the magnification. Alternatively, some adapters have variable magnification wheels—lenses are placed in a rotating plate, and rotating a new lens into the optical path varies the power. There are even more elaborate adapter tubes with zoom lens systems to provide an infinitely fine adjustment of magnification. These are very convenient for precise composition.

Since dedicated digital cameras mount directly on the microscope, you do not have to contend with mechanical vibration that blurs the photograph. These cameras lack an instant return mirror and do not require a mechanical shutter. No vibration is generated when exposing the sensor, and the resulting image is tack sharp.

Using the Cameras

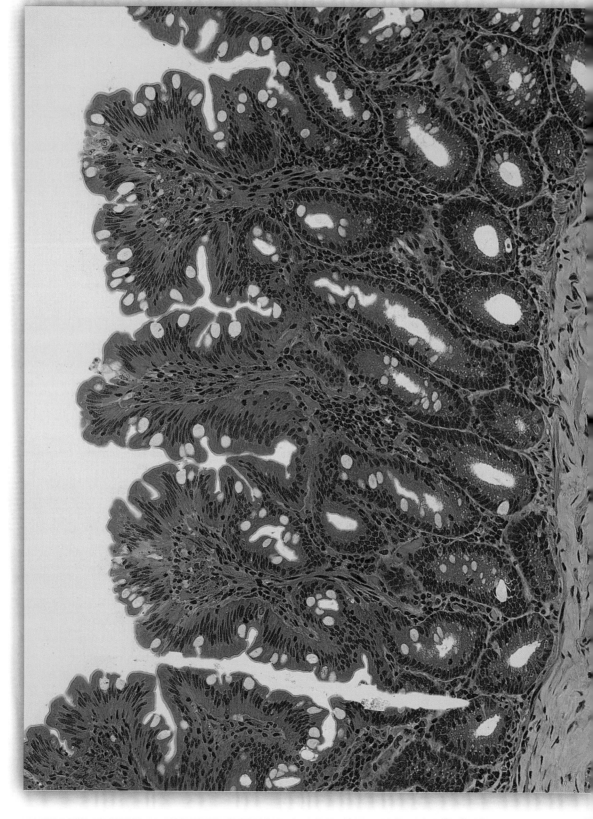

Illuminating the Specimen

The first step in obtaining a good photograph is correct illumination. For transmitted light work, that means using Köhler illumination to provide an evenly lit field and good contrast for the finest details. If the subject lacks contrast when viewed through the eyepieces, then an additional lighting strategy must be employed, such as darkfield, phase contrast, or interference contrast. Once a satisfactory view of the specimen appears in the eyepieces, the following details need attention.

Color Balancing the Specimen

If the goal is to capture realistic colors in the specimen, you need to consider the contribution that the light source plays in tinting the overall shade. Visually, the human eye can report color under a variety of lighting regimes. For example, a green-colored plant has the same color whether it is viewed with indoor or outdoor lighting. However, the camera is not as versatile, and it is incapable of adjusting for the effects of altered lighting. Its recording of the color green depends on the ambient lighting conditions.

Another example is apparent when using a tungsten illuminator with a microscope. When compared to daylight, this light has a preponderance of red. Quantitatively, this color is defined in degrees Kelvin (K) and is based on the assumption that an ideal black body, when heated, emits light whose color depends on the surface temperature. For example, light from a tungsten studio lamp (such as a photoflood lamp) is rated at 3400 K, while light from the sun is approximately 5600 K. The lower color temperature of the lamp reflects its reddish color. If the light source is known, the camera can be set to the color temperature of the illuminant so that regions without color appear as white (figure 7-1).

When photographing with the microscope, a common mistake is varying the illumination intensity with the rheostat that adjusts the voltage to the tungsten illuminator. While convenient for immediately lowering or raising intensity (figures 7-2 and 7-3), the rheostat induces a color shift as the voltage to the bulb varies. There is a shift to red tints as the light intensity is reduced. Visually, the operator takes little note of this because the eye accommodates to the change and the brain interprets the incident illumination as white. However, a digital sensor records the light accurately and registers the changing colors.

To eliminate this color shift, use the illuminator at a constant voltage. If the intensity of the light is too bright, reduce it by inserting

Simple columnar epithelium is a type of cell found in the gastrointestinal tract and allows the transport of material from the lumen of the intestine to the interior of the body. The formation of narrow projections, villi, increases the area through which material can pass. Such structures require a lower magnification to reveal, as in this photograph taken with a 4x objective and a 1x eyepiece.

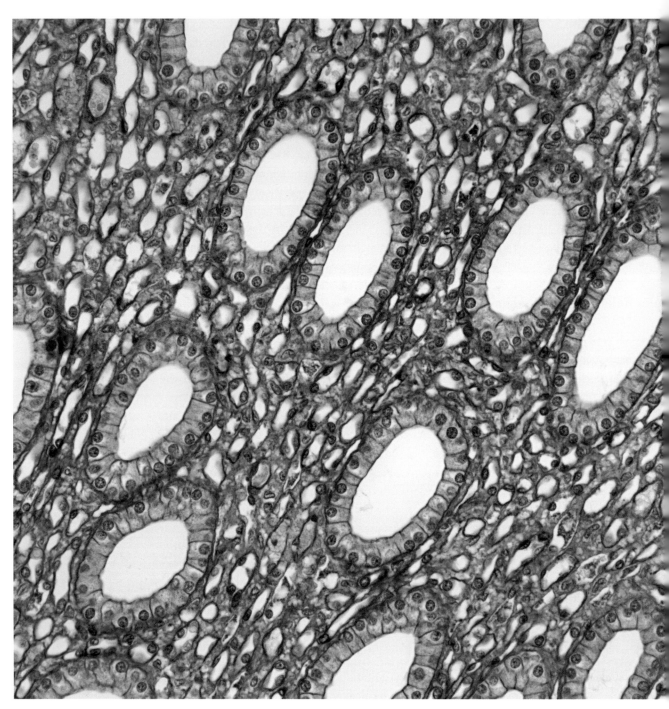

Figure 7-1: When the camera is properly adjusted, it records colors naturally and neutral regions do not have a color tint. In this micrograph of a cuboidal epithelial, the colors are recorded accurately. Note the clear, circular areas without tissue. These areas are neutral white and should be recorded as such.

Color Balancing the Specimen 91

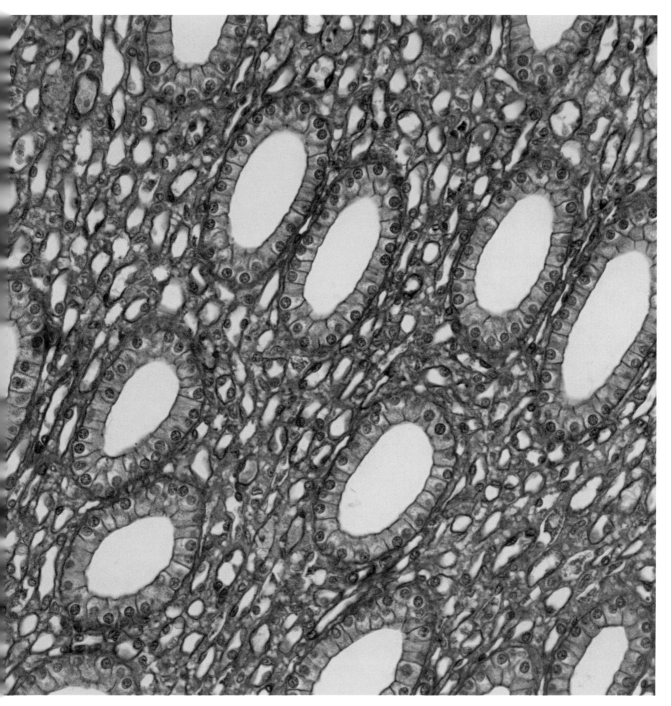

Figure 7-2: Turning down the voltage of the transformer reduces the intensity of the microscope illuminator, and its light assumes an orange tint. Visually, the microscopist may not notice this, but the camera will accurately record the change in color.

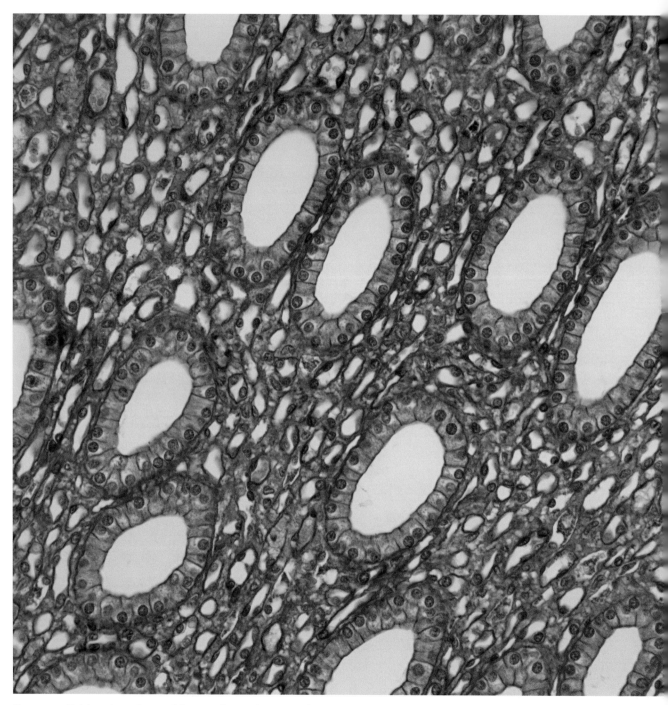

Figure 7-3: Raising the voltage of the transformer increases the intensity of the microscope illuminator, and its light assumes a blue tint. The effect can be seen in this micrograph.

special neutral density filters. These filters absorb all visible wavelengths of light uniformly and reduce its intensity without shifting its color.

Digital cameras have a setting to automatically correct white balance. They take the incoming light and attempt to record colors accurately, even if you vary the color balance by altering the voltage of the illuminator. Theoretically, this would seem to be the ideal setting since it should maintain colors under widely varying light conditions. However, it should be used sparingly. First, digital SLRs often fail to automatically correct white balance for tungsten illuminators, and the resulting images appear to have a reddish tint. Worse, if you attempt to record vibrant and saturated colors, the control may mute the predominant color. An example of this effect can be seen when photographing a vibrant, red-hued sunset. The intense colors are muted by the automatic white balance because the camera attempts to restore the "neutral" colors within the scene. A much better strategy is to set the white balance manually.

Many cameras have color balance settings labeled daylight, artificial, electronic flash, and fluorescent. These approximate settings are used to record scenes that are illuminated respectively by sunlight, tungsten illumination, xenon strobe, and fluorescent tubes. With a microscope, you would set the illuminator to the proper operating voltage with its rheostat. This generates light that is close to artificial lighting. Some cameras have a provision for measuring the light reflected from a white piece of paper to obtain color balance and then setting the camera's white balance so that the paper is recorded as white. This provision is the most accurate means of setting color balance. To use it, set up the microscope for photomicrography, then move the specimen out of the field of view. This can be accomplished easily by shifting the slide with the mechanical stage to a clear area. This area is treated as the equivalent of a white piece of paper, and the color balance can then be set. The slide can then be repositioned for photography. This operation need be done only once as long as the voltage of the illuminator does not change. White balance set by this method provides the most neutral colors, compensating for any tint introduced by the lens.

Color and Monochrome

Operating the illuminator at a specific voltage and a single color temperature might seem unimportant when photographing in black and white (figure 7-5). However, this is not the case. The color balance of the light affects the appearance of a colored specimen. For example, when imaging a colored slide with red-toned objects, you can lighten their appearance by using a light that is tinted red. The increased percentage of red light allows more light to pass through the red subject. In contrast, if you raise the color temperature so that there is a higher proportion of blue light, the red object then absorbs more of the blue light and appears darker. When you use high voltage and intense lighting, the incident light will have a higher percentage of light with blue wavelengths. In a monochrome (black-and-white) photo, the nuclei will appear darker than the cytoplasm. Thus, for consistent results, you should maintain a constant voltage to the illuminator for consistent monochrome images.

The differential absorption of colored light by stained samples can be used to enhance

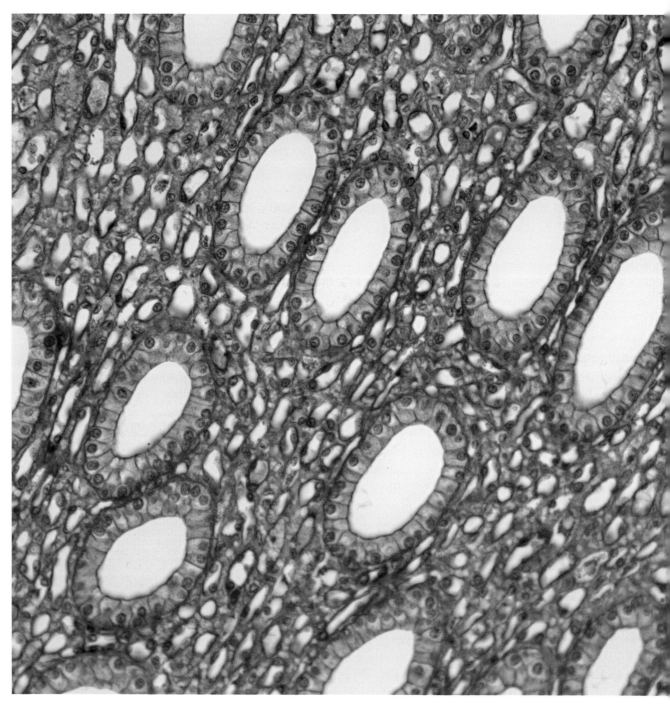

Figure 7-4: This is a color photograph of a simple epithelium with cells stained red and their nuclei a darker red. The extracellular compartment is stained blue.

Color and Monochrome 95

Figure 7-5: A black and white micrograph of the same tissue shown in figure 7-4 provides a different view.

Figure 7-6: By using colored filters and recording the image in black and white, you can emphasize different structures. Here the blue connective tissue is emphasized, while the red circular nuclei are de-emphasized when a red filter is placed in the illuminator.

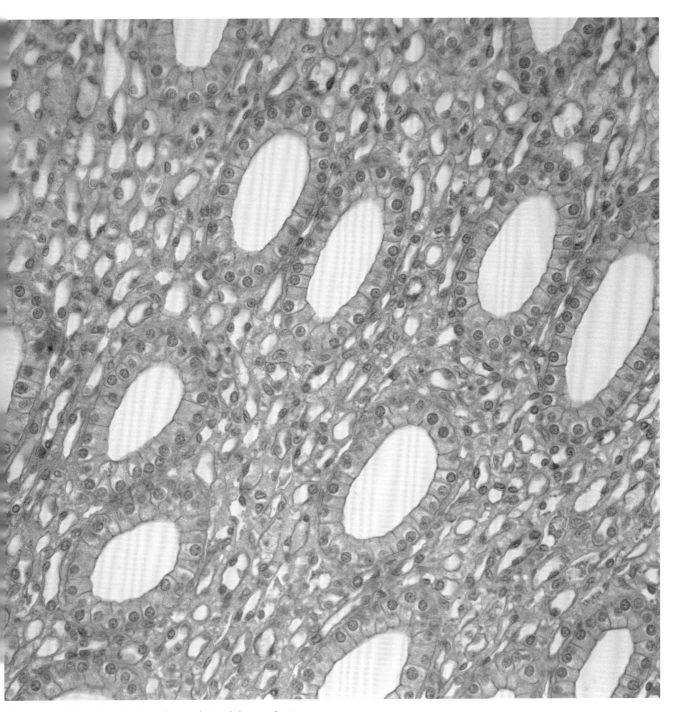

Figure 7-7: A blue filter darkens the nuclei and de-emphasizes the blue connective tissue.

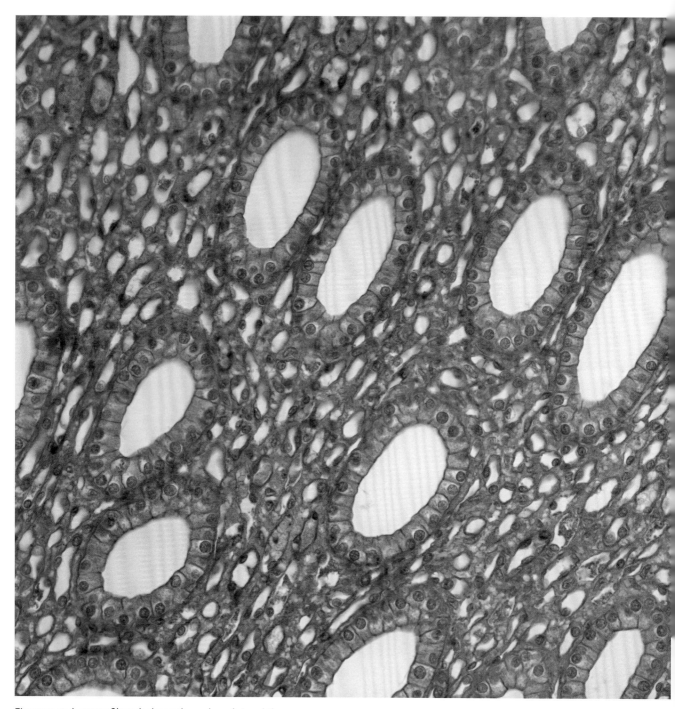

Figure 7-8: A green filter darkens the red nuclei and the blue connective tissue.

regions of interest. In the example of pink cytoplasm and blue nuclei, you can enhance the appearance of the nuclei by using a red filter. The filter allows more light to pass through the cytoplasm, making it appear lighter, while the blue nuclei block a high percentage of the red light, making them appear darker. In contrast, using a blue filter makes the cytoplasm appear darker because it blocks a higher percentage of the light, while the nuclei appear lighter because they pass a higher percentage of the light.

Using colored filters with a monochrome camera can provide a simple means of building contrast, thus enhancing detail and the resulting image (figures 7-6, 7-7, and 7-8).

White Balance and Fluorescence Slides

Typically, a fluorescent image is captured with a black and white camera. The illuminator's light is filtered to excite a single fluorochrome, whose emission passes through a narrow band filter set before being captured by the camera or viewed by the eyepiece. If done correctly, the image will have a single color. Recording the image in color is not necessary since the variation in intensity can be displayed as a gray tone. Also, recording and saving the image as a color file would increase its size 3x over that of a gray-tone image.

However, there are conditions in which color information is recorded. One may use a wide band filter set that allows multiple colors to pass, and under these conditions it may be desirable to record both colors as they appear through the eyepieces. Under such conditions, you would set the camera to record the image as a daylight scene.

Optimum Digital Exposure

A digital camera records light by collecting photons that increase the charge in its silicon matrix and in turn are converted to voltage. These values increase in direct proportion to intensity of light falling on the sensor. Unlike with general photography, there is no interplay between the f-stop of the lens and the shutter speed of the camera in photomicrography. The microscope's aperture is usually adjusted for maximum resolution and optimum contrast and is left at that setting. Only the shutter speed is altered to vary the light that falls on the sensor.

The rule for accurately recording detail is to expose for the areas with information and ignore the areas with no information. Since specimens can have an extreme dynamic range, you must evaluate which areas contain the details to be recorded and adjust the shutter accordingly. For example, in the cases of fluorescence and darkfield microscopy, the subject glows against a black background. The correct procedure is to adjust the exposure so that details are recorded in the brightest areas, ignoring the black background. For stained tissue slides where the details are in the dark regions and the brighter areas are empty, the procedure is to ignore the brighter areas and concentrate on the darker areas. This is referred to as exposing for areas of interest.

Setting the Exposure

Judging the optimum exposure is influenced by the type of camera and its features. The most efficient method is setting the shutter speed, which is done manually by evaluating the quantitative value presented on the

screen. This feature characterizes dedicated digital cameras that are tethered to computers. For most digital SLRs, it is not possible to evaluate the exposure with such tools prior to capture. It is necessary to rely on the camera's exposure meter to estimate the correct shutter speed and to make a trial shot for evaluating its effects. By judging the degree of over- or underexposure, you can set a compensation value within the camera to bias the exposure meter for subsequent shots. Alternatively, you can choose automatic exposure mode and allow the camera to adjust its shutter speed for optimum exposure. If there is a large sample size and a multitude of images need to be captured, presetting the exposure may not result in a perfect image for every shot. Better results might be obtained by using the camera in automatic exposure mode.

The control for adjusting exposure is the gain on a dedicated digital camera or the ISO setting on an SLR. In both cases, the electronic signal derived from the sensor is amplified, and it appears that the camera has an increased sensitivity for a given shutter speed. However, there is a penalty for amplifying the signal: an increase in noise. Noise appears as "salt and pepper" granularity in the image, and fine details can be obliterated by this defect. For the best image quality, a dedicated digital camera should be set to the default gain value (usually 1), and a digital SLR should be set to the default ISO (usually 100 or 200).

Automatic Exposure

As an alternative to manual adjustment, digital SLRs can be set to automatically adjust the shutter speed for the correct exposure. This is called aperture preferred mode. Some investigators feel that this mode is the most precise means of obtaining accurate exposure since the camera can set the shutter value to finer increments than can be performed with a manual control. While this is theoretically true, the advantages are of little practical import. Frequently, you will find that the suggested exposure is not optimum for the specimen because the background areas are either much darker or brighter. When this occurs, you must override the automatic setting. You can generally set the exposure up to three f-stops above or below the recommended exposure. But if you must often override the suggested exposure with this control, it becomes operationally identical to setting the shutter speed manually.

Since metering affects the degree to which automatic exposure is applied, it is necessary to standardize on the region that is to be metered. One strategy is reading a restricted area (spot meter). By metering only the region of interest, you can ignore the effects of lighting from areas that do not contain useful detail. For example, in darkfield or fluorescence imaging, the subject glows brightly against a black background. Spot metering the bright region ignores the dark areas without information. A meter that tries to measure the entire field attempts to strike an average between the bright and light regions. Metering the darker regions would result in overexposure of the light areas, while metering the brightest regions would result in underexposure of the dark areas. If you restrict the meter to the subject, the surrounding illumination (or lack of it) minimally influences the exposure.

Most meters are calibrated to read exposure so that an object is recorded as a mid-tone (gray). Generally, this works for objects with an average reflectance of light. However, using

general photographic scene as an example, exposing snow with a spot meter records its brilliant white appearance as dingy gray. The meter's putative exposure is based on objects that reflect only a fraction of light that snow reflects. To record snow as being "brilliant white", you would have to bias your meter to underexpose the scene.

Using spot metering in automatic exposure mode requires careful centering of the object of interest in the metering area. Obviously, if the specimen is outside the metering area, the exposure will be biased to the wrong region.

Other metering modes are more difficult to interpret. There can an overall reading of the entire field of view (average meter). If light levels vary widely in the camera's viewfinder, the subject of interest may not be recorded. To correct for this, the meter may be compensated as a center-weighted metering with higher priority given to the midpoint of the field of view. The assumptions are that the object of interest will be centered and that the background area will not unduly bias the exposure. Finally, there is matrix metering mode that attempts to balance the variation of lighting with a complex algorithm to provide a median exposure. Unfortunately, these paradigms may not be predictable for the photomicrographer recording images through the microscope.

Typically, if you use automatic exposure, it is necessary to use a single imaging modality and also to standardize specimen preparation and image composition. For example, transparent, low-contrast specimens may be captured using automatic exposure with an averaging meter. Thin cells observed by phase contrast lend themselves to a general averaging or center-weighted metering scheme. However, if these metering modes are used on a stained specimen, the areas without material bias for underexposure of the tissue. To automate exposure for stained specimens, you need to compensate by providing a higher exposure than indicated by the meter. This correction will vary unless the proportion of specimen and background is constant and unless the degree of staining is uniform from area to area and slide to slide. Since this is seldom the case, you can set the camera to "spot meter" and center the stained region in the area that is measured. If you employ darkfield or fluorescence microscopy, you must account for the large areas of black. Again, spot metering may be employed, but the meter may still not provide the best exposure.

The problem with automatic exposure is that regions with no pictorial value influence the system. In other words, you must decide what regions to sacrifice so that only the areas of interest are properly exposed. Automatic exposure, while intuitively appealing because of its perceived convenience, is undesirable because the metering system must still be overridden to provide details in the regions of interest. Fortunately, since the illumination for a given specimen during a round of experiments does not vary, manually setting the exposure is the way to go. The degree of exposure bias is determined by taking a trial exposure and using the image preview on the camera to evaluate it.

Manual Exposure

Digital SLRs have an automatic exposure control that can vary the f-stop of the lens and the shutter speed of the camera. Either the aperture varies while the shutter speed is held constant (shutter preferred) or the shutter speed varies while the aperture is held constant

Figure 7-9: A useful control for judging correct exposure is the clip detector. When the photosites are saturated with light, the camera indicates that they are overexposed. In this photograph, the red areas, i.e., the regions with no tissue, are overexposed. It is permissible to overexpose them since they do not contain anything of interest.

(aperture preferred). Many cameras have a Program mode in which the camera attempts to adjust both the aperture and shutter speed. This automated setting should be avoided.

The primary control for changing exposure is the shutter speed, not the lens aperture. In microscopy, you set the condenser iris to the value for maximum resolution and optimum contrast and leave it there; it is not used to vary light intensity. With either an SLR or a dedicated digital camera, adjust the shutter speed manually, judging the best exposure by taking advantage of the quantitative information recorded with the image.

There are two tools for this task. The first is the clip detector, which shows the position of fully saturated pixels by either coloring them (red is commonly used) or making them flash between black and white (figure 7-9). In stained slides, the regions without tissue transmit the incident light while the stained tissue absorbs the light. Together, these areas exceed the dynamic range of the camera. The solution is to adjust the exposure so that the saturation signal appears in the clear areas. Correct exposure is obtained just when the signal starts to appear within the areas of interest. Usually the clear areas have no tissue and the failure to record details is of no import. When the clip detector shows overexposure in those areas, it's inconsequential because they are simply empty space. As you increase the exposure, the saturation signal appears in the tissue at the point of correct exposure. With stained specimens, there is plenty of light and the gain of the camera is set to its minimum value to ensure the maximum signal-to-noise ratio.

In contrast, with darkfield and fluorescent illumination, the regions without the tissue are absolute black while the subject is bright. Correct exposure is attained when the pixels are just beginning to become saturated in the brightest regions. With fluorescent illumination, the exposure time is increased until the pixels just reach saturation in a small area of the glowing subject (figure 7-10).

The second tool for adjusting exposure is the histogram display. This is a graphical plot of light intensity (x-axis) against the number of pixels with a specific intensity (y-axis). Its appearance resembles a mountain peak between the minimum and maximum intensity values. An experienced user can determine the degree of under- or overexposure from this display. In moderate underexposure, values are concentrated to the left of the

graph; in moderate overexposure, they are concentrated to the right. In extreme underexposure, all the pixels will have an intensity value of 0, and there will be a single line on the extreme left of the graph. In extreme overexposure, all the pixels will have an intensity value of 255, with the data clustered on the extreme right of the graph. This display is limited in that it does not show where the areas of under- or overexposure are occurring.

As mentioned earlier, in brightfield work, the areas without a specimen are purposely overexposed to ensure the proper exposure of the denser tissue regions. In a histogram, this would appear as a cluster of intensities at the far right of the graph. In contrast, the clip detector would show only the regions lacking material as overexposed. When used together, the histogram and the clip detector accurately measure a monochrome camera's output and provide accurate exposure control.

The histogram and clip detector also work with color cameras. However, color imaging provides an additional detail of complexity in that these two tools must measure an intensity channel for each color (red, green, and blue). Unless there is a triple display, the output will be either an average of all three color channels or a measurement of only one channel. This can result in the color balance changing as a function of exposure.

For example, if the clip detector or the histogram takes information from the green channel, exposing for that channel may cause the signal from the red channel to be overexposed. This will result in a color shift. The best histogram displays show the color variation for all three channels. However, the clip detector may only show one channel, and you should keep that in mind to avoid color shifts.

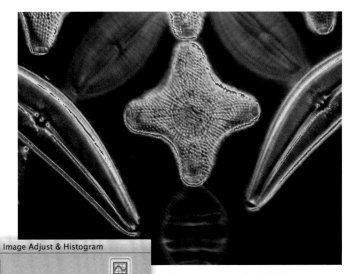

Figure 7-10: In darkfield images where the specimen glows against a black background, the clip detector should be used. In this photograph of a diatom, the central diatom has its border overexposed. The rim of the diatom on the bottom left is severely overexposed, and the photographer should reduce the light intensity. Beneath the picture of the diatom is a histogram of its intensities profile. Three colored lines show the intensity distribution of the green, blue, and red sensors of the color camera. This distribution represents the correct exposure for the image above—the peaks are within the frame of the graph and their base is just approaching its right border. If a longer exposure or more light was used, the graphs would abut the right border. The clip detector shows that some of the pixels are being overexposed, but the percentage is low and it is not seen in the histogram plot. For images of this type, the clip detector provides a more sensitive indicator of overexposure.

8 Improving the Image

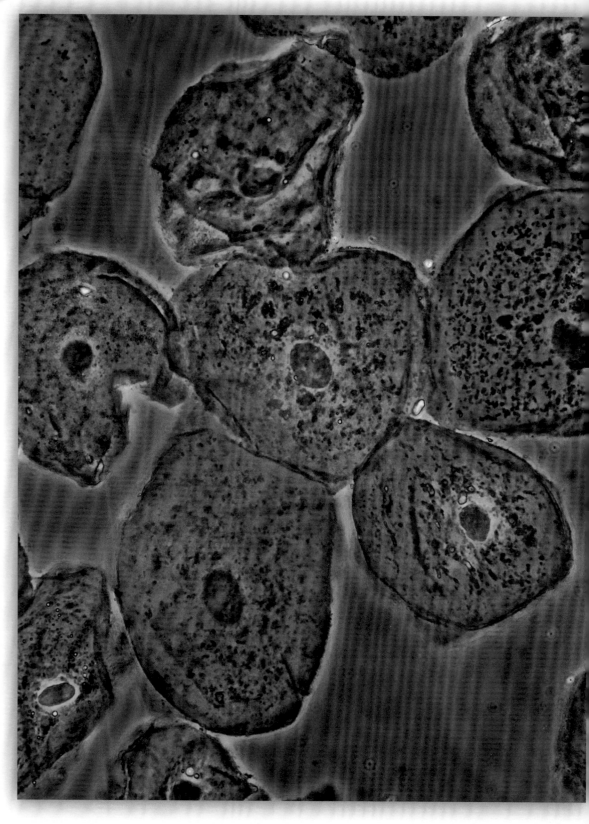

Introduction

The previous chapters describe using the microscope and camera with transmitted light illumination. It is assumed that the subjects have good contrast; however, such ideal conditions may not be available. Frequently, biological samples in their native state are transparent and virtually invisible when light passes through them. Photographs of such objects can be disappointing since the low-contrast image may not reveal fine details that can be discerned through the eyepiece.

Even if the samples are stained, there can be problems with contrast. Colors may appear anemic and washed out if the tissues are not fully stained. Also, the stains in older preparations can fade with time, and such images can fail to convey differences in staining intensity.

Generally speaking, the question is one of visibility. Strategies for enhancing visibility in the microscope fall into two general classes. The first is physical or optical, producing heightened contrast when the specimen is viewed through the oculars. The second is computational, altering the captured image so that its final appearance is improved. These two approaches are not mutually exclusive. You can use both; ideally, try the physical/optical strategy first and then improve upon it with image processing.

Coverglass Thickness and Contrast

A thin glass cover, or coverglass, is used to view most material under a microscope. If the coverglass is too thick or thin, the image will be blurred and lack contrast. This has been described in chapter 2, but the subject will be repeated here with the aim of providing ways to improve the photograph.

The easiest solution is preventative: always prepare the sample so that the coverglass thickness is 0.17 mm. Many investigators do not realize that microscopes are designed to work optimally with a coverglass of this thickness. A comparison of two images shows

The primary constituent of living cells is water with a small addition of proteins and salts. In older biology texts, cells were described as minute bags of water—and while this antiquated view is both inaccurate and incomplete, it does serve to remind the reader that a photograph of cells would be unimpressive. There is virtually no visible structure due to their transparency. To show the living cells, complex special illuminating techniques are required. This is a micrograph of cheek cells from the inner lining of the mouth photographed with such a specialized illuminating technique, phase contrast. Without phase contrast, there would be no contrast and little visible structure. With phase contrast, the interior of the cells show a number of fine granules and the large, circular-shaped nucleus is visible.

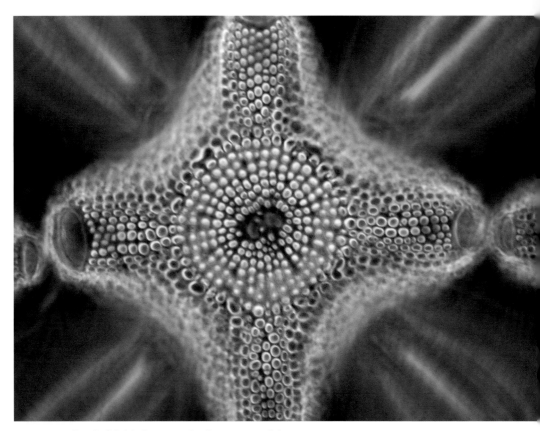

Figure 8-1: This darkfield photograph of an arranged diatom set was photographed with an objective correctly adjusted for coverglass thickness. The image has good contrast with an excellent darkfield that accentuates the brightness of the diatom.

Coverglass #	Thickness (in mm)
No.0	0.08–0.12 mm
No.1	0.13–0.17 mm
No.1.5	0.16–0.19 mm
No.2	0.19–0.23 mm
No.3	0.28–0.32 mm
No.4	0.38–0.42 mm
No.5	0.50–0.60 mm

how incorrect coverglass thickness reduces contrast and image definition (figure 8-1, figure 8-2). Coverglasses are sold in a variety of thickness and sized in arbitrary classes.

From the table, you can see that the majority of No. 1 coverglasses will be too thin, while all of the No. 2 coverglasses will be too thick. No. 1.5 coverglasses have the highest proportion of 0.17 mm. Demanding workers measure coverglass thickness with a micrometer, using only those of the correct thickness. Of course, the benefits of this exercise can be lost

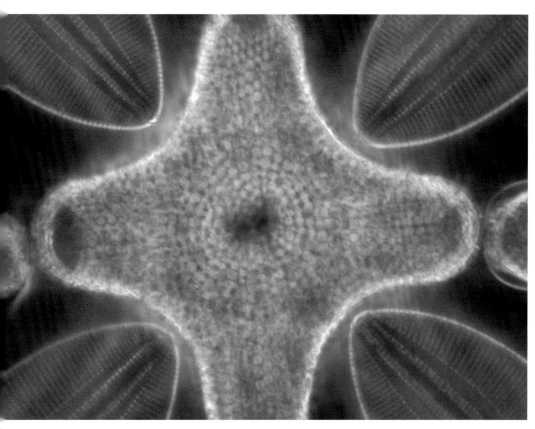

Figure 8-2: This is the same preparation shown in Figure 8-1, but with the coverglass thickness set incorrectly. Incorrect coverglass thickness degrades contrast and resolution. The circular apertures in the diatom are barely distinguishable, and the area between them is not black, but gray. The loss in resolution and contrast is characteristic of incorrect coverglass thickness.

by sloppy preparative technique. For example, applying too much mounting medium forms a film that separates the coverglass from the specimen—the equivalent of using a coverglass that's too thick.

One preparation technique that results in blurry photographs is the failure to apply any coverglass to the specimen. This is practiced in some laboratories that make smear preparations, e.g., when blood is drawn across a slide's surface so that it makes a single layer of cells. Typically, these preparations are stained, dried, and viewed using an oil immersion objective without a coverglass. This is acceptable with an oil immersion objective; however, with a 40x dry objective, the absence of a coverglass blurs the image and renders it unusable for publication. To improve the image, simply slide a coverglass over the smear (figures 8-3 and 8-4). Even though it's

Figure 8-3: This is a blood smear from a cat suffering from feline leukemia. Typically, this slide would be studied with an oil immersion objective; however, I have photographed it with a dry 40x objective. Without a coverglass, the image appears blurred and lacks contrast.

free-floating, the coverglass will not fall off the slide when it is on a horizontal stage.

This example serves to illustrate another point. Oil immersion objectives are insensitive to coverglass thickness, especially if the mounting medium consists of Permount or another reagent whose optical property is the same as glass. Using an oil immersion over such a preparation creates an optically homogenous environment. There are no optical changes as light passes from the specimen to the front lens of the objective. Thus, a specimen mounted in Permount and overlaid with a coverglass is optically equivalent to a naked specimen dipped in oil and viewed with an oil immersion lens.

If you suspect the coverglass is too thick or too thin, you can improve the image by using an oil immersion lens instead of a dry lens. If you use a mount with an index of refraction of 1.515, such a lens will be insensitive to variations in coverglass thickness. One caution

Figure 8-4: This is the same area shown in Figure 8-3. All of the conditions are the same, except a coverglass was slid carefully under the objective. Its presence improves the contrast and details of the slide.

with this strategy: oil immersion lenses have short working distances, so it is possible that the specimen cannot be brought into focus if the coverglass plus mounting medium is too thick. Typically, a 40x oil immersion lens has a higher numerical aperture than a dry 40x lens, so the resolution will be better.

The other alternative is to use a dry objective with a coverglass correction collar. This allows you to compensate for variations in coverglass thickness; the collar is found on most dry objectives with a numerical aperture greater than 0.8. These objectives are easy to use. Below is a step-by-step description for setting the collar:

1. Adjust the microscope for Köhler illumination.
2. Rotate the high dry objective lens (e.g., 40x or 60x dry objective).
3. Set the condenser iris so that it fills three-quarters of the aperture of the objective.

Figure 8-5: This is a micrograph of a human epithelial cell mounted on a glass slide. Without staining, the cell has very little contrast; few details can be seen when using a microscope with Köhler illumination.

4. Turn the correction collar so that the index mark is opposite 0.17 mm.
5. Turn the collar so that the index mark is opposite 0.19 mm. The image will go out of focus.
6. Refocus the image and see if it is improved. See if the fine details are more defined and if the contrast is increased.
7. If the image is improved, repeat step 6, increasing the index by 0.02 mm increments. Stop when the image quality degrades.

Note: if the image does not improve after step 6, turn the collar in the opposite direction to smaller values.

Stained Samples

The majority of samples studied by clinicians and medical students are thin preparations stained with dyes that absorb light. Thus, cell and tissues appear dark against a light background. Areas without tissue are usually clear

igure 8-6: This is the same cell as in figure 8-5 with the condenser ris closed to its smallest opening to increase contrast. To further mprove the image, other lighting techniques would be necessary.

nd allow the free passage of light—as such, hose regions are not of interest. Köhler illu-nination is the standard method of lighting hese specimens; if they are stained properly, here is sufficient contrast for easy photogra-ohy. The main concern is to adjust the camera or accurate recording of the sample's colors. This is described as adjusting the white bal-ance. To accomplish this task, adjust the cam-era in a region where there is no sample. This guarantees that the coloration of the specimen will not bias the color of the illuminating light.

If the specimen lacks intense colors and the image appears flat, you can increase contrast by using a black and white camera and making the light monochromatic with colored filters. Even with a digital SLR, this is a valuable strategy. To enhance the contrast of a dyed sample, choose a color that is the complement of the one you are interested in.

Examples of how colored filters can influ-ence the tone of an image are found in chapter 7 (figures 7-4 through 7-8). However, colored filters can be even more valuable if the sample is colored by a simple regime using only one

color. For example, in electron microscope laboratories, tissues are routinely stained with toluidine blue, a dye that colors tissues in various shades of blue. If a section is too thin, it may not take up enough dye to provide sufficient contrast. This deficiency can be remedied easily by photographing the specimen in black and white and using a red filter to impart greater contrast.

Unstained Samples

On occasion, the microscope may be used to study living organisms such as tissue culture cells, free-living protozoa, or small animals that live in pond water or sea water. Many of these organisms are transparent with little intrinsic contrast, so the skilled microscopist must devise a method of illumination to increase definition between structures.

The most immediate control is the condenser iris diaphragm. Typically, the condenser provides a cone of light that fills the objective lens. This is the usual practice with a stained sample that is chemically treated to display a wide range of densities. However, with a transparent cell, the image may disappear from view. In this case, close the condenser iris while looking through the microscope. Contrast will increase; however, do not close the condenser iris to its minimum setting.

There are trade-offs to closing the condenser iris diaphragm. While it increases the definition of the cell's edges, it also causes a loss of resolution. The degree that the condenser needs to be closed down is determined by practice. Some protozoa require very little closure, while a monolayer of flattened cells requires a great deal of closure. With experimentation, you will learn what works well under different circumstances.

To provide higher contrast and resolution when viewing transparent specimens, the microscopist may use lighting techniques that require specialized accessories. These techniques are described in the following section.

Special Illumination Techniques

Introduction

Since closing the condenser iris can result in a loss of resolution, the microscopist may use special illumination techniques to bring out the borders of cells or make their structures stand out against the background. Usually, such techniques involve special equipment and require modification of the microscope. The following illumination techniques are commonly used to increase contrast while maintaining high resolution.

Darkfield Illumination

As the name implies, this type of lighting produces a black background with the subject glowing against it. This effect is achieved by adjusting the microscope so that light from the illuminator does not enter the objective lens directly. This is accomplished by aiming the illuminator at an angle, which causes the light to miss the objective. In the absence of a specimen, the field appears black in the microscope's eyepiece. However, if a specimen lies in the path of the illuminator, its border will cause the light to scatter in all directions and be captured by the objective lens (figures 8-7 and 8-8).

Darkfield illumination requires a modified condenser. However, rather than buying an accessory, you can easily tape a quarter to the

bottom of the condenser to obtain this effect. To understand how this works, first consider a typical condenser with Köhler illumination. It receives a cylinder of light, collects the light, and then projects a cone of light to the objective lens. Normally, the entire cone of light enters the lens. To achieve darkfield, you modify the incoming light to form a hollow cone that radiates upward as it passes through the specimen. If you place an objective lens in this hollow cone, it does not receive direct light from the illuminator. If there is no specimen, then the view through the microscope is dark because there is no direct light entering the microscope. If there is a specimen, it scatters some of the light and appears to glow against a black background (figure 8-9).

Darkfield illumination is excellent for studying small particles, which appear as glowing dots against a black field. Living bacteria are easily visualized with this technique. Protozoa and small free-living animals in fresh water or sea water also lend themselves to this type of illumination.

Apparatus

The simplest and most inexpensive implementation of darkfield illumination is modifying the condenser with an opaque stop to generate a hollow cylinder of light. I have used a quarter to generate darkfield illumination for 10x and 40x objectives. This technique will show pond water organisms, free cells, and bacteria.

To apply this technique, adjust the condenser for Köhler illumination, attach the coin securely to the bottom of the condenser with clear tape, and open the condenser iris to its maximum. Make sure the coin is centered in the condenser opening and that the tape does not touch the lens. This is easy because the bottom lens is recessed so that the coin and tape are well separated from the glass. You may need to play with the height of the condenser to create a true darkfield. Slightly raising or lowering it may result in the sample appearing brighter and the background darker.

Student microscopes are often equipped with simple condensers that are uncorrected for spherical aberration. In other words, light rays passing through the periphery of the lens are not brought to the same focus as light rays passing through the center. Slightly raising or lowering such condensers can compensate for this defect.

Many older microscope stands can be easily modified for darkfield illumination. These scopes often have a swing-out holder for colored filters. Often, metal opaque stops can be purchased to fit in the holder. This allows you to shift immediately from brightfield to darkfield illumination by swinging the filter in or out of the optical path.

Dedicated Darkfield Condensers

For studies that require the most accurate results, you can purchase condensers whose sole function is to provide darkfield illumination. There are two types: dry condensers designed for lenses with an NA of 0.8 or lower and oil immersion condensers designed for lenses with a higher NA. In terms of resolution, dry condensers can resolve structures of 0.7 microns, while oil immersion condensers can resolve structures of 0.3 microns (assuming that one uses light of 550 nm and an objective with an NA of 1.1).

The increased resolving power of oil immersion condensers is attained at the expense of convenience and field of view. Using oil to join the top lens of the condenser to the slide can be messy. It requires cleaning the top

Figure 8-7: This arrangement of diatoms is photographed with brightfield illumination. Areas between the diatoms are bright, and the diatoms are visible because of their darker borders.

lens element whenever the slide is replaced. Frequently, when the slide is scanned, oil contacts the stage and wicks onto its surface, adding to the cleaning routine. Even more annoying is when the oil increases the friction between slide and stage until the slide cannot be moved.

Dedicated Dry Darkfield Condenser

It's a shame that this condenser is not more popular. It provides an excellent image for subjects viewed with a high dry objective lens whose NA is 0.75 or lower. However, its desirability is reduced by its expense. It can be used only for darkfield, and the ease of modifying a

Special Illumination Techniques 115

Figure 8-8: This image shows the same diatoms as in figure 8-7, but with darkfield illumination. Because the illumination does not enter the objective lens, the regions with no specimen are black—hence the term "darkfield". The diatoms scatter the illuminating light, which is collected by the objective lens. The diatoms now appear light against a dark background.

standard condenser for little or no money discourages purchasing such a specialized optic. In some cases, the expense can be justified by its superior performance. When a standard condenser is modified for darkfield work, the front element is immediately beneath the specimen. Any dust or dirt scatters the light and reduces the black background. In contrast, the dedicated darkfield condenser's front element is recessed and not as close to the specimen. Dust on this element has much less effect on the black background.

Dedicated Oil Darkfield Condenser
This condenser provides the highest resolution capability of all the darkfield condensers. Normally, its hollow cone of light has an "inner bore" of 1.2, and the objective lens must have an NA of 1.1 or less. When matched with the right lens, you can detect structures as small as 0.025 microns—a remarkable feat considering that the limit of resolution is only 0.2 microns.

However, not all oil immersion objectives are effective in practice. Many of the best lenses have an NA greater than 1.2. When used with this condenser, the front lens accepts some direct light and destroys the darkfield effect. Fortunately, many of these objectives can be purchased with built-in iris diaphragms that enable you to reduce the NA—for example, you can take a lens with an NA of 1.35 and reduce its NA to 0.8. This iris makes the lens more versatile; you can use it to provide the highest resolution for brightfield, and then stop it down to provide the highest resolution for darkfield.

Fluorescence Microscopy

Introduction
Although the rationale for using fluorescence differs from darkfield microscopy, both techniques record a bright object against a black background. In terms of imaging theory, fluorescence is also similar to darkfield in that the illuminating light is not recorded digitally. Instead, structures are induced to fluorescence—i.e., they glow when struck by light of a specific wavelength. Their emitted light is detected by the eye and recorded by the camera. Typically, a dye is used to generate fluorescence.

Fluorescence microscopy requires a special illuminator and filter. The condenser beneath the stage is not used. Instead, the objective lens concentrates light onto the specimen. The light originates from a special illuminator mounted behind the microscope and aimed toward a semi-silvered mirror just above the objective. This mirror is exquisitely designed to reflect light of one wavelength (illuminating) and transmit light of another, longer wavelength (fluorescent light). A barrier filter ensures that only the fluorescent light passes to the eyepiece or the camera. Any scattered light from the illuminator that hits the specimen is blocked by this filter.

Since the illuminator's light is not imaged by the eye or sensor, the view is black in the absence of a specimen. The only light that is imaged is that which arises from the fluorescent specimen. Because of this, the sample appears to glow against a black background, and photographing it has the same requirements as an image seen by darkfield photography.

Fluorescence Microscopy 117

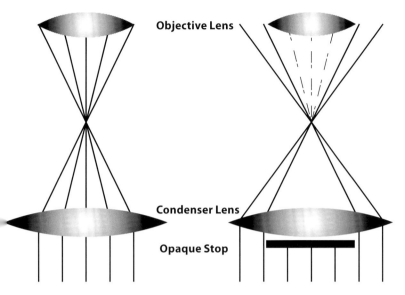

Figure 8-9: This figure compares the light path between transmitted and darkfield condensers. The transmitted light condenser is on the left, and the darkfield condenser is on the right. The solid lines represent light rays passing through the condenser and slide. The dashed lines represent scattered light. Scattered light is generated by the brightfield condenser but cannot be seen because the direct light that passes through the specimen is of much greater intensity. In contrast, if direct light is prevented from entering the objective, then only scattered light can enter it. The absence of direct light enables the microscopist to envisage the sample by scattered light. The darkfield condenser has an opaque stop that prevents light from directly entering the objective lens. This stop must create a hollow cone of light sufficiently large that the front of the objective lens lies in its shadow.

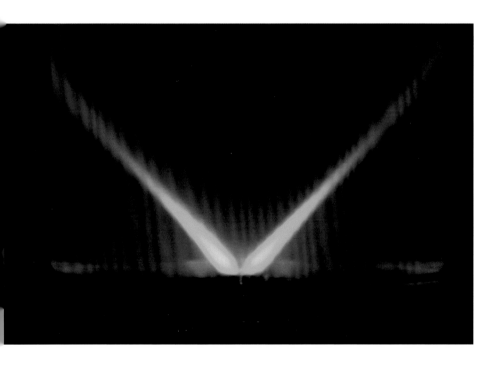

Figure 8-10: A plastic cylinder placed over a microscope slide shows the light rays emanating from a darkfield condenser. Note the dark shadow that lies between the two rays of light. If the front element of the objective lens lies in the dark shadow, you have darkfield illumination. If the light strikes the lens surface, the darkfield effect is lost.

Difficulties of Photographing Fluorescent Specimens

Fluorescent specimens are the dimmest specimens, darker than subjects recorded by either darkfield or brightfield photography. With those imaging strategies, a fraction of a second exposure is typical; in contrast, fluorescent photographs require several seconds. Unlike with most other techniques, it is impossible to shorten the exposure by using a more intense light. You will typically use all the light available from the illuminator. Accurately composing and focusing such dim subjects is a challenge.

The difficulty is compounded by the delicacy of the subjects. With continual illumination, fluorescence will fade. Precise photographic techniques must be used since failure to successfully record the image may mean the loss of the sample. In brightfield and darkfield work, trial exposures can be performed to evaluate the image. This is not an option in fluorescence; adding trial exposures ensures the loss of the sample.

This is one instance where a digital SLR is not always the most effective instrument. Cameras with optical viewfinders may not allow for adequate focusing or composition. For this type of work, a live preview feature is invaluable. When purchasing a digital SLR, consider a live preview screen that can be positioned for viewing by the seated microscopist. Typically, cameras with live preview provide increased gain and enable you to view fainter samples.

For cameras with live preview, I recommend buying software that enables you to operate the camera by a computer. Nikon, Canon, and Olympus cameras have USB ports that can be cabled to a laptop computer. This allows you to adjust the camera's shutter from the computer's keyboard—a more convenient arrangement than adjusting the small buttons and dials on the digital SLR. More importantly, many of these software programs allow live preview to appear on the computer's monitor.

For digital SLRs without live preview, it may be possible to use a Nikon PFM adapter with a telescope eyepiece for focusing and composing the image. This adapter has a clear optical path without an opalescent screen for image projection. Instead, the image is viewed directly with the eyepiece, providing a bright and detailed preview. With the PFM adapter, it is possible to accurately focus the camera for fluorescent work. The Nikon PFM adaptor can be used on Canon and Olympus digital SLRs by buying a third-party adapter for mounting Nikon lenses.

For most photographers, the convenience and control of a dedicated camera justifies its expense over a digital SLR. For example, selecting a camera that is black and white instead of color ensures that more light reaches the sensor. Removing the Bayer mask—the red, green, or blue filters placed over the sensor for color imaging—increases the light available for image capture. This in turn increases the camera's sensitivity, an advantage when imaging a faint sample.

Many dedicated cameras can be purchased with an electronic cooler (Peltier device) that reduces the deleterious effects of thermal noise. These effects become evident when exposures run for several seconds. Moreover, the binning and dual gain controls ensure accurate exposures by allowing you to preview the results of your settings in real time. As a result, you won't need trial exposures to ensure the successful recording of a specimen.

Color Imaging in Fluorescence

When looking through a fluorescent microscope, the microscopist sees a colored image. Typically one hue predominates—red, green, or blue—and it seems logical to use a color camera to record the scene. However, this intuitively obvious strategy is unwarranted and may be counterproductive.

The usual goal in fluorescence microscopy is to visualize a specific dye that glows with a characteristic color so the resultant image is monochromatic. A color camera equipped with the Bayer mask does not efficiently capture such an image since it is designed to record the relative proportion of all three primary colors. To capture a fluorescent image, a black and white (monochrome) camera is more suitable. Such a camera is more sensitive than a color camera and has the additional benefit of higher resolution.

As mentioned earlier, images from a black and white camera can generate color pictures. This is based on coloring the images digitally. For an image with a single dye, the photograph may be colored green to mimic the emission spectrum of fluorescein. However, the value of doing this for one dye is limited, and it provides no more information than showing it as black and white. However, when you have a specimen stained with three dyes, it is possible to show their relative positions by pseudocoloring them red, green, and blue. This generates a full color image. Where the dyes are separate, they have their primary colors; when two dyes occupy the same region, they form a secondary color. For example, if a green dye and red dye occupy one area, that area appears yellow in the pseudocolored image.

Such photographs do not represent a single color exposure but rather the combination of two or three black and white images. Each exposure is for one dye, and that dye is assigned a color in the final print. Customarily, colors are assigned to mimic the hue that the dye is fluorescing; however, this is not necessary.

Contrast by Phase Differences

Introduction

Many biological structures have no intrinsic contrast. They are clear and difficult to see against a bright background. Staining, as mentioned earlier in this chapter, is one method of increasing the specimen's ability to absorb light; however, this is deleterious to living organisms since the dyes are toxic. Safer ways to create contrast, sometimes referred as optical staining, require special optical accessories.

Light is slowed by the transparent structures of cells and thrown out of phase in comparison to the light that traverses outside them. These phase changes are invisible to the naked eye. However, by altering the microscope optics, it is possible to visualize their effects. This is accomplished by two imaging techniques: phase contrast and differential interference contrast. Both require the acquisition of a new condenser, and phase contrast also requires special objectives.

The main disadvantage of these techniques is the increase in expense over a standard microscope. However, for viewing live cells or studying free-living animals, they generate high contrast while maintaining resolution. Once the microscope is modified, it can still be used for traditional brightfield observation of stained samples.

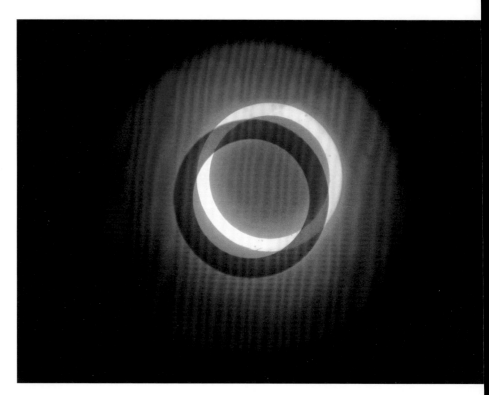

Figure 8-11: This photograph through a phase centering telescope shows the back focal plane of the objective and the phase rings. The bright circle of light from the condenser annulus is the direct light from the illuminator. The dark ring is from the phase plate in the objective. In this photograph, the rings are offset. The phase centering telescope magnifies the image of the phase rings and annulus to facilitate their alignment.

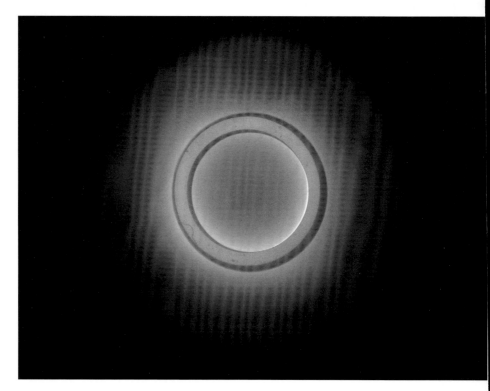

Figure 8-12: This photograph shows the condenser annulus aligned to the phase plate of the objective lens. All phase condensers have centering screws for aligning these two rings.

Phase Contrast

Phase contrast, developed by Frits Zernike, is a technique that provides high-contrast images of cells and living organisms. If a microscope has interchangeable condensers, it almost certainly can be adapted to phase contrast with a phase condenser and a set of phase objectives. These objectives are modified for phase work, but they can also be used for brightfield or darkfield illumination. Thus, a microscope outfitted for phase contrast is a versatile photographic instrument that can image a variety of specimens using several techniques. For brightfield work, phase objectives may have reduced contrast; however, this reduction in performance is not significant.

Phase condensers have an annulus, an opaque disk with a ring-shaped opening that generates a hollow cone of light similar to a darkfield condenser. However, there is one very important difference. In darkfield, direct light does not enter the objective, so in the absence of a specimen the field is completely black. In phase contrast, the cone of light is collected by the objective, so the field appears light whether a specimen is present or absent. The purpose of this design is to separate the direct light from the illuminator and the scattered light generated by the specimen (figures 8-11 and 8-12).

In the case of darkfield, the separation is absolute; since no direct light enters the objective, only diffracted or scattered light is used in image formation. When you remove the eyepiece, you see the back of the objective lens. If there is a specimen in the light path, the scattered light partially illuminates the back of the lens. Image formation is based entirely on this scattered light.

In contrast to the darkfield condenser, the phase condenser only partially segregates the direct light from the scattered light. The direct light is spatially restricted to a ring that can be seen when you remove the eyepiece and peer down the tube. The area surrounding this ring collects all the scattered light. The segregation between scattered and direct light is not complete since the annular region where direct light passes must also contain some of the scattered light.

The rationale for separating the light is to permit the optical designer to alter the scattered light as well as the direct light. This is based on Abbe's diffraction theory of image formation and the wave characteristics of light. Abbe postulated that image formation requires the interaction of light rays between direct and scattered light. This is shown by viewing a grating with the microscope and using a narrow parallel ray of light. By pulling out the eyepiece, you see a bright spot (the direct light) and the first and second order diffraction spots. The latter result from wave interaction between direct and scattered light.

With wave theory, you have constructive interference when two waves are in phase—i.e., when the peaks and troughs coincide. The height of the peaks and troughs adds up so that the peaks are higher and the troughs are deeper. This results in constructive interference and the spots appear bright. Conversely, if the waves are one-half wavelength out of phase, a trough coincides with the peak of another wave and the effects cancel out. The reduction in peaks and troughs results in diminished light intensity, an example of destructive interference. Abbe's experiment indicated that to achieve interaction between direct and scattered light through the eyepiece, the rays must be out of phase by one-half wavelength.

When light passes through a transparent specimen, the scattered light is only out of phase by one-quarter wavelength. The image has no contrast. If, however, you take this scattered light and increase its phase offset to one-half wavelength, you can generate a high-contrast image. Altering the phase difference between direct and scattered light is the basis of phase contrast. To accomplish this end, the phase objective has a plate with an annulus matched to the ring of light you see when the eyepiece is removed. The plate is a disc with a groove inscribed in the annulus. Depending on the depth of the groove, you can alter the phase relationship between the direct light and the scattered light. The greater thickness of the plate surrounding the groove imparts an additional phase shift to the diffracted light, and this results in a positive phase image—i.e., the cell in the medium appears darker than the medium. Optical designers can further alter the phase relationship. Instead of inscribing a groove in the plate, they can build up a ridge that is higher than the plate. This alters the phase relationship—but in this case it results in a reversal in contrast so that the phase image is brighter than the background.

The phase objective annulus has a coating that serves as a neutral density filter. It reduces the intensity of the direct light passing through the specimen and prevents it from overwhelming the surrounding scattered light. Correct matching of the objective and the condenser annulus is critical for generating good contrast with this equipment (figure 8-12). Theoretically, you can pull out the eyepiece and align the phase annulus to the objective's phase plate with special centering screws. However, the rings may appear too small to center accurately. To amplify this image, a phase centering telescope is used in place of the eyepiece to provide a magnified view of the back of the objective lens. Then you can easily center the phase annulus to the ring in the objective. This accessory is used in place of the eyepiece; once the rings are aligned, the telescope is removed and the eyepiece is replaced.

To image with phase contrast, you need the following:
- Objectives modified with phase plates
- Phase contrast condenser
- Phase centering telescope

The increased contrast obtained by a phase contrast microscope is striking. Figure 8-13 shows an epithelial cell photographed in phase contrast. Compared to the same cell photographed in brightfield (figures 8-5 and 8-6), the improvement in the image is dramatic.

When buying a microscope, you can add phase contrast accessories for a modest investment. Phase objectives can be used for regular brightfield and darkfield work, and their cost is only slightly higher than non-phase objectives. The major expense is the phase contrast condenser. Since the phase rings are matched to different objectives, the condenser typically has a large disc that contains several annuli. For example, the older Zeiss Oberkochen phase contrast system has three different annuli: the smallest is for the 10x objective, the next largest is for objectives with an NA between 0.4 and 0.8 (generally 16x, 25x, and 40x objectives), and the third is for objectives with an NA greater than 0.9 (40x, 63x, and 100x oil immersion objectives). The smallest annulus is unnecessary for investigators who dispense with the 10x objective and use the 16x for phase contrast work.

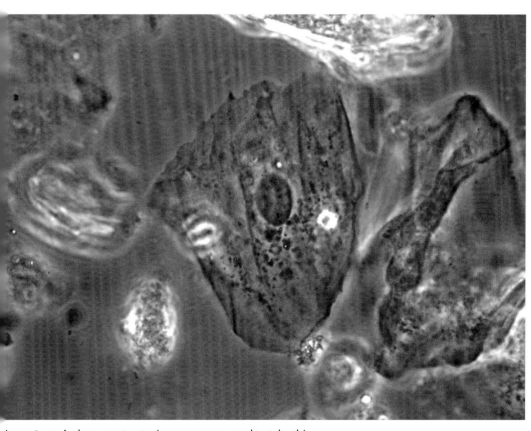

Figure 8-13: A phase contrast microscope was used to take this image of an epithelial cell. This is the same cell that appears in figures 8-5 and 8-6. Here, the improvement in contrast and definition is dramatic.

You can adjust contrast by altering the index of refraction of the medium. If you have a specimen that can be mounted in different mediums, the contrast can be enhanced or reduced depending on the medium. Another way to control contrast is by selecting objectives with special phase plates. This was a popular option with older microscope designs; American Optical microscopes had an extensive series of these objectives. Today, the selection of phase plates for adjusting contrast is much more limited.

Typically, modern microscopes are equipped with positive phase objectives so when a cell is observed, it appears darker than the surrounding medium (figure 8-14). You can purchase a negative phase contrast objective that reverses the contrast so the cell appears brighter than the medium (figure 8-15). Positive contrast provides a view that is more typical and easier to interpret. Negative contrast is more suited for counting where individual cells stand out and are readily identified.

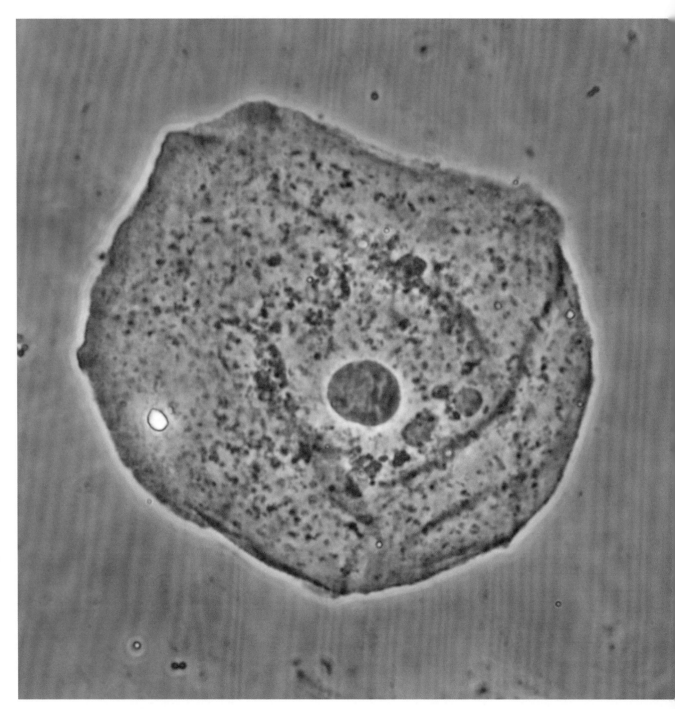

Figure 8-14: By choosing the appropriate phase objective, the microscopist can control the appearance of the cell. Typically, negative phase contrast produces an image in which the organelles appear dark against the background. This micrograph was taken with a negative phase objective—note the dark circular nucleus in the center of the cell. Surrounding the periphery of the cell is a bright rim; this is the phase halo.

Contrast by Phase Differences 125

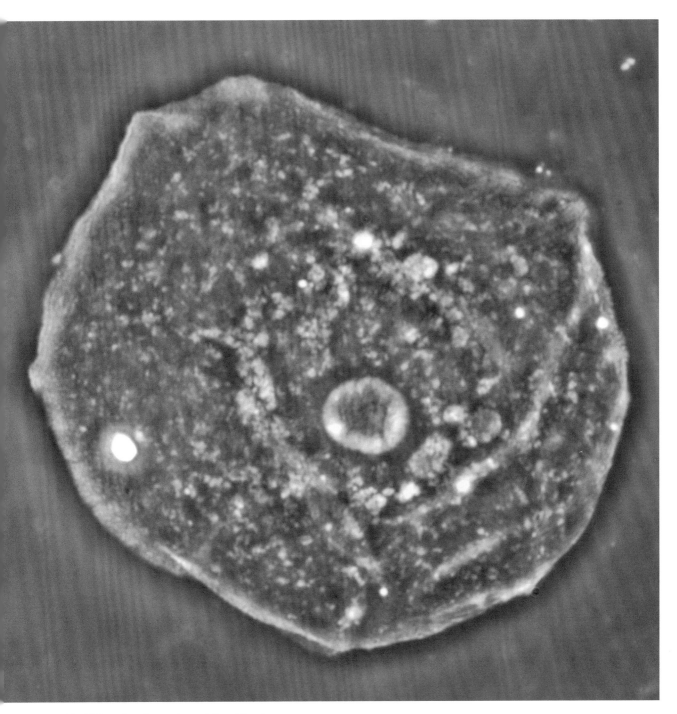

Figure 8-15: Modifying the phase plate of the objective reverses the contrast observed by the microscopist. In this case, positive phase contrast shows the circular nucleus as bright against the brown background.

The phase contrast microscope is a versatile photographic tool providing a variety of illumination techniques. The large phase annuli can be used for darkfield work with low-power objectives. The condenser also has an iris used for brightfield work, and of course there are the phase annuli for phase contrast. Thus, with one stand, you can photograph images with darkfield, brightfield, and phase contrast. Admittedly, the objectives with phase plates may suffer from a loss of contrast when used for brightfield work, and the darkfield is only usable for low-power work. Nonetheless, the stand is eminently useful as a photographic tool.

The Phase Contrast Image

Phase contrast images have an appearance that is easily interpreted by those who are used to looking at stained samples. Objects display variations in intensity and increased contrast. However, artifacts can result from a phase image, the most common being the phase halo. In positive phase images, there may be a peripheral bright region that obscures fine details at the border of an object. In negative phase images, this halo appears dark.

Differential Interference Contrast (DIC) Microscopy

Differential Interference Contrast (DIC) microscopy uses phase differences to generate contrast. It is a more recent development than phase contrast, and it is easier to find the accessories necessary for this form of illumination with modern microscopes. Older microscopes made in the 1950s or 1960s may not have these accessories. Finding proper DIC accessories for older, discontinued microscopes can be a challenge. Among the four major microscope manufacturers (Leica, Zeiss, Nikon, and Olympus), the top research grade microscopes come equipped with DIC optics for imaging live cells. Advantages include the ability to alter contrast and to provide views of thick specimens. The disadvantage is the expense.

There is a tendency among new microscope users to view DIC as a replacement for phase contrast, but this is not the case. Phase contrast and DIC are complementary illumination techniques; depending on the specimen, one may be more appropriate than the other for displaying fine details (figures 8-16 and 8-17).

The components of a DIC system include a polarizing filter for the condenser and a Wollaston prism for each objective lens. Above the objectives is another Wollaston prism used for adjusting the degree of contrast.

The DIC system generates image contrast with a polarized light, enabling the Wollaston prism to split the light into two beams; the beams are slightly displaced from one another (less than the resolution limit of the objective) so you don't see a double image. The two beams illuminate the specimen and are affected by its structures. They are recombined by a second Wollaston prism to generate contrast. The prism can usually be shifted laterally to change the contrast of the observed image. Generally, the highest-contrast image appears in shades of gray; however, by using a more extreme setting, you can generate a beautifully colored image.

Phase Contrast versus DIC Imaging

These two imaging modalities generate dramatically different results. Perhaps the easiest way to appreciate this is to compare

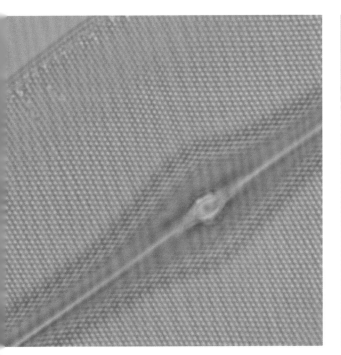

Figure 8-16: This image of a diatom photographed in brightfield shows the apertures in its shell. The apertures appear as lighter circular spots. The diagonal linear structure appears to have a dark border.

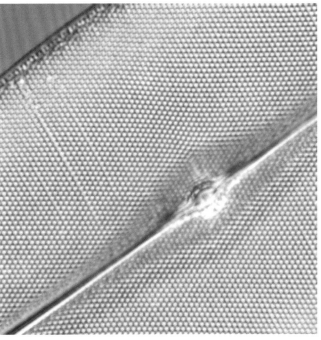

Figure 8-17: This image of a diatom photographed in DIC shows brighter apertures than the image in figure 8-16. The diagonal linear structure has a three-dimensional appearance, with the upper border appearing dark and the lower border appearing light.

a micrograph of a cell photographed with each (figures 8-18 and 8-19). By studying the smaller granules within the cells, the predominant difference between phase contrast and DIC is revealed. In phase contrast, the particles appear dark surrounded by a bright halo. In contrast, there is no halo with DIC; instead, the image has sharp borders with a three-dimensional appearance. One side appears light while the opposite side is dark. This gives a heightened sense of contrast and makes small objects stand out.

A comparison of brightfield with these two techniques shows that both phase contrast and DIC generate a much higher-contrast view with more detail. In the case of phase contrast, the nucleus is dark and elliptical, and its periphery has a bright border. With DIC illumination, the nucleus does not appear as a darkened ellipsoid; rather, it has an artificial, three-dimensional appearance. At the periphery, there is a bright edge on one side and a darkened shadow on the opposite side. In terms of the composition of the nucleus, there is no difference between one side and the other.

Determining which method of illumination to use depends on several factors. To obtain

the highest degree of resolution possible, the preferred technique is DIC with an oil immersion condenser. DIC is extremely sensitive for observing fine structures. It can provide sufficient contrast to detect objects smaller than the resolving power of the microscope. DIC has been used to visualize single microtubules—protein polymers that are 0.025 microns in width, or almost one-tenth the limiting resolution of the microscope. Moreover, DIC is amenable to computer-generated contrast enhancement. This provides even more sensitivity in detecting minute objects.

In most laboratories, DIC is viewed as the standard means of studying living cells. Its disadvantage is the expense. It is necessary to purchase a specialized condenser. In addition, a Wollaston prism must be purchased for use above the objective lens. Some manufacturers require only one prism for all the objectives. Other companies require the purchase of individual prisms for each objective. Overall, DIC is a much more expensive technique than phase contrast.

Phase contrast does not have the fine resolving power of DIC. Nonetheless, it provides high-contrast images that enable the study of cell organelles. The major problem with phase contrast is the halo artifact that can obscure fine details. For work with plastic culture dishes, the phase contrast system will generate a high-contrast image while DIC will fail. This is because the plastic depolarizes light, and contrast cannot be generated without polarized light.

Photographing Phase and DIC Specimens

Virtually any digital camera can easily record images produced by phase contrast and DIC illumination. Unlike darkfield or fluorescence, the background lighting does not overwhelm the light meter, allowing automatic exposure to easily record the images. The major concern for DIC images is that increasing contrast may cause the highlights to become overexposed. Generally, the contrast selected for visual observation is not the one that should be used for photography. It will take some trial exposures to determine the correct contrast to use for image capture. In this case, the highlight indicators are useful tools.

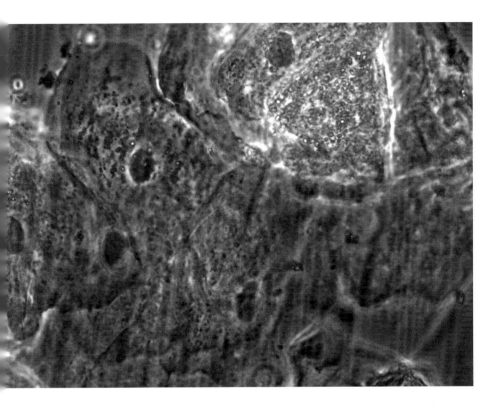

Figure 8-18: Human epithelial cells photographed with a phase contrast microscope. The cells are shown in high contrast, but the upper-right corner is so bright that details are not easily seen.

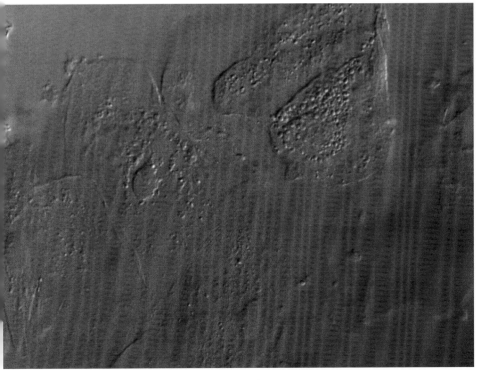

Figure 8-19: Human epithelial cells photographed with a Nomarski DIC microscope. These are the same cells shown in figure 8-18. Notice the region in the upper-right corner. It is easy to see details in this region, which illustrates how DIC can provide usable images in situations where phase contrast cannot. The nuclei in this image have a three-dimensional appearance. In comparison, the nuclei viewed in phase contrast appear as dark circles.

Improving the Image with Software

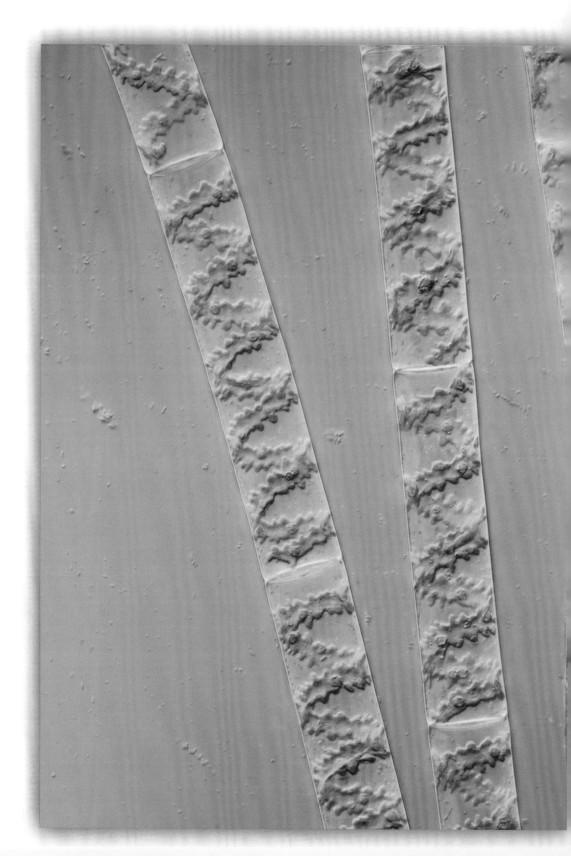

Introduction

The preceding chapters describe how to capture an image and how to use different illumination schemes to improve a specimen's contrast. However, details that appear obvious in the eyepiece may not be evident when the image is recorded. In addition, individuals who are unfamiliar with the subject may have difficulty observing subtle details or fine variations in intensity. In order to enhance the image's features and bring out the fine details, it is often necessary to use image processing software. Typically this requires increasing the contrast to provide definition and depth. This can be accomplished easily with almost any image processing software program, and you should be familiar with some of the most basic operations.

File Formats

Digital images are saved to the computer as files that can subsequently be used for analysis and image processing. There are different file formats to chose from, each with different benefits and uses. How you save a file can affect the quality of the image. With images used for either analysis or printing, it is best to select a file format that does not alter the image. This is especially important for archival purposes. Depending on the camera's sensors, these files can be 20 to 40 megabytes in size—too large to be sent as email attachments. Email attachments require a smaller file size, which results in a loss of image fidelity.

For archival purposes, use TIF or TIFF (Tagged Image File Format) format to ensure that the data is preserved accurately. TIF files are an example of a lossless file format—meaning data is not altered when the file is saved or opened. If the file needs to be sent as an email attachment, use JPG or JPEG (Joint

In pond water, algae are abundant and this genera is called *Spirogyra*, a reference to the spirally wound green chloroplasts within the cylindrical walls of its cells. When photographed with a 40x objective and a 1.25x eyepiece, a single micrograph cannot capture this spiral pattern because of the lens-limited depth of field. To reveal the spiral nature of this cell, image processing is needed. This micrograph is actually the summation of 20 images. Individual photographs were taken at different focal planes and combined to generate an image with an increased depth of field. To enhance the contrast of these cells, an illumination technique known as differential interference contrast is used. This type of illumination does not generate halos and provides a set of precise optical sections that can be used by image processing programs to extend the microscope's depth of field.

Photographic Experts Group) format, which produces a smaller file size. JPG files show a loss of fine detail and gradations in intensity, which is nevertheless acceptable to most users. JPG is an example of a lossy format in that information is altered when the file is saved.

Virtually all software programs recognize TIF files. They can be saved in 16-bit format, which provides the potential of saving files with 65,536 intensity levels. Quantitatively, the intensity levels are expressed with greater numerical precision than with JPG files, which are saved in an 8-bit format that allows for only 256 gray levels, making the file size smaller. Again, in terms of numerical precision, you have fewer numbers to work with in JPG format. This proves to be a limitation when the file requires extensive image processing.

Frequently, photomicrogaphers using digital SLRs cannot save their files in TIF format. More and more of these cameras offer the choice of saving files in either RAW or JPG formats. In this case, RAW is preferred for archival purposes because it has a 12- or 14-bit format, depending on the manufacturer. In most cameras, RAW format provides minimal alteration of the digital data, and some have the option of compressing the file in a lossy or lossless format. For scientific work, it is preferable to save in a lossless format.

Unfortunately, these formats are proprietary and may not be recognized universally. For example, an older version of Adobe Photoshop may not open RAW files from newer digital SLRs. To maintain compatibility with newer camera models, you will need to upgrade your software to ensure that it can open the files directly. If this route is impractical, you can convert the files to a format known as DNG (Digital Negative). This readily available format can archive RAW files from a variety of camera manufacturers. Adobe provides a free translation program for both Macintosh and PC computers that converts most digital SLR formats to DNG. Other programs that read DNG format include Apple Aperture and the freeware programs GIMP and IrfanView.

Improving the Image

If care is taken in adjusting the microscope and camera, it should be unnecessary to adjust the image's white balance. Adjusting this after the picture is taken is an unnecessary step, and for studies requiring collecting hundreds of images, it is more efficient to make sure that the camera and microscope are properly adjusted first.

That said, it may be necessary at times to correct an image's color balance. If you use a digital SLR and save the image in RAW format, you can adjust the white balance with either Adobe Bridge or the program supplied by the camera manufacturer. Adobe Bridge provides several ways to alter the white balance. The simplest is to use the white balance for transmitted light illumination. When activated, this tool presents an eyedropper icon than can be moved about the screen. Positioning it over a neutral area (without color) removes the colorcast caused by incorrect white balance. The problem is finding that neutral area. If you have a slide stained with several colors, the specimen cannot be used; the only area that would be neutral is the clear area without the specimen.

Another way to adjust the white balance is to use the color temperature slider. In figure

Improving the Image 133

Figure 9-1: This screen shot of Adobe Bridge shows the controls for adjusting white balance. At the top of the screen is the icon of an eyedropper. When this is selected, the eyedropper appears over the image, and it can be positioned to a region of the slide where there is no specimen. This adjusts the white balance so that the orange tinge is removed. On the right side of the screen is the White Balance menu with the As Shot option selected. This indicates that the image is displayed with the white balance setting that had been used by the camera. This can be overridden by selecting, with a drop-down menu, various items, such as Daylight, for adjusting color balance. Finally, the slider control labeled Temperature allows you to set the color temperature to various values; here, it is set to 6800 degrees.

134 Chapter 9

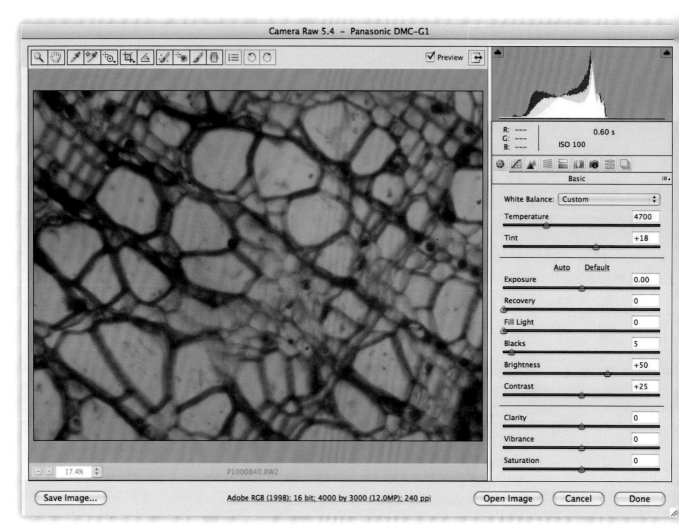

Figure 9-2: A screen shot of Adobe Bridge after adjusting white balance. I made the adjustment by moving the Temperature slider; to my eye, a setting of 4700 degrees provides the best correction for color balance.

Figure 9-3: This is the color balance menu in Adobe Photoshop. The slider adjusts the relative contributions of the red, green, and blue channels. You can adjust the color balance of an image in TIF or JPG format.

9-1, you can see the preview screen for an orange-tinged image and the slider control for adjusting white balance. In the figure 9-2, you can see the effects of moving the slider control from 6800 K to 4700 K. From the preview screen of my computer, this appeared to be the correct white balance.

There is a third option for adjusting white balance: a drop-down menu that allows you to select different light sources such as daylight, electronic flash, artificial lighting, and shadows. These are set values of color balance; you can duplicate their settings by using the slider control. For example, the Daylight setting is equivalent to setting the color temperature to 55000 K with the slider. I do not recommend using the drop-down menu. Generally, it is more advantageous to use the slider control because of its greater versatility.

This is because the microscopist is the usual source of colorcasts. Typically they occur when you vary the voltage to the bulb to adjust its intensity. Using a high voltage brightens the light source and tinges it with blue, while lowering the voltage dims the light source and shifts its tones to red. Since colorcasts can vary widely, a single white balance setting usually does not work; instead, you will need to fiddle with the temperature slider for each new image. For varying light intensity, the knowledgable worker sets his illuminator to run at a constant voltage and uses neutral density filters to attentuate the light. This varies the intensity of the illuminator without altering its color balance.

These convenient tools for RAW images are unavailable for images stored as TIFs or JPGs. In Photoshop and other image processing programs, there are controls for adjusting the relative contribution of the red, green, and blue channels (figure 9-3). These controls allow you to compensate for variations in color temperature. It should be emphasized that much time and effort can be saved if the illuminator is set to operate at one voltage and the camera is white balanced to that light. Post-processing adjustments can be avoided by a few moments taken to preset the microscope and camera.

Enhancing Contrast in the Micrograph

Many micrographs suffer from a lack of contrast—a common situation because living cells and unstained specimens are transparent, with no areas that are deep black or brilliant white. This is illustrated in figure 9-4 of a diatom photographed with brightfield illumination.

When a RAW file from a digital SLR is opened, there are several controls to adjust the image and improve its appearance. Referring back to figure 9-2, you can see the controls labeled Exposure, Contrast, Brightness, Recovery, and Fill Light in the Bridge program from Adobe. Adjusting these controls allows you to brighten or darken the image, recover intensity variations in highlighted regions, and lighten dark areas to reveal shadows. These adjustments can improve the image by revealing details in both areas that had previously been hidden in the highlights and shadows. Alternately, if the image does not have a wide range of intensities, so that it appears "flat", this can be remedied with the slider labeled Contrast.

Equivalent controls are present in other image processing programs. Although the interface may not be as intuitive, some of them provide a more quantitative sense of what these adjustments perform. For example, there is a control in Photoshop CS4 in

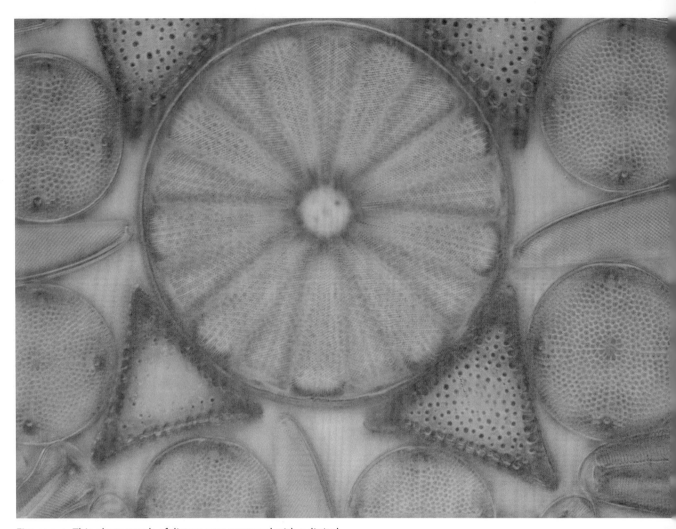

Figure 9-4: This photograph of diatom was captured with a digital SLR using brightfield illumination. The black and white image lacks contrast. It comprises of areas of gray with no region being absolutely black or absolutely white.

Enhancing Contrast in the Micrograph 137

Figure 9-5: A screen shot of the intensity histogram for the diatom in figure 9-4. Graphically, this shows that the histogram (single peaked mountain) does not have any regions that are absolute black (0) or absolute white (255). The lack of contrast is due to failure to use the entire range of intensity levels available for output.

Figure 9-6: To show all the intensity levels for the best effect, move the dark triangle beneath the histogram to the right, from 0 until it just reaches the base of the histogram (71). Then move the light triangle to the left until it just reaches the base of the histogram (214). The lowest intensity value of the image, originally shown as 71, is now displayed as absolute black (0), and the highest intensity value, originally shown as 214, is now displayed as absolute white (255).

the Levels dialog. To reach it, you first select Image, then Adjustments, and finally Levels. The graph in figure 9-5 shows the Levels display divided into two parts. The upper half is labeled Input, while the lower is labeled Output. The former is a graphical representation of the image's light values as a histogram —intensity values (x-axis) plotted against frequency (y-axis). It has the appearance of a mountain with a gradual slope on the left and an abrupt drop on the right. The output levels are placed beneath the histogram and aligned to its x-axis on a gradient bar, black on the left and white on the right.

In this case, the original image is not utilizing the full range of output levels since it does not have any values that correspond to black (0 intensity) or to white (255 intensity). To remedy this, you can grab the triangles under the histogram, sliding the dark triangle to the minimum intensity value and the light triangle to the maximum intensity value. This is seen in figure 9-6. It turns out that the lowest intensity displayed is 71 and the highest is 214. In other words, all of the intensities are grays—there is no region that appears as absolute white or black. To process the image so that it displays a wider range of intensities, it is possible to reassign the intensity values.

Figure 9-7: After readjusting the sliders, the histogram of the new image has this appearance. Notice how all of the intensities captured in the image are now shown, with the lowest displayed as 0 and the highest as 255. In other words, the intensity distribution now spans the entire gamut of output levels.

Figure 9-8: This histogram is from an 8-bit file whose intensity range was expanded as described in figure 9-6. The shape of the histogram is the same, but instead of generating a solid graph, this one has a striped appearance—reflecting the fewer data points present in the 8-bit file.

This is accomplished by translating values of 71 to 0 and values of 214 to 255. Moving the slider controls at the ends of the histogram inward accomplishes this task.

The sliders are repositioned in figure 9-6. This creates a new image with the histogram shown in figure 9-7. This histogram shows that all of the intensity values have been reassigned. The darkest area of the image, which was 71, now has a value of 0; the brightest area, which was 214, now has a value of 255. Intervening intensity values fall between a new range of 0 and 255. Essentially, the intensity values have been "spread out". You can see the effects on the image in figure 9-9. A comparison of this figure to figure 9-4 reveals that the new image has greater contrast. This new image is an improvement in that it is easier to see the details; the full potential of the monitor is used to show all of the intensity differences.

The Levels command also illustrates the advantages of using 12 bits to capture an image versus 8 bits. In figure 9-4, I started with a 12-bit image, and all of the manipulations were done in that file format. In the next set of examples, I employ the same strategy with an 8-bit image. Figure 9-8 is a histogram from an image captured and saved in 8-bit format. The clear areas represent the regions where the data points are spread. In the case of an 8-bit file, there are fewer points to expand—hence the appearance of gaps or stripes. Under extreme conditions, the image does not have enough gray levels to provide a smooth transition of intensities. Instead, the intensities change abruptly.

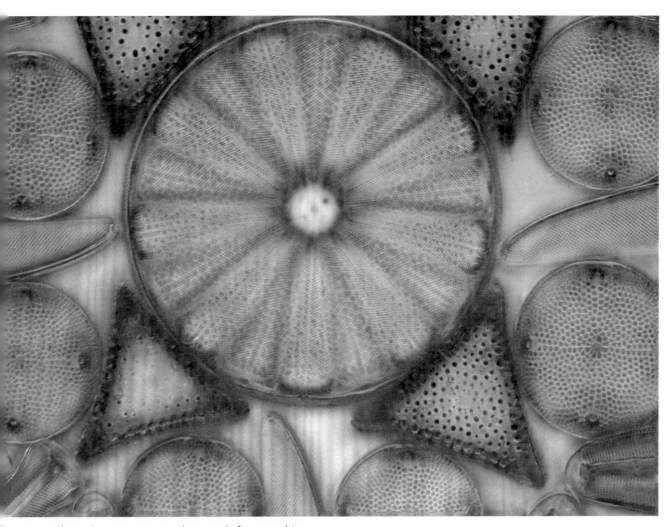

Figure 9-9: This is the new micrograph created after stretching the intensity levels to display absolute black and absolute white. The image has more contrast and impact than the original and represents the improvement that can be made by adjusting the output to the display.

Figure 9-10: A section of kidney stained with the blue fluorescent dye DAPI. This image, taken with a black and white camera, shows the nuclei within the tissue slice.

Color and Fluorescence Microscopy

Earlier I mentioned how a color image can be generated from three black and white images. This procedure is commonly done for fluorescent micrographs taken with three colored filter sets, or cubes. The three dyes used in this technique fluoresce blue, green, or red. Figure 9-10 was photographed with a filter set that makes its emission appear blue; figure 9-11 was photographed with a filter set that makes its emission appear green; and figure 9-12 was photographed with a filter set that makes its emission appear red. Individually, there is little point in coloring these images. The black and white rendition shows the details of the staining pattern adequately. However, if you are interested in showing the relative position

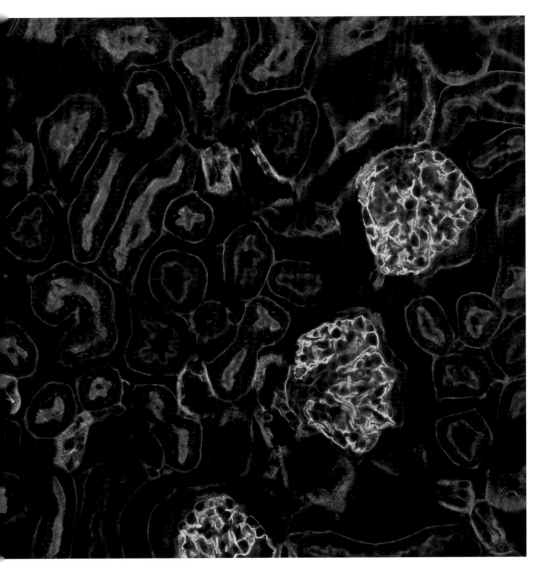

Figure 9-11: The same section of kidney imaged in figure 9-10, but photographed with a filter assembly that reveals only a green fluorescent dye. This photograph was taken with a black and white camera, and the monochrome display accurately reflects the distribution of the green dye.

of each of these three dyes on the slide, you can do so by using the corresponding red, green, and blue channels in digital imaging. By combining the three black and white images, it is possible to localize the relative position of the colored dyes to one another.

A simple method of generating a color image from three black and white images is to open all three in a graphics program and then create a new file with three color channels: red, green, and blue. Using Photoshop, you would open the three black and white files and use the commands Select All, Edit, and Copy on each one. Copy each of the black and white images into a specific color channel in the new file. Dyes that fluoresce blue go in the blue channel, dyes that fluoresce green go in the

Figure 9-12: The same section of kidney imaged in figure 9-10, but photographed with a filter assembly that reveals only a red fluorescent dye. As in the previous two photographs, the black and white display is sufficient for showing the position of a single dye.

Figure 9-13: When you make a new file, the Color Mode menu appears. Note that it automatically displays the Grayscale option. This is a black and white file.

Figure 9-14: This is the menu for a new file for generating a color image. The color mode is shown as RGB color. In this file, there are three color channels—red, green, and blue.

Figure 9-15: This screen shot was generated while creating a color image from black and white files. In this example, two black and white files are copied into channels. One image is copied into the red channel, and the other image copied into the green channel. The blue channel is white—no file has been copied into it. The top file is the RGB display that shows the integration of the colors. In this case, the image appears blue because the blue channel is all white; this channel is the predominant color in the RGB image.

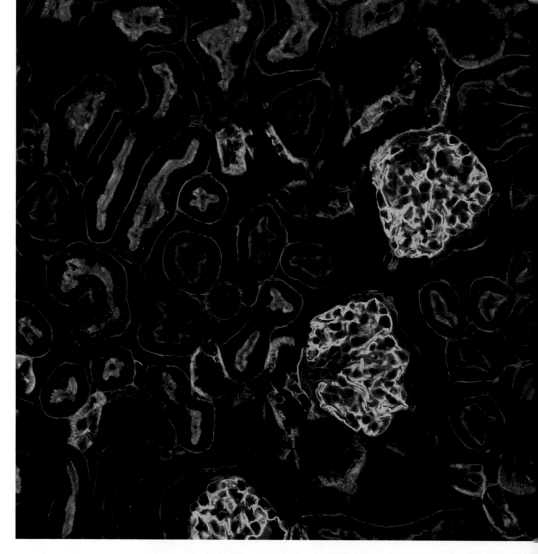

Figure 9-16: A fluorescent color image created by using the red and green channels. In the previous figure, the blue channel overwhelmed the color of the composite channel. To avoid this, the blue channel is made completely black and does not contribute to forming the final image.

green channel, and dyes that fluoresce red go in the red channel.

Make sure that the new file is RGB and that the color mode is properly set. The pixel dimensions of the new file are identical to the black and white files. In figure 9-13, using the File->New command, you can see that the new file is 2048 pixels in width and length and that it is an 8-bit file.

When Color Mode is set to RGB Color, you have the ability to work with three color channels. In figure 9-15, the menu shows that the red and green channels have black and white images. The row with the eye indicates that the large preview screen is displaying the image in

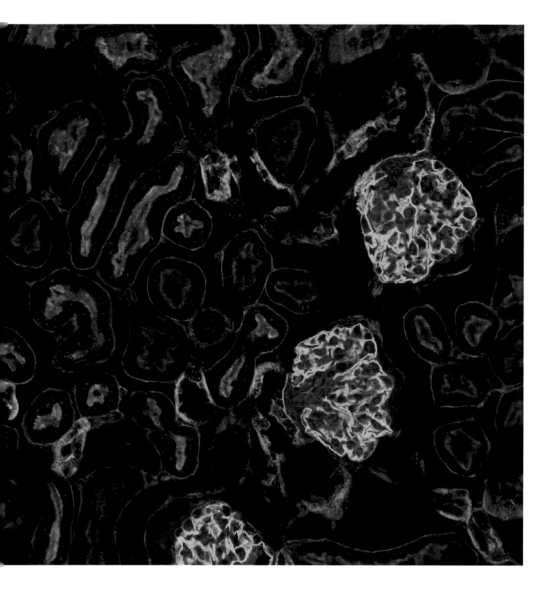

Figure 9-17: A fluorescent color image created by using three black and white images and the red, green, and blue channels.

he red channel. The RGB channel is at the top ow, and its predominant color is blue. This is ecause the blue channel is assigned a value of absolute white so that its contribution to he color image overwhelms the red and green hannels. If you wanted to display just two hannels, the red and green, you would have o assign the blue channel a value that is all black; with 0 intensity value, it would not contribute to the final image.

Figure 9-16 shows the effects of a two-channel image, where images are assigned to the red and green channels and the blue channel has 0 intensity. For a three-color image, all three channels are assigned black and white images. Figure 9-17 shows a photograph of a

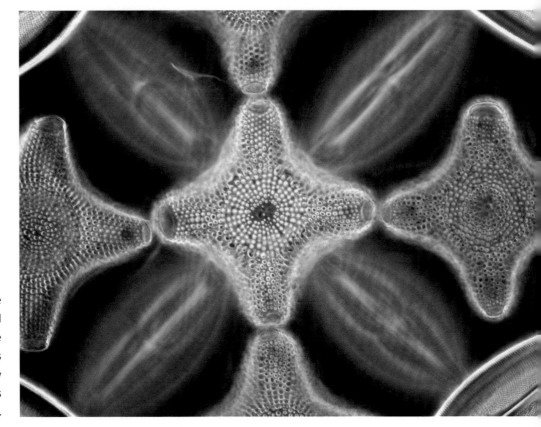

Figure 9-18: One plane of focus of an arranged set of diatoms. The depth of focus is narrow so that only the central diatom is sharply defined.

kidney section stained with three colors: blue for the nucleus, red for certain cellular sugars, and green for a cellular protein.

Extending the Depth of Field

Optical systems have only one plane of focus that is absolutely sharp; regions above and below that plane show a progressive loss of sharpness. In general photography, the drop-off in sharpness is gradual, and for a given lens and distance, a relatively wide zone appears to be sharp. This zone can be controlled by closing down the lens diaphragm and increasing the depth of focus—an advantage in landscape photography for showing vast expanses with fine detail.

However, a narrow depth of focus may be desirable for certain compositions. In portraiture work, the photographer seeks to have the face in focus and renders the background area blurred by throwing them out of focus. This serves to concentrate the viewer's attention on the object of importance, i.e., the face, and reduces the distraction that results from viewing a finely rendered background.

Microscope images have extremely narrow depth of field—i.e., the plane of sharpness is narrow, and areas slightly above and below that plane are out of focus. It can be advantageous to focus the observer's attention on a

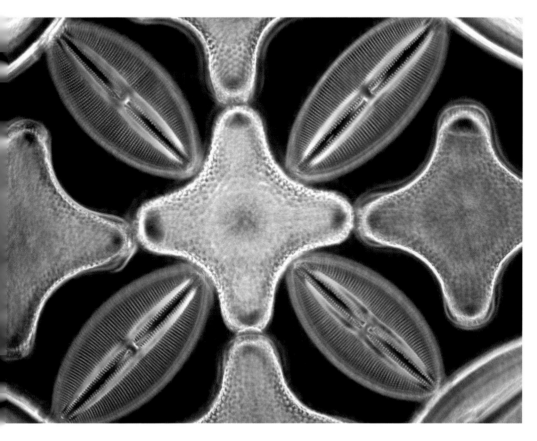

Figure 9-19: A different plane of focus of the arranged diatoms. The diagonally arranged diatoms are now defined; within them, the fine dots aligned in rows are clearly visible, although outside borders are still blurry.

mited region; however, by the same token, it an be disconcerting when large areas of the mage appear blurred. A more uniform appearance of sharpness can be achieved by taking everal images at different focal planes. This is ermed a stack. Each of the images in the stack vill have some areas in sharp focus and other reas that are out of focus. By digitally combining these images, it is possible to form an ntegrated view of the specimen with most of he regions appearing sharp—an image with xtended depth of focus.

For example, figure 9-18 is a darkfield photograph of an arranged set of diatoms that hows the central diatom in good focus; its mall, circular apertures are sharply rendered. However, the diagonally arranged diatoms radiating out from the center are out of focus. Since they lie outside the plane of focus, fine details cannot be seen.

By altering the fine focus, it is possible to sharpen more of the diatoms. Figure 9-19 shows the diagonally arranged diatoms after changing the fine focus. While they are now sharp, the circular apertures in the central diatom are now blurred. When you change the plane of focus further, the extreme edges of the diagonally arranged diatoms become sharp. At this stage, as shown in figure 9-20, only the edges are in focus and all the other fine details are blurred.

Figure 9-20: At this focal plane, most of the fine details in the diatoms are thrown out of focus. The only sharp regions are the peripheries of the diatoms.

Combining the photographs from this stack renders a micrograph that retains all the sharp areas of focus and discards the blurred regions. This is seen in figure 9-21. The overall detail of the subject in three dimensions is rendered in a single two-dimensional photograph with an extended depth of field.

Software programs for combining image stacks are available from a variety of sources. In the professional microscopy field, proprietary programs such as ImagePro and Metamorph have modules that accept stacks of images and combine them for an extended depth of field. These programs have advanced capabilities that integrate image capture and file saving. It is possible to automate a stack of images so that the microscope photograph each plane in turn, with the fine focus automatically advancing in small increments. The camera and computer then store the images that can be processed for extended depth of field. However, the cost of these programs runs in the tens of thousands of dollars, and they are typically purchased by research laboratories.

At no expense, photographers can download the program ImageJ, an open source program developed at the National Institutes of Health. This program runs on a several computer platforms including Windows PC, Mac OS X, and Linux. It can be downloaded at http://rsbweb.nih.gov/ij/index.html. You must also

Figure 9-21: This image shows an extended depth of focus for the diatoms in figures 9-18, 9-19, and 9-20. In the previous figures, out-of-focus regions prevent the viewer from appreciating the fine details in the diatoms. When you digitally combine the images, the fine details emerge.

download the Extended Depth of Field plug-in at http://bigwww.epfl.ch/demo/edf/.

Other downloadable programs are available on the Internet at intermediate cost. I use Helicon Focus with my digital SLRs. Its cost is justified by its simple interface and ease of use. For example, it directly translates RAW files from my digital SLRs and provides a convenient interface for adding or removing pictures from the stack (figure 9-22).

Extending the Dynamic Range of the Camera

The most common problem in photographing biological material is lack of contrast. As mentioned earlier in this chapter, it is necessary to increase the contrast in order to capture a good image. However, under certain conditions of illumination, the contrast may be too high. The range of light intensities between the lightest and dimmest regions is so great that it cannot be recorded with a single exposure. This situation is found in darkfield illumination where larger structures scatter more light than minute structures. When enough light is used to reveal the fine details

Figure 9-22: A screen shot of Helicon Focus, an extended depth of field program. The center shot shows the results of extended depth of field on a series of images. The images in the stack are shown on the right half of the screen; the check marks indicate which files are being used. To remove an image from the stack, you simply uncheck the photo.

of the smaller structures, the larger structures become too bright, making it impossible to see their interior details.

In figure 9-23, the arranged diatoms are photographed with enough light so the smallest diatoms are easily visualized. The larger diatom's interior is overexposed and appears as bright region without detail. However, if you reduce the exposure to reveal the interior of the large diatom, then the smaller diatoms disappear from the image (figure 9-24). To reveal all the details within this image, you can expose carefully for the highlight and hope that the dimmest structures have sufficient exposure to reveal their details in image processing. Or, you can take multiple images at varying exposures and combine them into one file that records all the intensity

Figure 9-23: This micrograph of an arranged slide shows the smaller diatoms well. The larger diatoms scatter so much light that their interiors cannot be seen.

information. This kind of file is an example of High Dynamic Range (HDR), which extends the range of the camera in recording intensity variations. The HDR file by itself cannot show these variations on a monitor or a print because the range of intensities is too great. Tone mapping software reduces the dynamic range to a level that can be translated for viewing. The results of using this software on an HDR file are seen in figure 9-25. The intensities are mapped so that they can be seen in a single micrograph.

Collecting the images to generate the HDR file is fairly simple. The first image should be

Figure 9-24: When the exposure is reduced so that the larger diatoms reveal details, the smaller diatoms disappear from the field of view. Combining this image with figure 9-23 generates an HDR file that has the full intensity information from both files. Unfortunately, the combined file cannot be directly visualized on the monitor or in print because the range of intensities cannot be displayed as a single image.

taken to reveal the dimmest structures, then the exposure should be reduced progressively by two f-stops. This is easily accomplished by reducing the shutter speed by a factor of four. For example, if you start with a one-second exposure, the next exposure should be one-quarter of a second. Continue reducing the exposure until the details in the brightest areas are properly exposed.

An HDR file can be generated by using Photoshop's File Merge to HDR in Adobe Photoshop CS4 You can then tone-map the file

Extending the Dynamic Range of the Camera 153

Figure 9-25: This is a tone-mapped print of an HDR image. By carefully reducing the contrast in some regions and raising it in others, you can display the entire dynamic range of the HDR file.

within Photoshop. However, it may be simpler to purchase software that is specially designed to make HDR files and tone-map them for output. A popular program for this work is Photomatix, which can be downloaded at http://www.hdrsoft.com/download.html.

10 Buying a Microscope

The best way to acquire a microscope is to buy it new from a reputable vendor. There are several advantages in doing this. First, you are assured of obtaining a microscope whose performance meets professional standards, especially if it's from a major manufacturer such as Olympus, Nikon, Leica, or Zeiss. Another advantage is that new microscopes have warranties and are backed by extensive sales and support teams dedicated to ensuring customer satisfaction. Whether you are a novice who simply wants to obtain a microscope as soon as possible or a professional who needs a productive research tool, this is the most efficient solution.

Although there are other competent microscope manufacturers, Olympus, Nikon, Leica, and Zeiss produce microscopes that are not only of very high quality, but that also provide extensive lines of accessories. As a result, their microscopes are capable of almost any type of research project. For example, if you need to do Nomarski DIC or fluorescence (see chapter 8), your best choice is to buy from one of the four major manufacturers; other manufacturers may not produce the accessories needed for those techniques. If you decide on another microscope brand, make sure it has a compatible line of accessories to accomplish your goals.

Another consideration when selecting a microscope is its ability to accept accessories. Major manufacturers offer microscopes in different categories priced to mirror the level of expandability; instruments that accept fewer accessories have lower prices. The least expandable instruments tend to be student or laboratory microscopes, while the most expandable instruments are research microscopes. Student or laboratory microscopes can usually be equipped for phase contrast or darkfield work (see chapter 8). However, they may not accept all the accessories for fluorescent illumination or DIC work.

For example, Olympus BX series microscopes are classified as research instruments and can be upgraded with advanced accessories. However, CX series microscopes, with smaller and lighter stands, accept only some of those accessories—including phase contrast condensers and epifluorescent illuminators of limited capability. Only two fluorescent filters can be mounted in the CX's epifluorescent accessory, as compared to the six that can be mounted in the BX. Similarly, the phase condenser houses only two rings instead of three.

A manufacturer's representative can help you determine the optimum microscope for any given budget. If you are certain that

Tissues, from either planets or animals, have to be prepared for observation with a microscope. Typically the cells are killed and the tissue is cut into thin slices, known as sections. The tissue constituents are given color and contrast by staining them with dyes. This photograph is a section from a tree commonly known as basswood or linden. It was taken with a 4x objective and a 1x eyepiece.

you won't use fluorescent illumination or DIC, other manufacturers produce credible microscopes for transmitted light observation. Make sure that whatever microscope you choose has an interchangeable condenser and a built-in Köhler illuminator. This should give you the option of upgrading the microscope for phase contrast or darkfield illumination in the future.

Used Microscopes

Purchasing used microscopes has its place and value. If you wish to obtain a research-grade microscope and save money, the best recourse is to buy used. Options range from modern stands that are still in production to older stands that have been discontinued for several decades. With the former, you get all the advantages of a new microscope, provided it is in good repair and supported by the vendor. However, the savings in cost can be quite modest, reflecting the high demand for a desirable instrument. Finding such microscopes can be difficult. Occasionally, a sales representative may have demonstration or used stands for sale.

Finding a used discontinued model, most likely an instrument with a finite tube length objective rather than an infinity optical tube length, is easier since such stands have been discontinued for at least a decade. They tend to provide the greatest savings; however, you face the risk that the desired accessories will not be available, making it difficult to fully upgrade the microscope. Moreover, the accessories may be obsolete. For example, microscopes of this vintage may be equipped with epifluorescent illuminators, but improvements in filter design and illuminator housings make newer microscopes more desirable. I acquired a used Leitz Ortholux stand; however, its fluorescent accessories are no longer, in my view, suitable for research work. Outfitting this microscope for fluorescent illumination is difficult because the accessories are rare. Worse, the filters that are available are inefficient when compared to modern filters. The newer illuminators by Leica for their modern microscopes, as well as those for in production Nikon, Zeiss, and Olympus Microscopes, are far superior in providing a bright, high-contrast fluorescent image. However, as a phase contrast system, the Leitz Ortholux costs a fraction of what an equivalent new microscope with a comparable lens would cost. For this application, it was an excellent bargain.

This microscope's performance is equivalent to a modern stand for phase contrast, darkfield, and transmitted light work. I was able to use the microscope for these purposes without any additional expense. A hidden benefit that made this purchase better than buying a new microscope is that the Ortholux's discontinued Heine phase contrast system provides superior resolution of phase objects—far surpassing modern phase contrast optics.

Although I would not recommend this for a novice, another option is purchasing a microscope through an online auction house. The increased savings come at the risk of buying an instrument that may be nonfunctional. Admittedly, you can obtain an outstanding microscope at a very low price—but for microscopes that are currently in production, the savings may not be as great as one might hope. Many of these sources are scanned by professional organizations that buy and resell microscopes. Occasionally bidding wars result,

using the price of a desirable used microscope to reach ridiculously high levels. Furthermore, auction houses do not guarantee the condition of the microscope, nor do they support it. At best, you can get a refund for the purchase minus the shipping cost, which is usually not refundable. Essentially, purchasing a microscope though an online auction house equates to "buyer beware".

That said, I have bid and won several microscope accessories through online auction houses. This was the only means for obtaining rare accessories. Frequently, I have found items with dusty lenses, dried lubricants that made mechanical controls stiff, and in some cases, delaminating lenses. An experienced microscopist, or an adventurous hobbyist, may be able to refurbish these items to their full capabilities. If one is fortunate, a thorough cleaning is all that is needed. However, there is a risk. Because of its delicacy, a highly corrected lens may not be in a condition that can be restored.

As an example, I was recently interested in acquiring an apochromatic Leitz 40x objective. I was able to purchase three lenses and found one of superlative quality and performance. The other two were of decent optical quality but not outstanding. This variation in quality is something that must be accepted with auction houses.

Another item that I acquired through an online auction house is a Leitz Heine condenser. Fully equipped, these condensers are rare, and finding all the components (upper lens element for oil immersion work and filter holder) takes patience and time. I also bought a complete used microscope stand with optics from Bunton Instrument Co. Inc. This purchase has been very satisfactory, and the instrument was available for immediate work as a photomicrography unit.

If you approach an online auction site with the attitude that a significant part of its value is the enjoyment of searching, bidding, and acquiring with an element of risk taking, then you will not be disappointed. However, if your goal is to attain an optically perfect system in excellent mechanical and cosmetic condition, fully usable, with minimal effort, you will most likely end up disappointed. Again, the most efficient approach is to purchase from a dealer or distributor. It's a trade-off: the price advantage of buying used versus the certainty of acquiring a microscope with guaranteed performance.

In summary, used stands that can be easily upgraded with plentiful accessories are the most expensive since they are usually still in production. In contrast, discontinued microscopes with fewer accessories are much less expensive. Online auction houses provide a possible source of microscopes—and indeed, they may be the only source for rare accessories.

What to Look for in a Microscope

For photomicrography, you should select a microscope with three tubes (a trinocular head): two for binocular viewing and one for recording (phototube). The most versatile units have a sliding prism for adjusting the ratio of light between the visual tubes and the phototube. For example, you can select one of three positions: 100 percent of the light to the visual tube, 20 percent to the visual tube and 80 percent to the phototube, or 100 percent to the phototube. These options are valuable when dealing with faint samples; all of the

	Objective				Eyepiece
	4x	10x	40x	100x	
Final Power	4x	10x	40x	100x	1x

Table 1: There are only four magnifications available for photography and this restricts the photographer's ability to compose the subject within the frame of the camera. The magnification is usually too high so that portions of the subject lie outside the camera's frame or too low so that there are not enough pixels to record a finely detailed image. For cameras with a 7-micron photosite, the 1x eyepiece enables this camera to reach the Nyquist criteria with a 100X objective with an NA of 1.2, so that the theoretical limit of resolution of the microscope can be recorded.

	Objective				Eyepiece
	4x	10x	40x	100x	
Final Power	4x	10x	40x	100x	1x
	5x	12.5x	50x	125x	1.25x
	6.4x	16x	64x	160x	1.6x
	8x	20x	80x	200x	2x

Table 2: With a magnification changer that provides 1x, 1.25x, 1.6x, and 2x, the photographer has greater control in composition. Images can be framed precisely within the frame of the camera. The only magnification range that has a doubling is between 20x to 40x. For the 100x objective, the additional magnification provided by powers greater than 1x do not record any finer detail for a camera with a 7-micron photosite and these higher magnifications are not useful.

light is used for a specific purpose, and none is wasted.

Occasionally, you can find a trinocular system without a sliding prism that simply splits the light between the eyepieces and camera. This alternative is convenient if the sample is brightly lit. There is no need to move a prism when switching between photography and visual observation, which is especially desirable when photographing a living, moving specimen. Both modes of use are available instantaneously.

Such a unit is less expensive than a unit with a prism and also more robust since it does not require any moving parts. The disadvantage is that the visual tubes permanently siphon light away from the camera, making this arrangement unsuitable for work involving low light intensities. A more expensive design, with an adjustable prism that allows 100 percent of the light to go either to the camera or to the eyepieces, is superior for work with dimly lit samples generated by fluorescent or darkfield illumination.

An often overlooked but highly desirable accessory is a magnification changer, which fine-tunes the degree of magnification imparted to a digital camera. As discussed earlier, precise control of the magnification is desirable for generating well-composed photographs. When a microscope is equipped only with objective lenses, the magnifications with a 1x eyepiece are typically 4x, 10x, 40x, and 100x. These magnifications are suitable for visual observation but too coarse for photography (table 1). A magnification changer provides intermediate magnifications for the camera, creating 16 steps between 4x and 200x. The magnification increases gradually, in increments of 0.25x, except between 10x and 40x where the magnification doubles

table 2). This can be remedied by buying a 20x objective and using the magnification changer to expand the range to include 25x and 32x (table 3).

Although higher-power eyepieces can be added to the phototube, this is inconvenient since the camera must be removed in order to change the eyepiece. A magnification changer simplifies this operation to a simple turn of the knob. The changer made by Zeiss Oberkochen, known as an Optovar, has more features than most magnification changers. For example, it has a focusable Bertrand lens for inspecting the back aperture of objective lenses. This is useful in phase contrast work or centering and aligning the microscope. In addition, it provides a useful diagnostic tool for aligning microscope optics or for finding dirt in the microscope's optical train.

		Objective				Eyepiece
	4X	10X	20X	40X	60X	
Final Power	4X	10X	20X	40X	60X	1X
	5X	12.5X	25X	50X	75X	1.25X
	6.4X	16X	32X	64X	96X	1.6X
	8X	20X	40X	80X	120X	2X

Table 3: The addition of a 20x objective and the replacement of the 100x oil immersion objective with one of 60x provides the photographer greater control in adjusting magnification. There is a gradual increase in magnification between 20x and 40x. I have found that a 40x objective with an NA of 0.95 or greater and a 60x objective with an NA of 1.2 or greater allow me to take advantage of the additional magnifications available with the 40x and 60x objective.

Stage

The microscope needs a large, stable platform to support the specimen. A stage equipped with clips is inadequate for anything but the lowest-power work—and while you can learn to move a slide manually at 400x with your fingers, it is a frustrating task.

For careful work, a mechanical stage is invaluable because it has a slide holder moved by a geared system. The least expensive slide holder clamps onto the stage. In contrast, the more expensive mechanical stages are massive and an integral component to the microscope. Because they have a low profile, they are capable of a wider range of movement without striking the objective lens. This enables you to scan the entire slide without having to reposition it manually.

The stage should be marked with a scale and vernier for recording the position of the specimen. Measurements can be made to a 0.1 mm level of accuracy, allowing you to return to an area simply by dialing in the recorded position. For biological microscopes, the stage moves in the x-y direction; however, for photographic composition, it is desirable to have a rotating stage to frame the specimen within the borders of the sensor.

Substage and Illuminator

Beneath the stage is the substage, which consists of the condenser, the condenser mount, and the field diaphragm for microscopes with an internal illuminator. Research microscopes allow the condenser to be removed and replaced with a darkfield, phase contrast, or interference contrast condenser. In addition, it allows the condenser to be focused and centered. A sliding dovetail mount or a simple sleeve may be used; however, there must be a provision for centering darkfield condensers and a means for focusing them. Typically, this is accomplished with a rack and pinion.

If the substage does not have an interchangeable condenser mount, the microscope will have limited ability to control lighting or to expand its functionality. Advanced imaging strategies such as phase contrast, Nomarski DIC, high-resolution darkfield, and Hoffman modulation contrast require specialized condensers to replace the simpler unit that comes with the standard microscope.

Most microscopes are equipped with built-in illuminators. For light-intensive applications such as darkfield or Nomarski DIC, newer microscopes come with 12-volt, 100-watt bulbs. Many older units designed primarily for transmitted light work have much dimmer 6-volt, 15-watt tungsten bulbs. This is sufficiently bright for work with stained specimens; however, for light-intensive applications, these bulbs may need to be run beyond their maximum voltage.

For visual operation, a variable rheostat allows you to vary the light intensity by under-running the bulb's voltage. This is convenient for visual work, and it prolongs the longevity of the bulb. Unfortunately, this practice is not recommended for photography since the bulbs show a shift in color values and impart a tint to the specimen. To maintain consistent color values, operate the bulbs at a constant voltage. If you wish to change light intensity, insert neutral density filters in the light path.

Some stands come equipped with a higher-intensity bulb such as a 6-volt, 30-watt illuminator. The Leitz Ortholux has a brighter illuminator; however, even this unit must be run at its maximum voltage for light-intensive applications. With some microscopes, it is simple to upgrade the illuminator to a 12-volt 100-watt quartz halogen bulb. In other cases, the bulb is located within the stand and you cannot simply substitute a higher-watt bulb.

Quartz halogen bulbs provide enough light for all microscope applications. However, they generate intense heat, which must be dissipated so that it won't shorten the bulb life or damage the microscope. Modern stands equipped with quartz halogen bulbs, such as the Olympus BX51, have well-ventilated housings that extend out from the microscope to prevent the bulb and housing from overheating.

Older Microscopes Suitable for Digital Photomicrography

In the following sections are descriptions of some older microscopes that I have used for photomicrography. This list represents my personal experience, and undoubtedly I missed some stands that would be suitable. However, the list serves as a starting point, and it can be a guide for what you might find desirable in a used microscope. It describes positive design features as well as pitfalls.

For work with phase contrast, brightfield, darkfield, or oblique illumination, many of

these stands rival modern microscopes. Some of them have a weakness in epifluorescent illumination, and for this particular function, the improved performance of current research microscopes is worth the extra expense. For the hobbyist, the epifluorescent capability of older microscopes is usually adequate.

All of these microscopes are available with trinocular heads that consist of a dedicated phototube for the camera and two other tubes for binocular viewing of slides.

Zeiss Oberkochen, 160 mm Mechanical Tube Length

Zeiss Oberkochen is a long-time West German microscope manufacturer that after the merger with Zeiss Jena is now simply known as Zeiss. This company produced a series of microscopes with a mechanical tube length of 160 mm that were widely used in United States research laboratories.

The Zeiss WL, Universal, and Photomicroscope stands are worth considering for digital photomicrography. They were made in the 1960s and can be equipped for almost all modern microscopy techniques. They are mechanically well built with the coarse and fine focuses operating as separate mechanisms. The stage and substage assembly are fitted via a dovetail and can be removed or repositioned by the operator. This allows for easy interchange of stages, and when the substage carrier is removed, you can extend the range of the coarse focus and use the stand for macrophotography. Another valuable feature is that these microscopes can be equipped with magnification changers. In addition, Bertrand lenses can be used to observe the back focal plane of the objective for centering the phase rings.

All of these stands should be purchased with trinocular tube heads and photographic ports. For example, it is possible to put together a microscope that provides epifluorescent illumination and Nomarski DIC. However, certain combinations of accessories are not possible. On the Zeiss WL, you cannot have both the Optovar (magnification changer) and an epifluorescent illuminator. To use this combination, you need the larger Universal or Photomicroscope stands.

Another problem with older Zeiss optics is that they are prone to delamination. Prior to purchasing, examine the objectives and intermediate heads carefully to see if there is any damage sufficient to degrade the image. Sometimes such defects are minor and have little effect on obtaining sharp photographs.

The Zeiss WL is a wonderful microscope for photography. Its compact design occupies a small footprint on the workbench. One of its valuable features is that the stage and substage condenser carrier can be separated from the focusing adjustment. Removal of the substage allows you to lower the stage 25 mm for examining unusually thick specimens.

If there is one fault with this microscope, it is the compact 6-volt, 15-watt illuminator. It is sufficiently bright for brightfield work but barely adequate for oil immersion work with darkfield, phase contrast, and Nomarski DIC. Fortunately, the bulb can be run at lower voltages to extend its life, as it is expensive and sometimes difficult to find. The 6-volt, 15-watt illuminator can be replaced with either a 12-volt, 60-watt tungsten or 12-volt, 100-watt quartz halogen illuminator; however, this requires raising the microscope about 25 mm to add the larger-sized lamp housings. These housing lie outside the base of the microscope to allow airflow to cool the

bulbs. These accessories can be found at online auction houses.

The Zeiss WL is unique in that it can also be used with an external illuminator. An adjustable mirror is available as an accessory for reflecting the light from such an illuminator to the condenser. Subsequent microscope designs do not allow the easy use of external illuminators but must be used exclusively with their internal illuminators.

Fluorescent illuminators and filters can be found for the Zeiss WL. They mount between the nosepiece and the trinocular head. Avoid the 50-watt mercury vapor lamp because its output is too low for fluorescence microscopy; the more intense 100-watt assembly is superior. The Zeiss WL can hold two fluorescent cubes and you can switch quickly between the sets of filters. It is possible, for example, to view a sample stained with either fluorescein or rhodamine.

If you wish to have a microscope that holds three filters, you will need the larger and more expensive Universal or Photomicroscope stand. These larger stands have the advantage that you can use the fluorescent filter illuminator with the Optovar and vary the magnification.

A popular and common microscope is the Zeiss GFL; however, it is not recommended for photomicrography because the coarse focus raises and lowers the body tube and carries the weight of the camera. To prevent the body from drifting downward from the camera's weight, the microscope is fitted with an adjustable friction clutch. Unfortunately, when the clutch is tightened, the coarse focusing knob becomes difficult to turn.

Leitz Ortholux, 170 mm Mechanical Tube Length

The Leitz Ortholux was one of the first research-grade stands designed to take a multitude of accessories and work solely with a built-in illuminator. Virtually all of its components can be adapted for specialized imaging tasks. For example, you can insert components to undertake fluorescence microscopy or specialized interference contrast microscopy. Such versatility has made this large stand one of the most popular among hobbyists, allowing them to explore some of the most advanced imaging paradigms available to research scientists.

The low position of the focus and stage controls allows you to rest your forearms and hands on the table while operating the microscope – an advantage when using the microscope for several hours. The coarse and fine focus carry only the weight of the stage, so heavy cameras can be mounted without altering the tension of the coarse focus. In addition, the fine and coarse knobs have different gearing systems; the fine focus has an excursion range of 2 mm.

Leitz stands are unique in using a mechanical tube length of 170 mm, and it is sometimes assumed that this precludes their use with fixed tube length lenses from Zeiss, Nikon, Wild, and Olympus. This is not always the case. Such fixed tube length lenses are designed for a mechanical tube length of 160 mm but for an optical tube length of 150 mm. Fortunately, Leitz eyepieces operate on an optical tube length of 152 mm—only 2 mm different from the other manufacturers' lenses. For most purposes, these other objectives can be used effectively, provided Leitz eyepieces are in the optical train.

The Leitz substage's dovetail mount allows for easy interchange of condensers by sliding them into and out of the holder. Since each condenser has its own centering screws, it is possible to interchange them so that they retain center. The Leitz Ortholux has two interesting and unique condenser designs. One is the Berek transmitted light condenser, a unit that possesses two iris diaphragms: one as the condenser and the other as the field iris. This is an older design for microscopes lacking a field diaphragm. While it is popular among collectors, its function can be matched by the less expensive 600 series of condensers, which have a single condenser diaphragm. The majority of Leitz Ortholux microscopes have a field diaphragm, making it unnecessary to use a Berek condenser.

Another unique condenser is the Heine, which serves a multitude of functions. It possesses a reflective element that generates a variable cone of light. Primarily, it is used with phase contrast objectives to provide an infinitely adjustable cone. This feature has proven valuable in my laboratory in that virtually any manufacturer's phase objective can be used on a Leitz stand equipped with this condenser. Another benefit is that the subject can be viewed by transmitted, phase contrast, or darkfield illumination. This condenser is no longer manufactured, and its versatility has made it an appealing accessory among hobbyists.

The major weakness of the Leitz Ortholux microscope is its illuminator. The design is dated, and replacement bulbs can be difficult to obtain. Although the microscope cannot be used with an external light source, the Leitz lamp housing can be modified easily to generate intense illumination for seeing and analyzing fine details. I have a modified illuminator housing for my Leitz Ortholux that uses a 12-volt, 100-watt quartz halogen illuminator. This modification has proved invaluable for working with darkfield illumination.

Accessories for darkfield, Zernicke-style phase contrast, fluorescent, polarized light, and differential interference contrast illumination can be found at online auction houses and occasionally at microscope shops.

Nikon S Series, 160 mm Mechanical Tube Length

This microscope series was made in the 1950s and 1960s. The older scopes are equipped with separate coarse and fine focus knobs, while the later models have coaxial controls where the fine focus operates throughout the range of the coarse focus. While convenient, the later design has a downside. The combined coarse and fine focus mechanism uses a nylon gear that is susceptible to wearing and cracking over time. Replacing this gear can be expensive, so a prospective buyer should make sure that the fine focus is fully operational. If the gear is damaged, I. Miller (http://www.imillermicroscopes.com/) sells a brass replacement. You can purchase the gear separately and install it yourself, or I. Miller can do it for you. This might be the way to go since I. Miller can also refurbish the microscope. Since the focusing controls only move the stage, the weight of the camera has no effect on them.

The Nikon S condenser is mounted within a focusable sleeve that does not have centering capability. The supplied condenser is unusual in that its diaphragm can be moved off center and then rotated for oblique illumination. For transmitted brightfield work, the illuminator provides ample light with a 6-volt, 30-watt bulb.

An unusual accessory is the differential phase contrast unit mounted beneath the binocular head and above the nosepiece. This unit has four phase annuli and provides phase contrast images for standard brightfield objectives. It is a quantitative tool for measuring optical path differences, and it can generate a color phase image that is aesthetically pleasing. The Nikon S series can also be purchased with more conventional Zernicke phase contrast objectives and condensers.

Olympus BH Series

The Olympus BH series is a more recent design that can be outfitted with almost all modern microscope accessories. Unlike with most of the other microscopes described in this chapter, the fine focus is operational throughout the focusing train; you can turn the knob and travel more than 2 mm in excursion. This feature is convenient in that you do not abruptly reach the end of the fine focus travel. The fine focus is made of different material than the fine focus for the Nikon S series and is reportedly not subject to wearing or cracking.

The mechanical tube length is 160 mm, and there is an accessory that allows the microscope to be used with the new infinity tube length objectives. The binocular head can be equipped with larger diameter tubes for a 30 mm eyepiece, which creates a wide field of view. The microscope comes with either a 6-volt, 20-watt quartz halogen bulb or a 12-volt, 100-watt bulb that is brilliant enough for darkfield, phase contrast, or Nomarski DIC.

The available accessories make stands in the Olympus BH series suitable for almost all aspects of research, and they are superior for fluorescence work and interference contrast microscopy. These stands command a premium price, which may be well worth it depending on what you want out of a microscope.

Glossary

Abbe condenser
A simple two-lens condenser commonly found on laboratory and teaching microscopes. It is not corrected for chromatic or spherical aberration.

achromatic condenser
A condenser lens for brightfield microscopes corrected for chromatic and spherical aberration. It is used for studies demanding the highest-quality imaging.

additive color mixing model
A color system comprising the three primary colors of light: red, green, and blue.

analog signal
A signal that measures intensities with a continuously variable value.

angular aperture
The half angle of the cone of light accepted by the objective lens.

articulating LCD
The liquid crystal display, of a digital camera, that is used for previewing the subject or displaying the final image. It is mounted hinged so that it can be positioned

Bayer mask
A 2 x 2 color filter array mounted over a digital sensor so as to place a red, green, or blue filter over individual photosites. For the entire sensor array, 50 percent of the photosites are covered with a green filter, 25 percent with a blue filter, and 25 percent with a red filter.

binocular head
The part of the microscope that holds two eyepieces to enable the observer to view the sample with both eyes.

bit
For computer systems it is a basic unit of information; a contraction for the term binary digit. Its value is either 0 or 1.

black level
For the output display, it defines an intensity value of 0.

brightfield illumination
The process of lighting a microscopic subject by transmitted light. Light passes through the specimen, and where the specimen is absent in the field of view, the field appears bright.

Canada balsam
A gum derived from the Canadian fir tree and used as a medium for mounting specimens on slides. When dried it has a refraction index of glass, 1.515.

CCD
An acronym for charge coupled device—a solid-state sensor used in digital and video cameras. The circuitry for amplifying its analog signal and converting it to a digital format is located outside the chip.

CMOS
An acronym for complementary metal oxide semiconductor—a solid-state sensor used in digital and video cameras for detecting light. Each photosite has its own amplifier and output circuitry

color temperature

A measurement scale used for describing an illuminant's spectral properties in kelvins (e.g., 5500 K). Its value is correlated to the theoretical emission of a black body that is being heated so that at lower temperatures the radiated light predominates with red and at higher temperatures, its emission shifts to blue.

condenser centering knobs

Adjustment controls used for laterally moving the condenser's optical axis so that it is in line with that of the objective lens.

condenser focus knobs

The adjustment controls used for vertically moving the condenser for maximally concentrating the illuminator's light onto the specimen.

condenser iris

The diaphragm within the condenser used for adjusting the cone of light that is being concentrated on the specimen.

coverglass

A thin, optically parallel transparent material that covers the specimen and separates it from the objective lens. Typically it is made of glass, and has an index of refraction of 1.515, and is 0.17 mm thick.

DAPI

A fluorescent dye (4′,6-diamidino-2-phenyl-indole) used commonly to stain deoxyribonucleic acids. It absorbs light that is violet in color and emits light that appears blue when viewed through an epifluorescent microscope.

darkfield illumination

A type of lighting that is aimed at an angle so that it does not enter the objective lens. In the absence of a specimen, there is no light passing through the microscope objective and the field appears dark.

darkfield stop

An opaque circle fitted underneath a condenser so as to block the central rays of light. Peripheral light passes around the circle and is focused at an oblique angle so that it fails to enter the objective lens.

depth of field

The area in front of and behind the region of sharpest focus that appears adequately sharp. This region is defined for the subject area in front of the lens.

depth of focus

The areas in front of and behind the plane of sharpest focus of a lens that renders an adequately sharp image. Optically, this region is defined as the area behind the lens.

diatom

A unicellular algae that secretes a shell composed of silica (silicon dioxide). The shell has perforations that are arranged geometrically and whose regular spacing is such that they can serve as resolution test subjects for the microscope.

differential interference contrast
A method of lighting used for generating a high-contrast image of transparent specimens. It converts phase variations into intensity changes and is characterized by generating images whose fine structures have a shadowed appearance were one edge is bright and the opposite is dark, giving small particles and linear structures a three-dimensional appearance.

digital
In this context, describes signals that are presented as values in two different states, such as on or off. These discrete and discontinuous values are precise.

digital single lens reflex (digital SLR, DSLR)
A camera whose photographic lens serves to project the image of the subject to the viewfinder as well as to a digital capture sensor.

dipping lens
An objective lens designed to have its front element immersed in water. The specimen is not covered with a coverglass.

direct light
Light that passes through the specimen without deviation.

DNG
Digital Negative—a computer file format by Adobe for images. Its purpose is to provide a standard file format for archiving digital image files.

dry lens
An objective lens whose lens element closest to the subject is designed to work in air.

dynamic range
The extent between the highest and lowest limits of light intensity that can be recorded by a sensor.

epi-illumination
An illumination system for the microscope where the objective lens serves as the condenser and imaging lens.

epifluorescent illumination
A fluorescent illuminator that uses the objective for both the condenser and imaging lens.

extended depth of focus
A means of increasing the depth of focus beyond the optical limits of the lens.

extended dynamic range
A means of increasing the dynamic range of the sensor by employing multiple exposures of varying duration.

eyepiece
The imaging lenses positioned closest to the eye of the observer. It increases the magnification of the objective lens.

field iris
A variable diameter diagram positioned so that it is focused on the image plane. It is the part of the illumination system that limits the area being lighted, thereby reducing glare.

filter cubes
A holder for fluorescent filters that holds the exciter filter, the dichromatic mirror, and the barrier filter in optical alignment. It allows the rapid replacement of filter assemblies for fluorescent microscopes.

fluorescein
A dye commonly used in fluorescence microscopy. It absorbs light of wavelength 494 nm (visually appearing blue) and emitting at 518 nm (visually appearing green).

fluorescence
The process by which a molecule releases a photon after it absorbs light. An absorbed photon raises the molecule's electron to a higher energy level. Within nanoseconds this energized electron drops to a lower energy level, releasing a photon.

fluorescent filters
Light filters that are used to either isolate the excitation wavelength (exciter) of a fluorescent dye or limit the imaging of the dye by isolating its emission wavelengths (barrier).

fluorescent microscope
A microscope equipped with illuminators and filters for the visualization of fluorescent dyes.

focusing telescope
An optical device used for inspecting the back focal plane of the objective lens. It is commonly used for aligning the phase rings of the condenser to the phase plate of the objective.

frustule
The external shell of a diatom. The regularity of its markings makes it a usable object for testing microscope objectives.

gain
The amplification of a sensor's output so that the resultant image appears brighter. The resultant image has higher contrast, less dynamic range, and increased noise. On dedicated photomicrographic cameras, this control is labeled as gain. On digital SLRs, the control for adjusting the camera's ISO setting is its gain control.

glycerol immersion objective
An objective lens designed so that its lens element closest to the specimen is submerged in glycerol.

head
The part of the microscope stand that has the eyepiece. It may hold one, two, or three eyepieces.

high dry lens
An objective lens of 40x or greater power designed so that its lens element closest to the specimen works in air.

high dynamic range (HDR)
The image processing techniques to allow capturing and displaying a range of intensities beyond what can be accomplished by a single exposure with a sensor. Typically it involves capturing multiple images at varying exposures and then merging them and displaying them in a single image.

highlight
The region of an image composed of pixels with the highest value. Highlight most often refers to the white areas in an image. By convention, the term usually excludes points of light caused by specular reflection.

histogram
A graphical display of the frequency of a variable plotted against its category. For digital cameras, brightness is represented along the bottom (x-axis) and the frequency of pixels falling within that brightness value is displayed along the vertical (y-axis). Black is displayed on the left; white is displayed on the right. It is a display of the intensity values within the image plotted against their frequency.

ImageJ
A public domain software package used for manipulating images and quantifying intensities.

immersion objective
An objective lens used by dipping its front lens element (the one closest to the specimen) in a liquid medium. In microscopy, the liquid may be an optically defined oil, glycerol, or water.

immersion oil
An optical defined oil to be used with an oil immersion objective. It has an index of refraction of 1.515 to match glass.

differential interference contrast microscopy
An optical contrast enhancement technique used for viewing transparent specimens. It converts phase variations into a differential change in intensities, giving the image a three-dimensional appearance. Polarized light and birefringent prisms are used for creating this effect.

International Organization for Standardization (ISO)
An international organization whose role is to establish many commercial standards. Its members are representatives of national standards organizations. ISO standards were established for specifying the sensitivity of film to light. For digital SLRs, ISO settings are used to increase the gain of the sensor so that it can detect lower intensities of light.

JPEG or JPG
A computer digital file format used for compacting the file's size. JPEG is an acronym for Joint Photographic Expert's Group, the committee that created the specifications for this format. In the naming of computer files, .jpg is the filename extension used for files saved in older versions of DOS.

Köhler illumination
A method of illuminating the specimen for a microscope that ensures an even field of illumination, minimum glare, and high contrast. It was developed to provide homogenous lighting when using inhomogeneous light sources.

live preview
A feature of digital single lens reflex cameras characterized by using an electronic sensor and an LCD screen for viewing the subject prior to taking the exposure. Typically it uses the camera's recording sensor to generate the electronic image.

lookup table (LUT)
A matrix used for translating data into different numerical values. Intensity information from a digital sensor can be transformed into different intensities values or into color.

lossless compression
An algorithm used to reduce a computer files size so that no data is lost. Opening and expanding the compressed file re-creates a file that is identical to the original, noncompressed data.

lossy compression
An algorithm used to reduce a computer files size at the expense of data integrity. Expanding the compressed file will result in a file that is not identical to the original data file.

low dry lens
An objective lens designed so that its element closest to the specimen is designed to work in air. Generally, it is a lens that has a magnification less than 20x.

LUT
See *lookup table*

magnification changer
A generic term for an accessory placed beneath the head of the microscope and used to change the magnification to the camera and/or visual eyepiece.

mechanical stage
A geared device mounted on the stage of the microscope and used for moving the slide.

monocular head
The part of the microscope positioned above the objectives for holding a single eyepiece. It is used for either visual or photographic imaging.

MOS
MOS is an acronym for metal oxide semiconductor. A digital sensor used in Olympus and Panasonic digital SLRs that is advertised to provide increase sensitivity and reduced noise in comparison to CMOS sensors.

mountant
A material placed between the coverglass and the slide for supporting and preserving the specimen for observation.

Nelson illumination
An illumination system used for lighting transparent specimens under the microscope. The condenser lens focuses an image of the light source onto the specimen so that when the specimen is in focus through the eyepiece, the illuminant is also in focus.

Nomarski differential interference contrast
See *differential interference contrast*. Nomarski is in reference to George Nomarski, who modified the Wollaston prisms so that they can be used with this illumination technique.

nosepiece
A circular disc mounted on the head of the microscope for holding several objectives (2-6) for convenient interchange.

numerical aperture
The angular aperture of the objective lens times the refraction index of the medium between the coverglass and the lens.

objective
The imaging lens on the microscope positioned closest to the specimen (object). It generates the first magnified image of the specimen.

oil immersion lens
An objective lens designed so that its front element works in a special oil with defined optical characteristics.

Optovar
An optical device manufactured by Zeiss Oberkochen for changing magnification. It is equipped with a Bertrand lens that can be rotated into the optical train for viewing the back focal plane of the objective lens.

Permount
A synthetic mountant commonly used for making permanent slides in histology laboratories. It is trademarked by Fisher Scientific and is used in place of Canada balsam.

phase annulus
A mask shaped as a ring and found in the condenser of a phase contrast microscope.

phase contrast
An illumination system used to render phase variations as variations in light intensity. It is sometimes described as optical staining.

phase plate
An optical platter that is found in the objective lens of a phase contrast microscope and alters the phase relationship of light and attenuates the light intensity from the direct light from the illuminator.

pixel
A graphics term used for the smallest fundamental element of an image, the smallest digital photographic element. It is a contraction for picture element. In digital sensors, it is the single photosite that detects and measures light.

pseudocolor
In imaging, the assigning of color to intensity values in a black and white image. Its role is to provides a means of distinguishing different fluorochromes in a single image.

RAW file
A digital image file used for cameras to preserve the full information captured by the sensor. It is proprietary to the camera manufacturer and is not universally recognized by all imaging software.

resolution (optical)
The minimum distance between two objects that records them as being separate. For microscopes, it is calculated to be

$$R = \frac{0.61\,\lambda}{NA}$$

where λ = wavelength of light used to image the specimen and NA is the numerical aperture of the objective.

resolution (image)
The total number of pixels used to make an image.

rhodamine
A dye used in fluorescence microscopy that absorbs light at 550 nm (light appearing visually as green) and emits light at 590 nm (light appearing visually as red).

rotating stage
The part of the microscope stand used to support the slide and capable of being rotated around the optical axis of the objective.

saturation level
The maximum light limit for a photosite so that higher light intensities are not recorded as increasing signal output.

scattered light
Light that is directed to move in all directions after striking the edges of the object.

single lens reflex (SLR)
A type of camera in which the photographic lens functions both in a viewfinder and as an image collection tool. A mirror reflects light to an optical viewfinder for focusing and composing the image. When the mirror is swiveled, light is directed to the light collection element. This camera was first used with film.

slide
The glass substrate used to support the object that is to be used for viewing with a microscope. Typically, it is an optically flat glass 1 mm thick, 25 mm wide, and 75mm long.

TIFF or TIF
Tagged Image File Format.

trinocular head
A component of the microscope that holds three eyepieces: two for visual observation and one for photographic recording.

vernier
A small movable scale that is adjacent to a larger fixed scale. It is graduated to provide fractional settings of the fixed scale, thereby increasing the accuracy of measurement.

water immersion lens
An objective lens whose lens element closest to the specimen is submerged in water. Typically, this lens is used with a coverglass.

white balance
A digital camera setting that adjusts the recording of the color image so that neutral gray areas without color are recorded without color.

Wollaston prism
A component of the differential interference contrast microscope.

References

Abramowitz, M.
Microscope Basics and Beyond.
Melville: Olympus, 1985.
This is a very compact reference that was distributed by the Olympus Corporation. It is an excellent, short introduction to light microscopy.

Abramowitz, M.
Photomicrography A Practical Guide.
Melville: Olympus, 1998.
This is a very compact reference for those investigators interested in recording microscopic subjects with film.

Bracegirdle, B., and S. Bradbury.
Modern Photomicrography.
Oxford: BIOS Scientific Publishers, Ltd., 1995.
This is a compact reference for the film photographer that describes methods of recording images. There is a chapter on making on the tools for making drawings with the microscope and recording moving objects with film.

Bradbury S., and P. J. Evennett.
Contrast Techniques in Light Microscopy.
Oxford: BIOS Scientific Publishers, Ltd., 1996.
A compact reference useful to all users of the microscope who are interested in learning about the theory and practice of phase contrast, oblique, Rheinberg, darkfield, and polarized illumination light. It is very readable and it has a chapter on using photographic and digital image techniques for enhancing contrast.

Cox, G.
Optical Imaging Techniques in Cell Biology.
Boca Raton: CRC Press, 2007.
A recent text on microscopy and digital imaging for the professional research scientist. Covering advanced topics on fluorescence, confocal, and total reflection microscopy, it has a chapter on contrast enhancing techniques but its emphasis is modern fluorescent techniques.

Delly, J. G.
Photography Through the Microscope.
Rochester: Eastman Kodak Co., 1998.
A practical reference for readers who wish to undertake film photography with the light microscope. Its information on optical techniques is applicable to digital photography and it is well illustrated.

Herman, B.
Fluorescence Microscopy.
New York: Springer Verlag, 1998.
This is a compact reference that serves as an excellent reference to fluorescence microscopy. It has a chapter on video recording of fluorescent images and another chapter on confocal and multi-photon imaging.

Inoue S., and K. R. Spring.
Video Microscopy: The Fundamentals.
New York : Plenum Press, 1986.
An advanced text on using electronic imaging cameras and recorders for the microscope. It is a recommended resource for the advanced student interested in learning the theory and practice of electronic imaging. This text is highly detailed and an invaluable aid to the cell biologist.

Kiernan, J. A.
Histological and Histochemical Methods: Theory and Practice.
Cold Spring Harbor: Cold Spring Harbor Laboratory Press, 2008.
A comprehensive text on tissue processing and staining methods. It has formulations for water-soluble mounting mediums and describes the dyes used in fluorescence and brightfield microscopy.

Murphy, D. B.
Fundamentals of Light Microscopy and Electronic Imaging.
New York : Wiley-Liss, 2001.
An up-to-date reference that describes modern microscopes and microscopy. It provides an excellent description of theory and practice for modern microscopy techniques. This is a reference text that should be present in every research laboratory.

Needham, G.
Practical Use of the Microscope: Including Photomicrography.
Springfield: Thomas, 1958.
This older text is invaluable to the microscopist interested in general microscopy theory and in the author impressions on some specific microscope objectives and microscope stands. It predates the development of the infinity tube length microscopes for biology of Olympus, Zeiss, Leitz (Leica), and Nikon; however, its discussion of the older stands is of value to the modern researcher or hobbyist interested in the older techniques. The author provides instruction on using oblique illumination for revealing the fine details in diatoms. Also, there is a section on near UV imaging and using Nelson illumination with external light sources.

Rost, F. W. D.
Fluorescence Microscopy V1.
Cambridge : Cambridge University Press, 1992.
This is part of a two-volume set that meticulously references fluorescence microscopy. It is recommended for advanced students of this type of microscopy. The first volume discusses general principles of fluorescence microscopy while the second volume deals with quantitative techniques.

Rost F. W. D., and R. Oldfield.
Photography with a Microscope.
New York: Cambridge Press, 2000.
A text covering microscope basics and film photography with the light microscope. It has a chapter on digital and confocal microscopy.

Sluder, G., and D. E. Wolf.
Digital Microscopy 3^{rd} edition: Methods in Cell Biology V 81.
New York: Elsevier Press, 2007.
This is a collection of articles for the professional microscopist who wishes to learn recent developments in electronic imaging. It is an advanced reference for the professional research scientist.

Smith R. F.
Microscopy and Photomicrography: A Working Manual.
Boca Raton: CRC Press, 1990.
This is a practical manual for using film to record microscope images. It has a useful chapter on making surface replicas. It is an excellent reference for those who use film to record microscopic specimens.